Freelance
Travel
Photography

Freelance
Travel
Photography

Helene Rogers

 BFP BOOKS London

British Library Cataloguing in Publication Data

Rogers, Helene
Freelance travel photography.
1. Photography. Special subjects: Travel –
Manuals
I. Title
778.9′991

ISBN 0–907297–17–X

First Published 1988

Published by BFP Books
Focus House, 497 Green Lanes, London N13 4BP
Printed in Great Britain by
Butler & Tanner Ltd

For Bob, Zoe, Marc, Ben and Matthew

Contents

Introduction

The library shelves are filled with travel books. The illustrations they contain are a source of inspiration not only to photographers but to the large number of people who simply enjoy looking at pictures from distant lands. Yet, despite the proliferation of such books, there are few that contain the personal experiences of a travel photographer. Equally, few photographic books set out to help photographers improve their travel photography; instead they are filled with massive amounts of technical data, most of which is readily available in the camera manual.

Simply looking at photographs does not help the outsider to enter into the world of the travel photographer. The photograph is the result, but it does not explain the equation – the story of how that photograph came to be. This book is an attempt to redress the balance, as well as an effort to answer the endless stream of questions that I am asked about travel photography.

The story of how a photograph came into being is always interesting and relevant to photographers who want to take better pictures themselves. I have often gazed at those glossy coffee table books with their tantalisingly exotic pictures and wondered about the photographers who took them. Was this picture simply the result of a holiday? How much time did the photographer spend in order to secure a particular photographic opportunity? These are the questions often asked but rarely answered. For example, my photograph of a woman and ox taken in North Yemen has been successfully published many times. The photograph is the result, but the story behind it – four years of negotiations to get suitable employment and to secure a plane ticket to the country, plus a week spent finding the local transport without which this photograph would not have been possible.

A Personal Vision

On some occasions a commission is obtained in advance and the whole photographic trip is sponsored by an employer. Most such work is straightforward, with everything prearranged. The photographer has few money worries and knows in advance where the photographs will be used and how much he will make from their sale.

Yet the vast majority of really interesting photographic trips are undertaken by a person who has made all the necessary arrangements alone. The photographer will often have invested large quantities of his or her own money on transport and on film, and is totally dependent on marketing the work when he returns home. Freedom from specific commissions enables photographers to broaden their horizons and choose their own destinations, through not only personal preference but knowledge of market requirements. But of course this method of working, although enjoyable, creates far more financial risk.

Some travel photographers can see only cliche pictures, but those who have the ability to lift them-

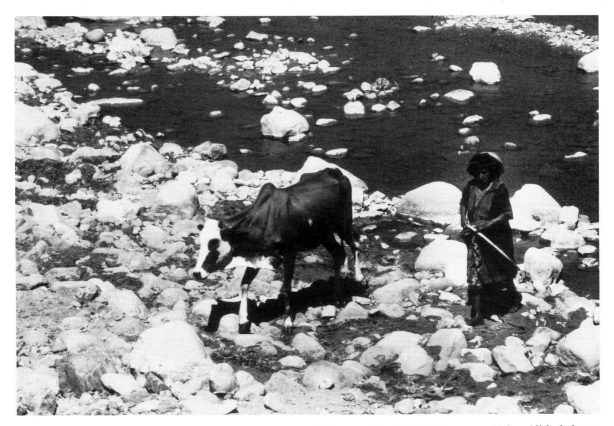

Woman and ox in North Yemen; a widely published picture due to its rarity value.

selves out of this mould frequently develop a personal style and a quality that makes their work more marketable. Successful travel photographers develop a perceptive vision and an ability to absorb different cultures that enables them to convey, through their photography, the atmosphere of the countries they visit.

A Fresh Vision

Anyone who is seriously interested in photography will soon discover that it is easier to find subjects in strange and foreign lands than at home. Essentially this is because nearly everything abroad is new and exciting, whereas at home familiarity makes finding interesting photos that much harder. The photographer is constantly stimulated by the newness of the surroundings, from the ways in which people behave to the differences in the landscape. This is the main reason why so many photographers spend a great deal of their money and time travelling.

I will never forget watching women wash their clothes in mountain streams in North Yemen. How much more interesting the simple act of washing seems in a foreign country than back at home, where it is just a boring chore! The same is true about many other simple, everyday occurrences – for most photographers familiarity really does breed contempt.

Large numbers of photographers become initiated into the world of travel photography by going abroad on holiday, and once they have sampled the delight of discovering new worlds it is not long before the desire to travel further and further afield becomes firmly established.

It may seem strange that despite the numbers of photographers travelling each year, there is still an opportunity to turn this pleasure into a lucrative pastime. Yet there are many professional travel photographers who do little else and make a good living, and there are also scores of amateur photographers who make their hobby pay for itself by selling the photographs they take whilst on holiday.

The skills required vary tremendously. There are those who are highly trained and with a great deal of experience, but there are also some relative beginners who manage to make a useful income whilst they are still in the process of learning, and many photographers just 'starting out' have had great successes. Although there are many reasons why this happens, in the main it is because they have freshness of vision. Of course, it can be very hit and miss if the photographer is not sure of exactly what he is doing, but there are many beginners who are more daring and more likely to have a go in situations where the more skilled photographer may not bother. This usually happens because the beginner does not realise the potential pitfalls and there-

fore is not worried about things that could go wrong. Occasionally these rather naive attitudes pay off and an exciting and unusual photograph is the result.

A Rewarding Life

With time a photographer will become known and established, and this will make selling their photographs easier. Sales increase because the people that buy travel pictures will know the name and the type of picture the photographer specialises in. But the complete beginner, as long as he continually circulates his photographs, bringing them to the attention of picture buyers, may also do very well.

The market for selling photography is incredibly big and changing all the time, and there are quite literally thousands of customers in need of good travel photography. There are books, magazines, newspapers, and brochures all of whom consume vast quantities of such material. To sell travel pictures it is not necessary to have any special qualifications – all that is required is to be able to produce a good travel photograph.

Travel photography can be very addictive – the more pictures a photographer takes the more he will be able to see and the more he will want to take. Anyone who has experienced the sheer joy of arriving in a new and interesting place with a camera will immediately be able to understand why so many struggle to make a living from this popular type of photography. But to become really successful the photographer must be prepared for hard work. The sheer grind of writing to editors, trudging round, and banging on doors, is enough to put even the most strong-willed people off for life, whilst the rejection slips which every photographer receives can have a most demoralising effect. On the other hand, there is the thrill and excitement of having that first photograph published. When you see your name in print for the first time, all past disappointments disappear with this first heady taste of success. Such success may not mean a great deal of money, but is the beginning of that recognition that most travel photographers ultimately seek.

Wool merchants in the market, Fez, Morocco.

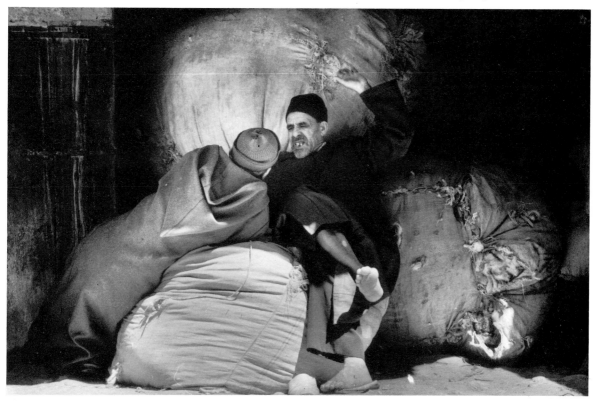

Beginnings

The first serious travel photography that I became involved with was the result of my first trip to Africa. For me the trip was a mixture of trepidation, fear and excitement. It was a journey full of hazards and pitfalls, but one with tremendous rewards. I remember feeling not unlike some of the great discoverers of the past, venturing into a land unknown! This sense of adventure and discovery has never left me. Even when I am travelling in Europe I feel this excitement. With my camera I discover people, ways of life, and strange worlds that can be turned into images, and through my vision I am able to communicate my thoughts and ideas around the world – photography transcends language barriers. The images I like best are frequently simple aspects of everyday life, such as a mother scolding her child, or they can be as transient as fleeting light painting a landscape.

The Challenge of the New

Too many photographers worry incessantly that everything they see has been photographed before; this never worries me because what I see is personally mine and therefore new and exciting. Most photographers have the ability to see through their own eyes and so tell a story with their pictures, not only about the scene in front of them but of their interpretation of that scene.

There are times when travelling alone becomes difficult. To succeed the photographer must be prepared to suffer discomforts and realise that not everything will always turn out the way it was intended. There are even times when the photographer will have to put up a struggle to achieve the results he requires. On the other hand, many find that it is precisely these challenges that make travelling with a camera so exciting.

In Africa I felt very vulnerable; a woman alone with a great deal of expensive camera equipment, in a strange land, on a strange continent. Slowly, as the days passed, I came to understand the way of life and began to assimilate the environment, and although there were situations which could be classed as dangerous these could now be put into context. Strangely, it was these feelings of danger and the unknown which helped to strengthen my feelings of excitement and adventure.

Africa is the continent where I learnt my photography and how to make the most of situations over which I have no control. After Africa my photography changed and my own style of working evolved. The travelling photographer alone in a strange land learns a tremendous amount not only about the people and places he visits but also about himself. There is much time in the evenings for

The covered market (souk) of Marrakech, Morocco.

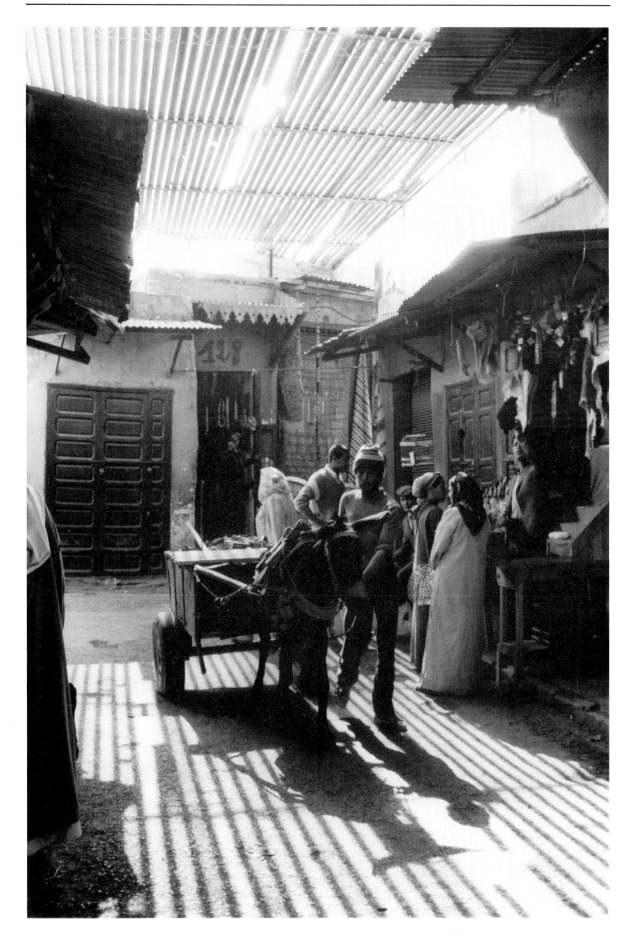

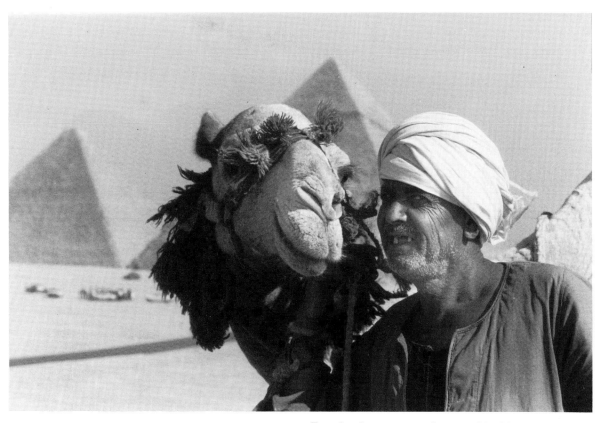

Egyptian faces amongst the pyramids, Giza, Egypt.

reflection and self-analysis, and a greater understanding of oneself makes it easier to understand others. Languages can prove to be quite difficult, but luckily the art of communication is not based on language alone. In Africa I had conversations with people who spoke languages I had never heard before. Although conversation without language is necessarily limited, it does not mean that it is of no value. Most of my photographs are a direct result of the people I have met all over the world, people who I have never met before and may never meet again, but who have influenced my choice of subject and the directions I have taken.

Strangers Become Friends

Friendships made en route whilst travelling in strange countries have a tendency to become very strong. The travelling photographer learns to depend on new acquaintances and develops an instinct for selecting those who are likely to prove helpful. All over the world photographers are helped by comparative strangers.

One evening whilst sitting on the banks of the Nile, watching the sun set and the beautiful after-glow rise over the surrounding land, a young man, seeing my camera, started a chance conversation. Initially the conversation was predictably about photography, but the subject began to broaden and we began to ask each other about our very different

life-styles, his in Khartoum and mine in London. We spoke at length about many different aspects of our lives. He was particularly fascinated by the everyday life I led at home, and in turn I found his family life intriguing.

Life in Africa is often carried out at a far slower pace than in the West, partly due to the heat which makes it far more difficult for people to rush about. But this does have a direct advantage; people are on the whole far more relaxed. Leisurely conversations lasting hours are possible since neither party is in a desperate hurry. At the end of the conversation we had become friends and he invited me to his sister's wedding the next day. He also promised that he would ask his sister if I could take some photographs. As it happened the reception was to be held at the hotel where I was staying, and later on the couple had planned to go from the hotel to an open-air arena set aside for celebrations.

My new friend arranged everything just as he had promised. During the following day he called me to say that his sister had a further idea – she wanted me to be guest of honour at the pre-wedding celebrations where all her closest friends would be helping her prepare for the wedding. He came to the hotel and collected me at three o'clock that afternoon, and I was taken to the family home to watch the bride being prepared. Two ladies were busily painting her hands and feet with henna; the patterns they use are based on passages of the

Qu'ran. Her feet looked as if they had been embroidered with delicate black lace. When the decorations on her hands and feet had been completed the bride dressed in her special yellow tobe (dress), heavily embroidered and encrusted with sequins. Next her hair was combed and arranged by her friends. As soon as she was ready I asked for permission to take a few photographs, but she immediately became rather nervous, and I realised that if I insisted I might put later picture making opportunities at risk. I decided that I would settle on taking a few close-ups of her beautifully decorated hands and feet, and this she agreed to. When I had finished I returned to the hotel to wait for the next part of the ceremony.

Later that afternoon the bride's brother came to let me know that the party were on their way to the hotel. As soon as the sun began to set a tremendous noise – beating of drums and shouting – could be heard in the distance. Suddenly two car loads of travellers arrived at the hotel. The bride and groom, who had arrived shortly before, came out to greet their guests and I was asked to take photographs of the group. The couple then left the hotel accompanied by their friends to carry on to the main part of the reception.

Following the bride in her brother's car we zigzagged through the Khartoum streets until we reached the outskirts of town. We pulled up in front of an open-air arena which to all intents and purposes looked like a football pitch. In the centre of this open space was a small stage, and clustered together in one corner just to the right of the stage was a strange collection of chairs on which some of the older guests were seated.

The arena was packed, and as the bride made her entrance the guests started to cheer. The celebrations began with a series of slow waltzes, the first dance being led by the bride and groom who waltzed Western-style round the arena. Suddenly the whole tempo changed, the air became electric as a tremendous beat boomed out, and most of the guests took to their feet and began to dance. I have never seen so many fantastic dancers gathered together in one place at one time! Their dark skins beaded with sweat in the warm night air as the rhythm grew wilder and wilder. Looking around I found myself surrounded by a sea of writhing Sudanese; they moved so fast that the only way I managed to get photographs was by using a small automatic camera with built-in flash and infrared focus. The older guests, in the main, stayed seated, but added to the atmosphere by whooping and banging their hands on the tables. The music was largely a mixture of tribal Sudanese and Western rock-and-roll.

Posters in Gijon, Asturias, Spain.

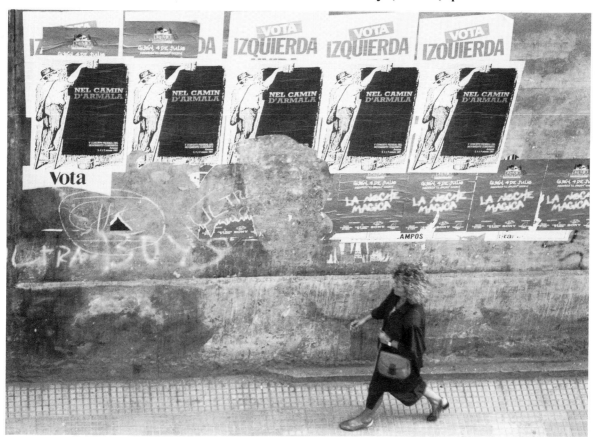

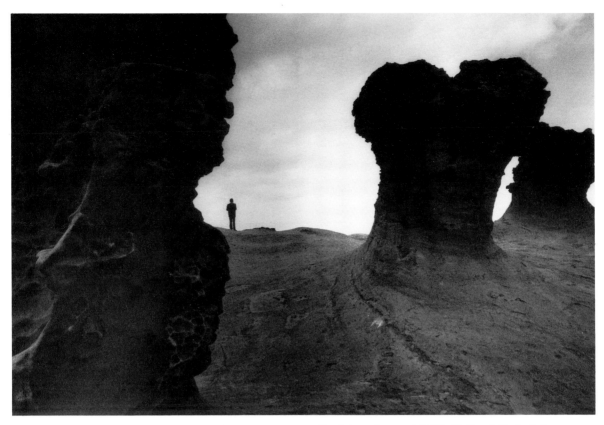

Sandstone shapes at Yehliu National Park, Taiwan.

I finally returned to my hotel at four in the morning, being one of the first to leave. I was, as far as I could tell, the only foreign guest at the celebrations, and the photographs I took show a rare insight into the Sudanese way of life. The whole series of pictures would not have been possible had it not been for that chance meeting on the banks of the Nile.

Whilst many people feel that such experiences are unlikely to happen to them, the Sudanese wedding incident is typical of the many interesting invitations and photographic opportunities I have obtained from comparative strangers. All over the world similar chance meetings have made possible similar photographs.

A Flexible Approach

Through experience I have learned to be extremely flexible; to change plans at a moment's notice should something come along which is better or more interesting than the photographs I have already planned. Being flexible allows the photographer to maximise the opportunities that arise en route, leading to far more interesting and unusual photographs that will often increase the sales potential of the trip.

Girl from a petrol station on the road to Casablanca, Morocco.

In Abu Dhabi, whilst busy taking photographs of the sun setting behind a mosque, I noticed a local woman watching me. She seemed fascinated by my camera, and when I had finished she came up to me and invited me to her home for some tea. As the sun had virtually set and there did not seem to be many more picture making opportunities presenting themselves, I gladly accepted. I was taken into her home, and whilst she made the tea I was introduced to her entire family. The children also seemed fascinated by this strange Englishwoman and showed me all their toys. The family included grandparents, uncles, aunts, brothers, one sister and the children; her husband came home later. I left my camera on a chair and did not ask to take photographs, since Arabic people tend to be shy. However, once they get to know and trust you they often suggest taking photographs themselves. I attached my flash to the camera just in case and turned it on to be prepared. When the tea was finished the elder relatives made their farewells and left. Sure enough, a few minutes later the lady asked me if I would like to take some photographs of her home and her children.

I am convinced that had I asked to take photographs when the elder generation were present I would have been refused permission. It is important

to read the situation and not be too pushy. As it was I was able to get photographs of her without her veil, an honour only afforded to the most trusted of friends. I have never seen the lady since, although I still have her parting gift of a gold necklace. I had tried to refuse the gift, but she said that I had insulted her and so I eventually agreed. These photographs have proved very useful because they show an unusual insight into family life in Abu Dhabi.

Taking Chances

Many times, when I have been in a street carrying out my work, a chance opportunity has given me unique photographs that could never have been arranged. I used to think it was a little easier for me because I am a woman, and it is unusual to find women travelling on their own. I now disagree, since I know many male colleagues who have had comparable experiences. The trouble with most photographers is that they are unable to take advantage of the unique opportunities that occur whilst travelling. Instead they stick only to the obvious and known, and often end up with very few special images as a result. If your photographs are different, and say something about the people and their lifestyle, they become more original and unique, both of which help to increase sales. An example of this happened recently when a trade magazine contacted me desperately seeking photographs of Middle Eastern food. The magazine had tried all their usual picture agencies without success. I was able to supply a total of eight pictures for consideration, of which five were selected for use.

The first photograph, which they used immediately as a cover, was taken in a restaurant in Jordan when I was invited out to dinner. I took a couple of photographs of the traditional food, and had made sure when I took the pictures that only Jordanians were included. Then there were two from Morocco, from the city of Fez, both grab shots as

I walked down the street being shown the way by a guide. The first was a photograph of a bread seller surrounded by crusty loaves of traditional bread, the second was a picture I nearly didn't take at all because it was in a covered market where the light was extremely difficult. In the end I took a series of pictures lit mostly by the small tungsten lights which were illuminating the market stalls selling Moroccan sweetmeats. Only two of the photographs I took were sharp; the rest were hopelessly blurred. One of the other pictures chosen was taken in the city of Taiz in North Yemen. I had been invited to a local house to have a meal, but my travelling companions, local people whom I had met en route and had given me a lift, were in a great hurry so I only had a few minutes to eat. I decided the photographic opportunity was more important than eating, and although I managed a few mouthfuls, I spent most of the time photographing my companions enjoying their meal. This photograph, taken inside a traditional Yemeni house with the food laid out on great platters on the floor, has sold at least ten times now.

In fact, these days I photograph anything I can find that shows the local people and their way of life. Although this has become my speciality, there are many other different types of travel pictures that photographers may choose to concentrate on.

Most travel photographers shoot a full range of subjects which enables them to illustrate complete articles, whilst at the same time specialising heavily in several selected aspects. In this way it is possible to built up a reputation. Picture editors will contact a photographer specifically for the subjects that they know he has in his files, but then will often take the opportunity at the same time to ask for some of the more general pictures. If the photographs are all available from one source it will save time on picture research, so provided that the quality is sufficiently good most researchers will always consider the whole range of a photographer's work.

Seeing the Picture

Over the years a photographer gains much insight and valuable experience through the different jobs, commissions and assignments that he undertakes. Having to cope with widely varying situations makes a photographer very versatile. Short cuts are evolved which suit one's personal style of work, and the ability to see pictures becomes easier and easier. Frequently, looking back on those experiences which at the time seemed dreadful and fraught with problems, they come into perspective and no longer seem that bad at all.

Travelling alone with a camera in a strange and unfamiliar land can be an exceedingly pleasurable way to earn a living. Everything is new, exciting and stimulating; the senses become heightened and the photographs seem fresh and visually exciting. Familiarity has the opposite effect, and makes it difficult to rise above everyday events to sort out the photographic possibilities.

First Reactions

Many travel photographers feel that it is necessary to familiarise themselves with a new place before travelling. This is fine up to a point, but if the photographer spends too much time planning and reading he is in danger of missing his first intuitive reactions. Depending too much on guide books puts the photographer in danger of seeing only what the author of the book saw. It is also worth remembering that guide books are written for tourists and not for photographers, and frequently advise spending a few days looking around before taking any photographs. This not only jeopardises valuable shooting time but can spoil those first intuitive reactions.

When a photographer arrives in a new country, everything he notices should be photographed because these first reactions are extremely valuable. After a few days or weeks, the visitor 'acclimatises his vision' and the differences will no longer be so sharp and clear in his mind, but those images that photographers notice first can be the ones that best show cultural differences. A good travel photographer is one who develops the ability to express his reactions and feelings towards the subjects he sees, as well as documenting the life-style and people he meets on his travels.

Many times I have visited cities for the first time and have been captured by the enchantment of a different world, far removed from my own. The city, its life and its endless variety of shapes and forms stimulate me, and almost always it is those very first impressions that are the forerunners of those images that convey – better than all the cliches – the real differences. Many people who visit that city may be struck by the same newness and the same differences, but most probably are unable to express those feelings in either words or visual images. Therefore the photographer who can

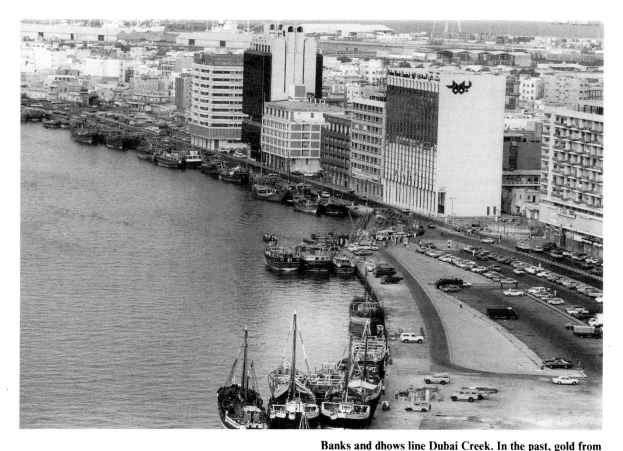

Banks and dhows line Dubai Creek. In the past, gold from British banks would be shipped to Dubai, and the dhows would then smuggle the gold into India where vast fortunes could be made.

capture these reactions on film will be offering an image of the city that will be immediately recognisable by other visitors.

So many travel photographers have little to say in their photography. But pictures are visual communication, and the photographer who is visually literate with plenty to say will succeed better than the tourist who takes pretty pictures with virtually no thought as to content or what the picture has to offer.

Perhaps I can relate this to my photographs of the United Arab Emirates. The first photograph I made of Dubai was of a dhow on the creek, and although I spent many months in the Emirates, this first picture is always the vision I conjure up when I think of that place. It has since become one of my best-selling photographs. I have visited Dubai at least six times, and lived there for a year, but although some of the subsequent photographs sell well because they document things that can only come through intimate knowledge of the place, that first picture of the dhow on the creek still outsells them all.

Many of the sales have been to people living there. The area has now changed considerably, and huge skyscrapers have transformed the skyline, but the photograph of my first impressions is also how

the Dubai people see their own home. They still buy it in preference to the photographs that show the Dubai of today because they still associate themselves with the atmosphere that first photograph of mine captured.

The next Emirate along from Dubai is called Sharjah. I have a photograph taken on the edge of the creek, of dhows and fishing pots. This again has always sold well, and again it was one of my first photographs of the place.

I always try to read a lot about the people and their culture before a trip, but I try to keep such knowledge as general background material that makes me more aware of how the people came to be as they are, and not let that knowledge dictate the photographs I make. I try not to formulate opinions before I see the country for myself. I also keep a record of my first reactions on tape, as I find this very useful material for any articles I may write later.

Flexibility, to me, is extremely important. I am always prepared to change my plans drastically at a moment's notice should a better opportunity present itself. It is often impossible to arrange for a large number of specific ideas to coincide, so it is often better to base a trip round one or two concrete ideas and allow the rest to come naturally whilst on

location. When travelling my mind is bombarded with ideas, they seem to emerge on every street corner, and I have to carefully evaluate which to follow and which to ignore. Sometimes, the unplanned place or event that is stumbled upon can increase the value of the photographs, although it can equally lead you up a blind alley.

Early Days

Having lived in the United Arab Emirates, I have retained close associations with that country. In fact my first photographic work was that of a local photographer/reporter for an English language newspaper in Dubai. The experience I gained working on the paper was very useful, since I was expected to find the news myself. The paper had no links with the main news agencies and my job each day was to find suitable local photographs for inclusion in the paper. In order to keep my job I rapidly had to develop the ability to 'see' pictures.

I knew nothing at the time about photographic processing and relied totally on my technician to develop the film and produce the final print. This freed me from much of the mechanics and allowed me to develop my skills of seeing and finding

pictures. There was an added incentive – if I did not find any pictures worth printing I was not paid. There was, to be honest, little competition at the time in Dubai, but today the ability to make my own news has freed me from many of the ties other professional photographers have.

With the aid of my little Daihaitsu jeep, I would follow any passing siren in the hope of getting a picture, often with my two children, aged two and three, strapped in the back.

One of the biggest assignments I covered during my stay in Dubai was when the Liverpool football team came to play the Dubai team, who at the time were being trained by an English coach, Don Revie. Looking back it was perhaps one of the funniest of my assignments, since I had never seen a football match before.

Having been appointed chief photographer for the Dubai Stadium, I was asked to fly in a helicopter over the stadium before the match commenced. The helicopter was also carrying two parachutists dressed in the colours of the different teams and, with typical Arab style, they parachuted out carrying two footballs to start the match. I made a few pictures before heading back to the airport where a driver was waiting to race me to the stadium to

From the roof of the Intercontinental Plaza – dhows at daybreak on the banks of Dubai Creek. Sleeping sailors can still be seen on the deck.

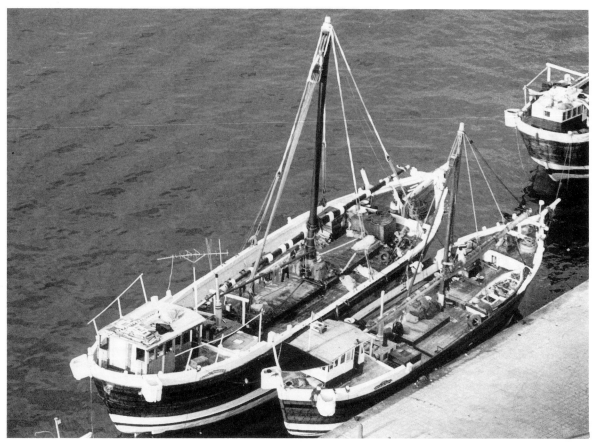

Dhow builders in a boatyard at Ras al Khaimah, United Arab Emirates.

cover the match itself. Unfortunately my driver, seeing the heavy traffic, decided it would be a good idea to drive down the wrong side of the dual carriageway to get me to the match quicker. After several narrow escapes I arrived at the stadium a bag of nerves barely able to hold my camera still!

The match over, I was assigned to spend most of the next few days accompanying the Liverpool team as they toured the area and bought presents for their families. Everybody seemed to know their names apart from me, and never having had any interest in football I kept confusing them. I think they found this highly amusing. Most of the young Arabs were positively in raptures about their honoured guests, and spent most of the time following them around trying to make their acquaintance.

I return regularly to the Emirates, and I love watching the way each one has developed and evolved. Most now have their own airports and ports, and although they are classed as one country there is still a fair bit of rivalry.

Being an accredited female photographer in the Middle East does have its advantages. I am allowed to work with both women and men, which no male photographer is able to do. For example, on my last visit to Abu Dhabi one of the main jobs I undertook was to photograph a girls' school. This had been built by a British company, but they had been unable to make any photographs until they could find a female photographer. This was in Ras al Khaimah, which, although not the smallest of the seven Emirates, is one of the least developed. The Ministry of Information sent me as their guest on the long journey from Abu Dhabi to Ras al Khaimah in a taxi.

In Ras al Khaimah I befriended a local photographer who acted as my guide, showing me interesting places to photograph. These included the ruins of a palace that the locals believe once belonged to the Queen of Sheba. There are, however, those that insist the ruin is an old bakery, but as it still has not been properly excavated no-one is entirely sure. To get to the ruin I had to climb up a sheer cliff covered in loose scree. I managed to reach the top and make photographs, but not before falling down and cutting my legs quite badly. The photographs were well worth the effort, and there was nothing to suggest that this was once a bakery.

Old dhow at Ras-al-Khaimah, one of the lesser known emirates. The dhow will eventually be turned into a museum.

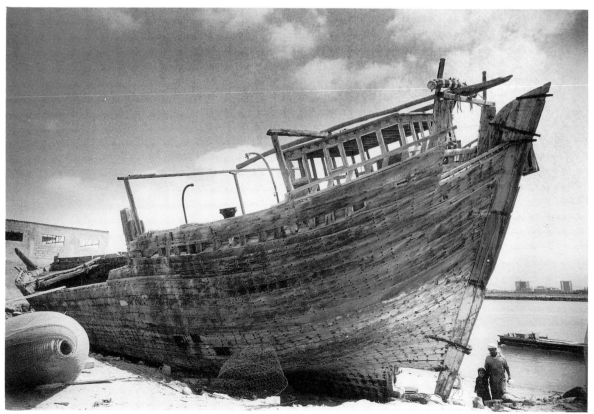

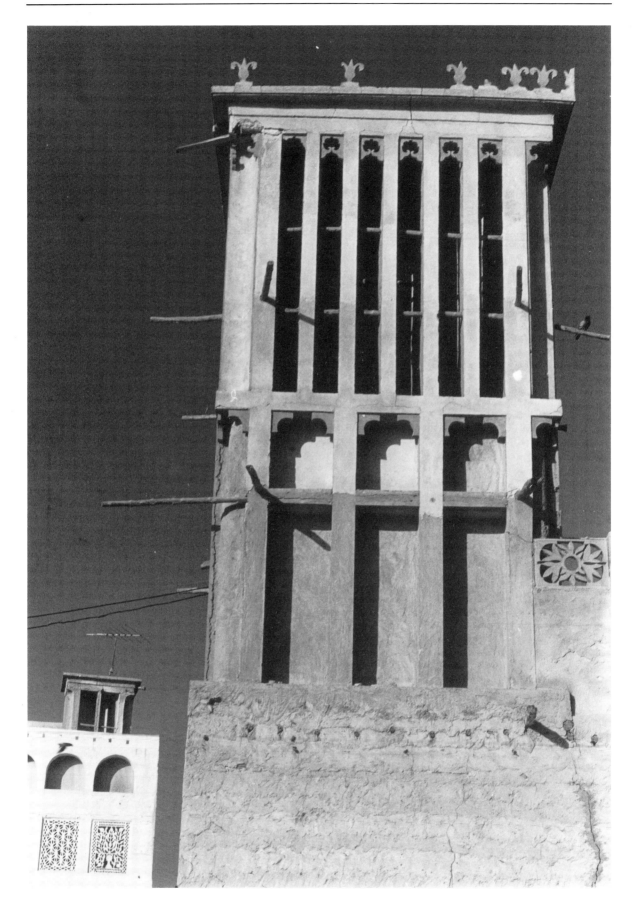

There appeared to be a series of holes in the ground, some of which contained arch shaped outlines where once walls clearly stood.

Talking to People

In the remoter areas of the Emirates I find the people far more relaxed than those that live in the city. Once I asked a lady in the street if I could photograph her; initially she refused, but her husband persuaded her. In the main cities this would never happen.

In Dubai I have spent a great deal of time documenting the old Bastaki area of the city where there are many wind-tower houses. The wind-tower is a forerunner of the air-conditioning unit. Each tower has four concave faces that trap little breezes, channelling them to the living areas below. The wind-towers were built by Persian immigrants who settled along the shores of the Dubai creek, having left their home town of Bastaki following the introduction of taxes.

I particularly wanted to visit one of these homes and take a series of pictures showing the interior, which traditionally included a courtyard in the centre where a tree is planted to give shade and life to the home. The only problem I faced was that I did not know anybody living in the Bastaki. Early one morning I set out with my two small children and cameras to try to photograph the area, and it wasn't long before I was noticed. After a lot of hand waving and smiles I was invited into one of the wind-tower homes for a traditional cup of Arabic tea, and during the visit I was able to take all the photographs I needed.

It has always been my experience that if a photographer can set aside a little time for talking to local people about their objectives, a great deal can be achieved. I can understand that in countries that are popular with tourists the constant photography can quite annoy the locals. I make considerable efforts to photograph quietly and unobtrusively, gaining the trust of my subjects, where possible, in advance. Unfortunately time is a precious commodity for a freelance photographer and it is not always possible to spare the necessary time to get to know people. Language is often seen as a barrier, but in reality very few words are needed. Still, I make a habit of trying to master at least a few words of the local tongue. It doesn't matter how badly one speaks or how few words one knows, the very fact that a person has bothered is often enough to gain a friendly response.

Wind towers in the Bastaki area of Dubai. The wind tower has four concave faces that channel breezes down into the rooms below, an ancient version of the air-conditioner.

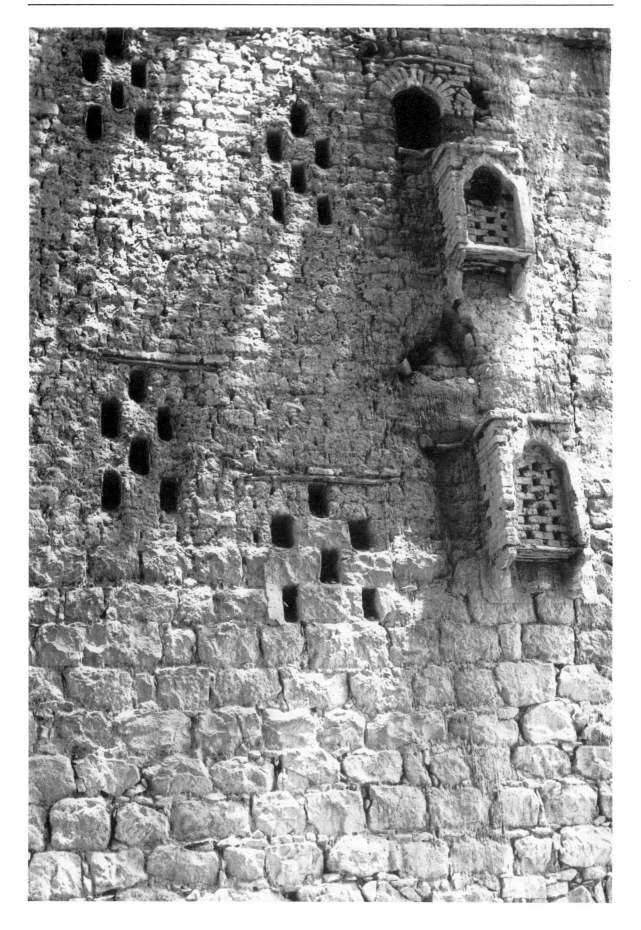

Composition

It is quite possible to teach composition of photographs through basic rules and guidelines, and many people make a successful living by simply following these predetermined paths. Indeed, without using these guidelines they may well not be able to visualise their photographs at all. There are, however, a substantial number of photographers who are able to discard such formulae, and through their own vision are able to compose their photographs by an instinctive reaction to their subject and without any need for conscious thought. There are also many who make a good living using both systems, but it is really only possible to *teach* a person to see photographs using the first method of predetermined rules.

The basic rules of composition are exactly the same for photographers as they are for artists, and these rules can be used to provide a basic formula that produces a picture which is pleasing to the eye. Although there are many variations on the formula the main rules include: that the principal subject of interest should be placed on the thirds of the picture area; that subjects placed on the diagonal are more pleasing than those on a straight line, particularly

in portraits; that the heaviest and darkest part of the picture should be on the base; and that odd numbers in groups are more pleasing than even – in other words 3 and 5 are better than 2 and 4. In colour photography it is preferable to have the background consisting of cool receding colours such as blue, with the foreground containing the strong dominant colours; colour used in this way creates depth within the picture.

However there is no formula that can guarantee a 100% successful composition. If photography were that simple then the need for skilled photographers would be negligible. The photographic press frequently carries advertisements for cameras that are supposedly capable of doing almost everything for the photographer, but rules and automatic cameras can only produce an average picture with an average exposure. The skilled photographer can achieve far more than a basic picture, but his successful photographs may break all the traditional rules, and his pictures will most probably have required considerably different exposures than the average readings given by a camera's light meter.

Detail of bakery wall showing steam outlets, at Wadi Dahr, N. Yemen. Shows construction of mud brick houses that use no cement, the bricks being embedded on gravel.

Intuitive Composition

Whilst there are many photographers who make a living without having any real vision of their own, the really successful workers in nearly all fields always have plenty of personal vision that results in their own individual style. Very often the photographer is unaware that he is actually using most of the rules anyway – since these rules produce visually pleasing images, they tend to suggest themselves quite naturally. Few photographers have the time to think each rule out in relationship to every frame they shoot!

The format of the camera used will also have an influence on the composition. It is far easier to compose with the larger formats, since composition may be carried out in two stages – the larger film area allows for recomposition of the negative or slide by cropping after the picture has been taken. When such cameras are properly used, each photograph has the ability to be used both vertically and horizontally. The big disadvantage of large format cameras is that they are less portable as they weigh considerably more. They are also slower to operate, but without a doubt, large format cameras give superior quality which is particularly advantageous for landscape and commercial photography, although it is certainly not a necessity.

One way of overcoming the limitations of 35mm is to take every possible photograph both horizontally and vertically, giving the picture editor the choice of two formats. The main advantage of 35mm is the speed with which it can be operated, making possible a whole range of spontaneous and candid photography that would be extremely difficult, if not impossible, with the larger formats.

The scope of my photography is very wide, but amongst the pictures that have been really successful are many that have been the result of my intuitive reactions to a given situation. When I am confronted with a situation, or a particular scene, I do not consciously think about how I will take the photograph. Very often I do not know why I use a particular composition; the way in which I see the photograph seems to happen naturally. I see life these days through a 35mm viewfinder! Even when not holding a camera in my hands I frequently find that I am framing-up as I walk down a street or drive my car. The more pictures I take the more pictures I see, and I am convinced that there is a natural progression that photographers can follow, one that leads from one picture to the next.

One of the most successful photographs I have taken, 'Castles in the Sky', was not knowingly composed: I saw the photograph as a passer-by was walking in front of the castle, and immediately reacted to capture this fleeting moment. Although I never thought about it at the time the man is essential, as he gives both life and scale to the picture. There could only have been five seconds in which the photograph could have been taken, and during that short time I was able to shoot two

frames. The first is slightly overexposed whilst the other is fine. What actually happened is that I shot one picture instantaneously so that I was able to capture the image as I saw it, but as the man was walking quite slowly I was able to adjust the exposure before taking the second frame. It was nearly twenty minutes before another person came into the picture, but I waited so that I could also make a black and white picture. However this one did not have the spontaneity of the first shot. I am able to respond so quickly because I know my camera extremely well, and these days never consciously think about the way in which it works – taking pictures has become totally instinctive. I also use the same film type again and again, and so I know exactly how certain films respond to different lighting situations, also without any need for conscious thought. The camera is simply the tool I use to convey my thoughts, impressions and ideas. My picture 'Castles in the Sky' breaks all the rules, as the subject is in the middle of the frame, but if the balance feels right then it usually works.

One of the best ways to increase the number of photographs seen is to take more. The more a photographer looks for pictures the more he sees, and the more he practices the faster his reactions become, until with sufficient practice taking pictures becomes almost second nature. Many photographers spend a fortune on cameras and lenses

and are constantly changing both make and model, but before changing they should consider whether they are using their present system to its maximum potential. As for constantly changing films, it is far better to know a few well, than many in a limited way. There is no such thing as the perfect film, and sometimes knowing the limitations of your chosen film can be extremely valuable.

Colour in Composition

In black and white, composition can be greatly assisted by the use of filters – orange, red or polarising. These simplify the tonal range of the picture, with the polariser particularly useful as it cuts down haze as well. These filters are generally used in black and white photography to eliminate some of the middle grey tones, and the resulting picture gains greatly in strength as a result. The red filter is useful for its ability to make little white clouds stand out against a darkened sky.

Colour composition is very different from that of black and white, with the result that many photographers prefer to specialise in one medium or another. Specialising in only one medium does limit saleability of work, although many photographers shoot colour only as black and white pictures can be made from a colour slide. However there is still

Myvatn Lake on the edge of the Arctic circle, Iceland.

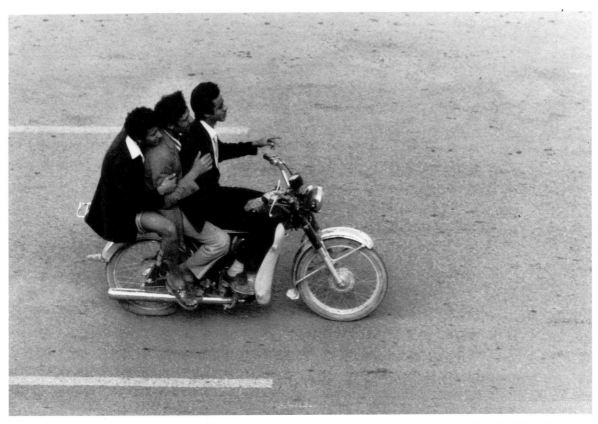

Motorbike taxi (local transport), Sana'a, North Yemen.

no real substitute for the black and white negative. Black and white taken from colour, although acceptable to some, loses a great deal of quality. If a picture buyer has more than one source for certain pictures he will always choose the photographer who has the black and white negative, in preference to the photographer who has a black and white taken from colour. The primary reason why black and white photography used to be in great demand was one of cost – it is far cheaper to reproduce a black and white photograph than a colour one. These days this is no longer strictly true, but black and white photography is now fashionable and is beginning to be appreciated for its selective qualities and artistic values.

Colour adds an extra dimension to the photograph, but can confuse photographers who see only the colour and not the picture as a whole. The use of lighting, the image and the arrangement are still extremely important. Colour as a dimension must be considered, but not to the exclusion of all else. I consistently hear picture editors complain that they cannot find good colour these days. One recently told me that colour has become almost mundane. Photographers are used to seeing colour everywhere and make little effort to use it in an interesting way. An effective composition can be created by the use of a limited colour range or muted colour. Successful colour photography may also use colours that harmonise or even colours that clash, but invariably the best colour photographs have some form of colour selection. This selection can be the result of conscious thought, or again simply a colour range that the photographer reacts to intuitively.

Pictures that Sell

There are two main types of colour travel photographs that sell well. One is the picture that represents a place and its people, and whose main purpose is to accurately convey to the viewer the feeling of being there. The second type, which is equally saleable, is that which uses colour in a compositional sense, and is derived from the photographer's own selection and personal vision. These photographs are frequently strong enough to sell in their own right, and although they may have originally been taken as part of a collection of photographs, they have enough strength to stand up on their own. Therefore strong creative travel pictures may sell as illustrations for an article and as photographs in their own right, falling into both categories quite happily.

Alleyway in Chechaouen, Morroco.

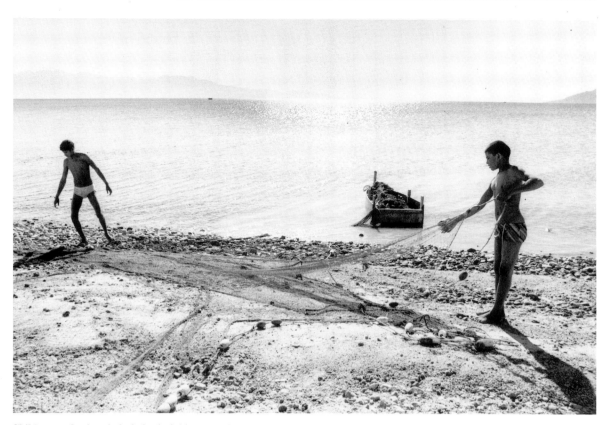

Children gathering their father's fishing nets, Nuweiba, Sinai, Egypt (mountains of Saudi Arabia in the background).

For example, one particular photograph, of a mud brick wall on which light is dancing, has an extremely limited colour range, and being only part of a wall the picture shows little of the place where it was taken. However this photograph with its limited use of colour has sold in two very different contexts. It has been used as an illustration of how these bricks are used in the construction of North Yemeni buildings, as it shows clearly the lack of mortar and the gravel chips used to bed down the mud bricks. The same photograph has sold also to a magazine that wished to show the use of light in photography, as a creative picture in its own right. There are frequently many uses for the same picture, and travel photographs can have many applications. The travel photographer who can see other possible uses of his photographs will greatly increase their value. Often a photographer realises that he has missed a photographic opportunity too late. It is only when you are marketing your photographs that it is easier to understand how important it is to have a wide range of composition to suit the differing needs and styles of the various markets. To limit the photographic style to suit only one

particular market would limit future sales; every feasible picture should be considered if the trip is to pay for itself. After all, the most expensive consideration is normally the expense of travelling; getting to the destination costs far more than film, which is relatively cheap. Current film cost is approximately 15p per frame, so it is false economy to save film at the risk of losing saleable work.

Perhaps one of the easiest solutions is to photograph 'into' a subject. In other words, take all the obvious photographs first and clear them out of your mind, then start again trying to find another way of photographing the same subject. This leads to interesting and varied viewpoints as well as interesting and varied compositions.

It is a strange phenomenon that a photographer can take half a roll on one subject, yet even though all the photographs may be beautifully exposed and beautifully composed one will always outshine the others. This has happened to me time and time again, and becomes especially noticeable when selecting work for publication. One photograph will dominate a set, yet if that one were to be excluded another will take over. If you notice this happening

Castles in the sky, Wadi Dahr, North Yemen, the home of the former Imam. It is said that he was so disliked he built his castle on top of the sandstone rock because of the number of assassination attempts.

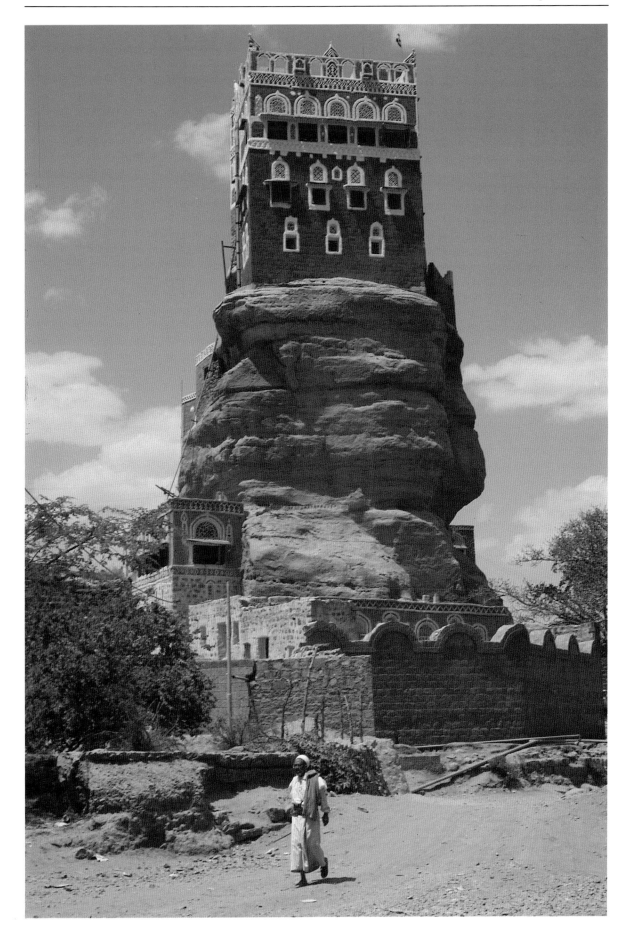

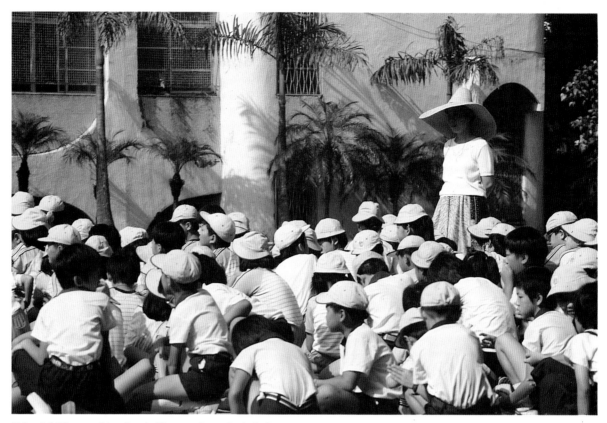

**Schoolchildren and teacher (with a sombrero hat) during
early morning assembly, Taipei, Taiwan.**

so will the picture editor, but if you remove the dominating photograph the editor will often happily settle for another! This does not mean that the rest of the work is bad, it only means that one picture is stronger. Occasionally when I have had the misfortune to damage a slide or negative that has sold well, one which had never previously achieved sales will start selling instead.

Remember the Editor

When shooting I am always conscious of the different needs and tastes of the editors I work with. Some are in frequent need of vertical photographs for cover pictures, others prefer scene-setting shots intermingled with a few more selective ones, whilst still others prefer a theme running throughout the photography. I recently sold a set in which every photograph had a tiny patch of scarlet; this the editor felt linked them together as a whole. I must confess that it was only when I was making the picture selection that I noticed I could use the inclusion of scarlet as a common denominator.

I always make a point of taking several shots that could be used as a cover picture wherever I go, and in this way should a cover be needed I am always able to supply a suitable photograph. The composition of a cover photograph is normally quite different from that of an 'inside' picture. In particular it should allow an area at the top of the frame where the logo of the magazine can be superimposed without confusing the image. Since I have always taken into consideration these specific requirements, I have been able to sell a large number of my photographs from all over the world for cover use and also now have a considerable collection of such pictures in my library. Some picture editors call me regularly for cover material even when they are using another photographer for the inside pictures. It is surprising how few photographers actually take suitable cover shots.

The prime function of a cover photograph is to attract the reader to the magazine on the bookshelf. Cover photographs literally sell the magazine's contents, so they need to be strong both visually and photographically and have interesting content in themselves. Occasionally an ordinary photograph will appear on the cover, but this is the exception rather than the rule. Jazzy colours, strong composition, movement within the photograph, or even composite pictures all stand a good chance of being considered. When shooting cover material I often

**? Cloud, Esposende, Portugal. The picture was seen in
reverse so had to be inverted to be shown.**

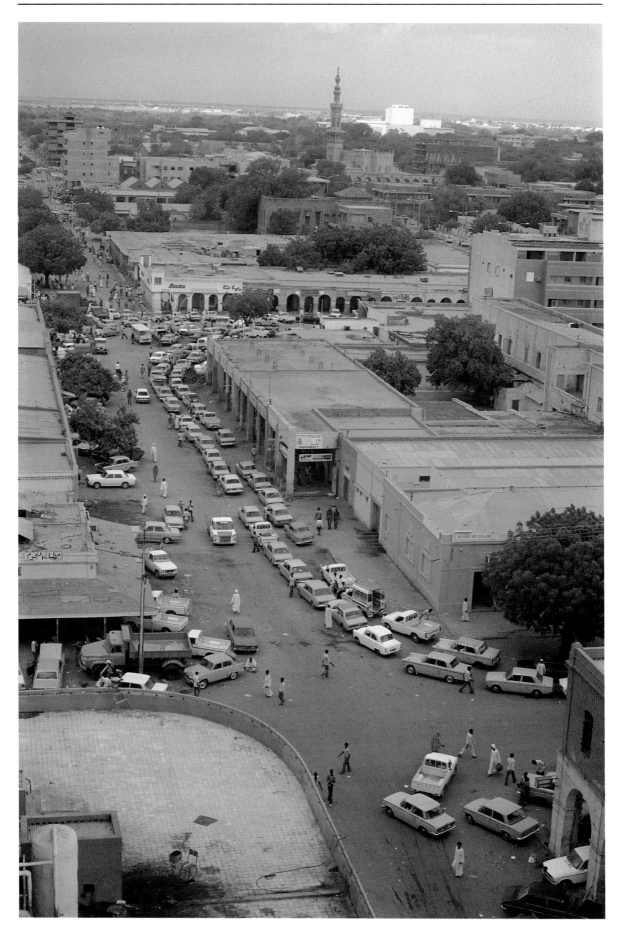

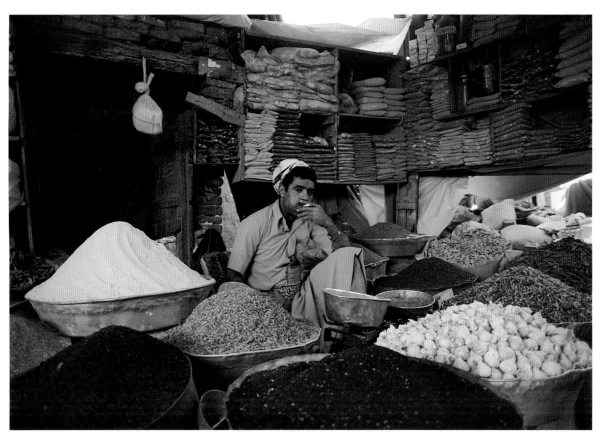

Spice seller in the old souk, Sana'a, North Yemen.

try to picture in my mind the sort of photograph that will attract a particular magazine editor and his reader. It is no good submitting photographs that do not take into account the style and image the magazine is trying to portray. Studying magazines and the pictures used by them can help the photographer's awareness of each magazine's requirements, and ultimately influence the selection chosen for submission.

A Different Viewpoint

Photographs that frequently do well are those that show life from an unusual viewpoint. If you consider that the whole world sees life though a 50mm lens at about normal eye level, then that viewpoint is commonplace, and best avoided. The photograph that attracts most interest is the one that shows life from a different or unusual angle, one that the majority of people would not normally see. Therefore photographs that stem from the use of either a telephoto lens or a wide-angle lens tend to be more desirable than those taken with the normal 50mm lens. It is always good practice to try different angles; climb up high and then look down and see the difference the viewpoint makes to the subject,

Taxis in a petrol queue, Khartoum, taken from the top of the Arak Hotel.

and compare that viewpoint to the straightforward one. Being shorter in height than most people I find I often use this viewpoint. On other occasions I have chosen to lie flat on my back to make the photograph more interesting. In the past this has given me a few problems; to the uninitiated onlooker unused to seeing photographers sprawled on their backs on street corners it is natural to assume the worst!

Occasionally a picture editor has offered me advice, and I have found the suggestions extremely useful. Picture editors have helped me tremendously in improving the range and quality of my photography, and wherever possible I try to engage them in conversation about my work. However this is not always possible because they do tend to be working most of the time under considerable pressure. One of the hardest things for a photographer is to be totally objective about his own photography, and advice from professionals, especially editors, can be extremely beneficial, since they have both the ability to select pictures and the impartiality to stand back and be objective. When a photographer selects, all too often a photograph that was easy to take is passed by in favour of one that was extremely difficult, yet the first one may well be far more interesting.

High and Low

There is a constant demand for 'different' pictures of famous landmarks. I am always on the look out for the unusual viewpoint of famous places, and occasionally have landed in amusing situations trying to photograph them.

On one occasion a few years ago, I hit upon a marvellous idea for getting a 'different' photograph of the Statue of Liberty. The Statue stands on Liberty Island just off the coast of Manhattan, surrounded by a few rather sparse trees. Having taken all the usual, ordinary, standard – almost obligatory – photographs, I started to look into my subject searching for that elusive photograph which showed the Statue clearly but was more interesting. I observed that from a certain angle the sun's rays were hitting the torch and making it look as though it were lit up. I also noticed a small tree and some shrubbery. I worked out that if I used a wide-angle lens and lay on my back underneath the shrubs, I could not only get the light to hit the torch but I would frame the entire Statue in a natural aperture of greenery! What I had not bargained for was the effect this was going to have on the general public, and in particular on that caring person totally uninitiated into the peculiar antics of photographers. Few of them have seen photographers lying on the ground half hidden by a clump of bushes. After I

had exposed a couple of frames, I was suddenly lifted into the air and onto a stretcher by a couple of paramedics! When I told them that I was quite alright and had not collapsed they seemed disappointed. The look on their faces told me exactly what they thought of me – one of those mad British tourists!

When I am after an image, it is the image that is important, not what people think of me, and frequently it is convenient that people think I am a tourist, since tourists are of far less concern than a photographer. However, there cannot be many who on a day trip to Liberty Island can take a photograph that ends up being sold back to the States to be used by an American banking magazine as one of their covers.

In Khartoum, I found particular advantage in shooting from a high viewpoint, not only as I had a need to find photographs with strong composition, but more importantly because the height helped tremendously in cutting out unnecessary sky and allowed me to have better control over the contrast range. There was also the added advantage of reducing the apparent size of the incredible amount of garbage in the Khartoum streets! Sudan is a very poor country and there simply isn't enough money to spare for street cleaning.

Vats of dye fill a square in the city of Fez, Morocco.

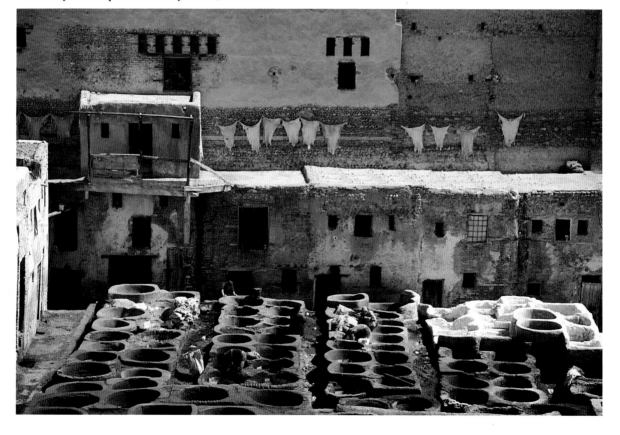

Remote farmhouse, Iceland.

Amongst a series of photographs taken from a hotel roof is one particular frame which seemed very attractive because of its colour content. Most of Khartoum's buildings are brown in colour as they are covered in thick layers of desert dust. Even the sky, during the hotter months, takes on a brownish tinge. The bright yellow colour that caught my eye was a long line of what appeared to be parked cars. I shot a couple of vertical photographs and thought no more of it, carrying on with the work I had planned. It was not until I showed the photograph to one of my Sudanese friends that I began to realise the significance of the yellow cars. My friend immediately confirmed my suspicions – that these were taxis queuing up for petrol. After making enquiries we established that the petrol queue had been there for three weeks!

Sudan is facing severe economic problems, a third world country with no money to buy fuel. This photograph has become a way of illustrating how severe economic difficulties faced by such a poor country can affect the lives of its people. The photograph has been reproduced at least twenty times, and was even shown on Dutch television on a programme dealing with third world problems. It seems incredible that one of my best selling photographs was taken without my realising what I had captured.

After my travels are completed and I am back at home, I examine and consider the contents of my photographs, and often it is only then that the importance of what may have seemed like a casual incident becomes apparent.

In Dubai I was finally given permission, after a lengthy debate into the reasons why it was necessary, to stand on the roof of the Inter-continental Plaza, the tallest building on the creek. I managed to gain access at about 5.30 in the morning so that I was ready in position with my tripod for the dawn, even though in doing so I had to have a security guard in attendance! As the sun broke the horizon I took a series of photographs with my 300mm telephoto lens, solely of the sun and the parting clouds. I then turned my lens on the dhows lining the creek below. It was so early that on the decks sailors could still be seen in their sleeping bags. As the early morning light began to strengthen, I made a series of pictures showing the twin towns of Dubai and Deira with the creek flowing between them. This series has been amongst my best selling photographs, and they are used frequently as illustrations of the Middle East. The photograph of the sunrise has also been published many times. Once it was used as a double page spread in an Arabic magazine, earning me a large fee for a single reproduction. The following year the same magazine telephoned for the same photograph; this time a poem was reversed out on top of the picture.

The tallest building in the Middle East is the Dubai Trade Tower. Recently, when another build-

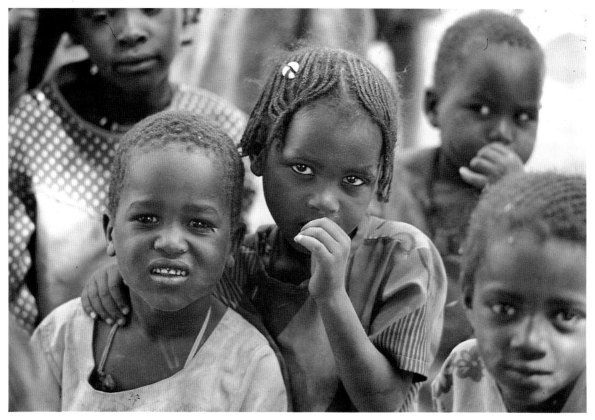

Chadian refugee children at El Geneina, Western Sudan.

ing overtook it in height, the Sheikh became so upset that he had the roof removed and added extra floors so that his building could once again be the tallest in the Middle East! This little incident prompted me to exaggerate the building's tremendous height. I photographed the building with a wide-angle lens, lying on my back, making full use of the converging verticals, with the result that the building looks as if it is reaching up to the sky. The Dubai people loved the photograph and it has been well used. At the time though, I did get some odd looks from passers-by as I lay on my back in the centre of a major thoroughfare! Another view of the same building, also making use of its height, was taken on the outskirts of Dubai. The photograph shows the Trade Centre like a shimmering white mirage, towering over the surrounding houses and desert landscape.

Sudan

The Sudan has always held a particular fascination for me, and especially the Sudanese people. Sudan is a country of one million square miles, the biggest country in Africa and a former British colony. Following several months of planning, I managed to secure enough work to cover the basic cost of a visit to the country. Through Sudan Airways in London, and the Embassy, I made contact with a hotel and arranged reservations.

Unfortunately, nobody mentioned that Khartoum in April is the hottest place in the world, situated as it is on the edge of the Nubian desert. I arrived late one Friday just after midnight. As I walked down the steps of the aircraft I felt as if I was walking into a brick wall; the heat was so oppressive. I had been told that somebody would meet me at the airport. In the event no one was there, the Sudanese I had travelled with dispersed very quickly, and I was left on my own, my first time in Africa, with no idea what to do next. I had been unable to acquire any Sudanese money as it is classed as soft currency and available only in the Sudan itself. The airport was deserted, and even the single taxi driver was asleep. I managed to wake him up and, having no idea where I was meant to stay, asked him to take me to a good hotel. When I enquired whether a reservation had been made in my name they told me that the telex had been down for three weeks! I stayed in this hotel for several days before I was finally able to reach my contact.

During my stay the temperature reached an incredible 54 degrees Centigrade. The Sudanese spent most of the day sitting under the shade of trees or in the air-conditioned hotel foyer. Nobody could work from 11.00 in the morning until about 4.00 in the afternoon, and it became necessary to alter my whole timetable. I woke up before dawn in order to get out before the heat of the day and to make the most of the few hours I was able to work before the heat haze completely ruined any chances of getting photographs.

I tried to make as many interviews as possible during the middle of the day, ostensibly to learn more about the Sudanese, but mainly so that I had an excuse to sit in air-conditioned offices or in hotel lobbies where it was cooler! However, there was a shortage of air-conditioned places in the city that were not already filled with people suffering from the incredible heat. The planning of photographs had to be very accurate, as I realised the heat was sapping all my strength. As soon as the sun began to sink on the horizon and the worst heat of the day receded, I would again begin to make photographs.

Despite all my precautions of taking extra salt and drinking vast quantities of water, I soon became very ill with sunstroke. I was so ill that for two days I could not move, and the only thing that saved my life was the instinct to lie in a bath of cold water until my body temperature dropped to normal. I could not focus my eyes or eat any food for 48 hours.

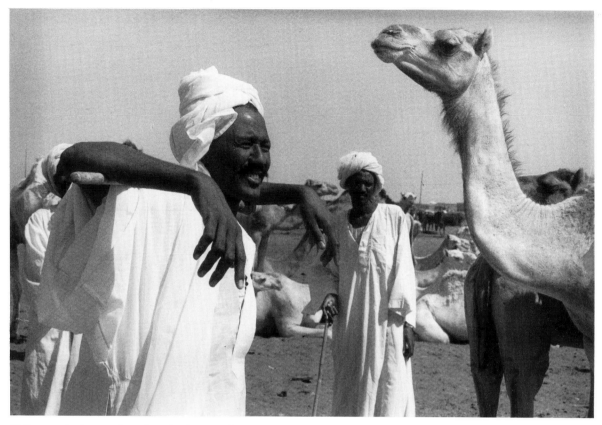

**Tribesman in the camel market, Omdurman, Sudan.
Sudanese often walk with their arms over a stick to allow
ventilation through their robes during the hottest months.**

The Answar

I was taken ill whilst making photographs of the
Answar, a people that are often wrongly called the
Dervish Dancers (Dervishes are a tribe in Turkey).
The dancers meet in Omdurman every Friday after-
noon, as soon as the sun begins to set at the Hamad
el Nil cemetery. There they re-enact the battle
between the Mahdi and General Gordon. Using
long staffs they whirl round and round dem-
onstrating their fighting skills. They wear patch-
work as a sign of their rejection of material wealth,
and dance chanting passages from the Qu'ran. The
Answar are a very important religious force in the
country. They also look after and help handicapped
people. The Sudan is a third world country on the
brink of bankruptcy, and there is no money for
expensive medicines and hospitals; people have to
take care of one another if they are going to survive.
The Answar encourage the handicapped people to
dance and sing and thereby give them precious
happiness in a world where there is no hope for a
cure.

As I was taking the photographs, even though the
sun was setting, the heat was oppressive. I became
confused and my head began to ache, but I kept on
trying to make the photographs I needed. In my
confusion I managed to put an orange filter on the
colour camera and the polariser on the black and
white. I was using both to try to limit the effects of
heat haze. It was only on my return to England that
I discovered I had four rolls of bright orange colour
film!! I have rescued some of these to a limited
extent by copying them onto black and white film,
but some of the colour has also sold in its own right
to people who want to show what happens when
the wrong filter is used, whilst a few people actually
seem to enjoy the violent colour! I was accompanied
by a local taxi driver who, seeing my state, managed
to get me back to the hotel where I lay for two days
before being able to carry on with my work.

Kenana

After a few days in Khartoum I continued with my
journey, travelling on to Kenana. Kenana lies some

**A Chadian refugee at El Geneina, Darfur Province,
Western Sudan.**

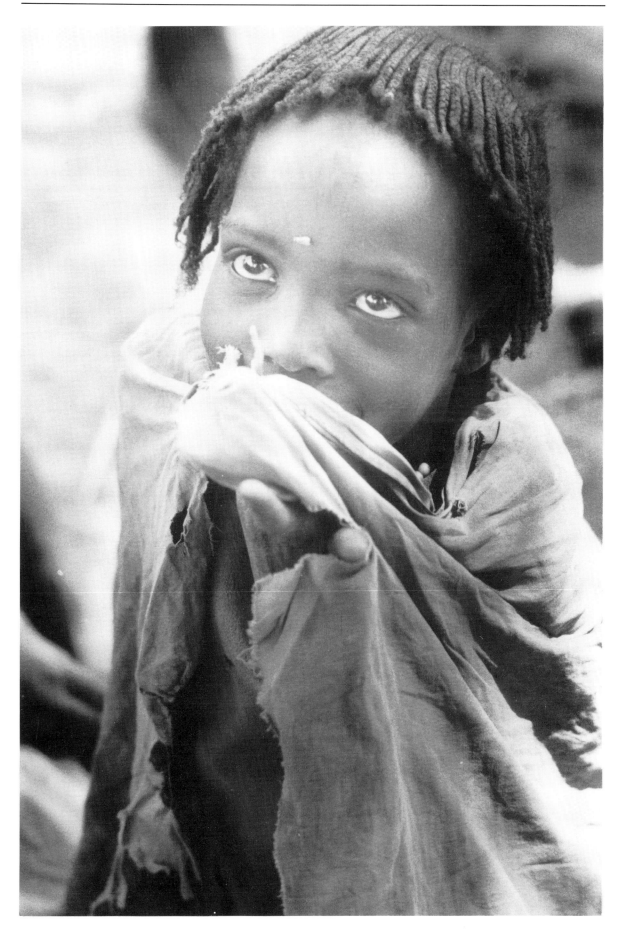

250 kilometres from Khartoum on the banks of the White Nile. It is the biggest sugar estate in Africa, and has the third biggest sugar factory in the world. It was here that I had been guaranteed a few days work to cover some of my costs. I had great difficulty in getting to Kenana; fuel was in short supply so I could not hire a car, and it soon became apparent that the only certain way of getting there was by taking the company plane which commuted between Khartoum and the plantation. Having made an appointment with the chairman to arrange for a ticket, he informed me that no journalist or photographer was going to be allowed on the sugar estate. Apparently the company had recently received some bad publicity and they hoped that by preventing access to the media they could control what was written about the project.

It suddenly occurred to me that I had just flown round the world to photograph the factory and that here I was, so close but still so far. Something inside me snapped, and I told the chairman in no uncertain terms that I had flown around the world to visit his stupid sugar factory and was furious that he should think ill of me before I had a chance of proving myself. There followed an exchange of words best forgotten and, sensing defeat, I left and sat in the reception area trying to sort out in my mind what I was going to say to the companies that had engaged me.

I was just about to leave when the managing director presented me with an envelope; in it was a return ticket to Kenana. When I asked him why the change of mind, he told me that the chairman was most impressed, no woman had ever spoken to him in that way before, and he would like me to go as the company's guest. As a result, I worked at Kenana on and off over a period of two years, and became the only officially accredited photographer. I ended up working for not only the British companies, but also Irish and French ones. The American management team also used my pictures, as did the Kuwaitis and Saudis who were the financial backers.

The Aerial View

The most successful photograph I have taken to date was an aerial photograph of the sugar factory. This was my first ever aerial photograph, but one of the companies employing me had insisted that I should include a selection of aerial shots.

The plane was supposed to arrive early in the morning, allowing me to take advantage of the morning light, and before the heat of the day set in. However, due to mechanical failure, the plane was delayed and finally arrived at Kenana in the midday heat. Apart from not having any experience of

Harvesting cotton, Wadi Medani, Sudan.

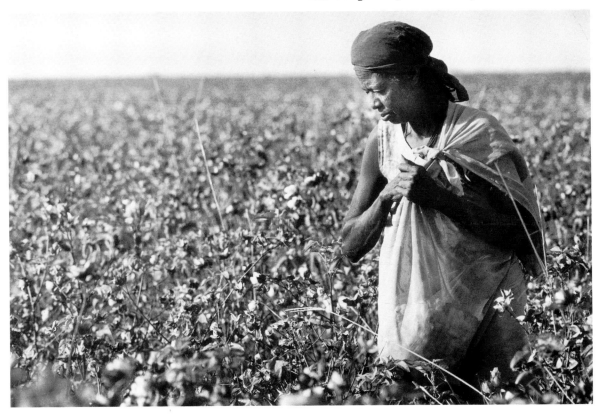

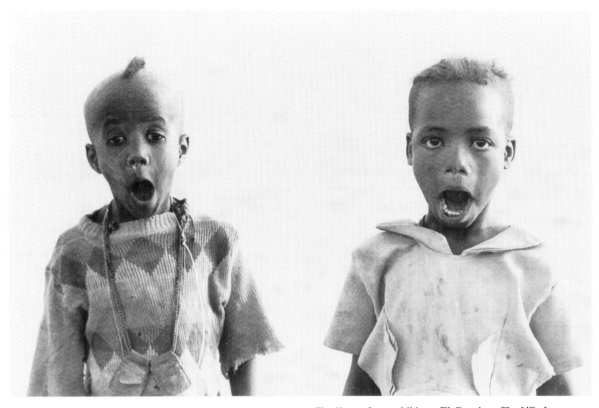

Chadian refugee children, El Geneina, Chad/Sudan border. They thought I was the dentist!

aerial photography I also suffer badly from a fear of heights, and was petrified about even getting into the aircraft. The pilot, who I can only describe as a Kamikaze Kenyan, had a very strange sense of humour. He removed the door of the plane so that I could get an uninterrupted view of the ground below, and tied a single rope around my middle and fastened it to the base of a seat. He then handed me a pair of scissors saying that should I fall out, he would fly low over the River Nile, and I could then cut the rope around my middle. This, he said, was no problem, as he would come and fetch me later in the Landrover! This did precious little to boost my flagging morale.

Before we took off, he rigged up a temporary headset so that I could relay my instructions to him in the cockpit during the flight. In the event neither of us could hear anything that was said because of the noise of the engines! He offered to fly six feet off the ground towards the factory and, just before we hit it he would climb steeply and clear the roof. Apparently this had been the idea of the last photographer who had, not surprisingly, failed to get any pictures. Apart from such a manoeuvre being nerve-racking, the ground speed would have been impossible.

The only photographic guide I had with me put the main requirement of aerial photography as a minimum shutter speed of 500th second, this being required to arrest the vibrations of the plane. I attached the motor drive to my camera so that I could take advantage of the AF finder's aperture priority mode. This allowed me to ensure that whatever happened, no photograph would be slower than the required 500th. I used a telephoto zoom to allow me to compose the pictures as I shot them, and asked the pilot to fly in three circles round the estate from the height he felt had the best visibility. That height turned out to be around 100 feet.

I found it absolutely impossible to take any photographs on the first two approaches; panic and near hysteria set in. I could feel the sweat from the palms of my hands making the camera slippery and difficult to hold. I was so frightened that at one stage I could not even open my eyes! But it was the fear of failing that turned out to be stronger than my fear of flying. How was I going to explain to the company who had employed me that yes, they had sent down a plane and no, I had not even taken one photograph. Once the thought of failure had crossed my mind I found it a little easier to gain control over my paranoia. During the third circle I managed to shoot four or five frames and, as we circled around the estate on the landing approach, I managed a few shots of the irrigation canal.

My fear was so strong that I have no recollection of the actual focusing or pressing the shutter release. It was only after landing that I realised I had taken a few photographs, but I could not remember what I had seen at all. As it happens, all of the pictures

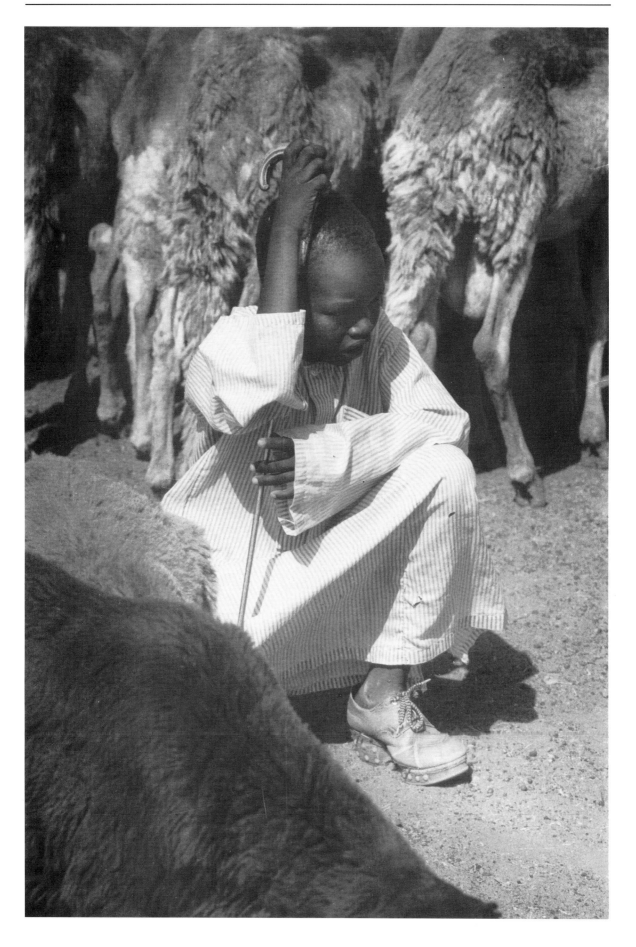

Shepherd boy in the Omdurman sheep market, Sudan.

are pin sharp, well composed and well exposed, taken purely by instinct.

When I returned home, I processed the slides and was so delighted with the results that I made a large Cibachrome print of the best one and sent it as a 'thank you' to the company chairman with a note telling him that I had forgiven him for our first meeting! He was so pleased that he had the print framed and hung in his boardroom. During the very next directors' board meeting he had to fight off the other directors, all of whom wanted the print! I received a telex a week later ordering forty more large, unframed prints, which made this my best-ever selling photograph!

When the sugar estate was finally inaugurated, a brochure and calendar were produced illustrated with my photographs. The pictures of Kenana have now been used all over the world, and I still receive regular requests to supply them. I have written and illustrated nine articles on the factory's success in this country alone. Recently I was told the aerial photograph had even been selected for use on a Sudanese bank note!

A Friend of the Sudan

Kenana was my introduction to the Sudan, and following the success of that first commission I became known and was offered a string of other assignments – road construction, port construction, fertiliser plants, a hotel and even a mosque. As a result I made a series of further visits to carry out all these new assignments. Sudan is such a vast country that every time I went I visited different areas, and soon I had covered most of the country and my knowledge of the Sudan had become extensive.

Companies would telephone my office to see if I knew certain people or to ask advice. I even recorded interviews on Sudan News for BBC Radio Africa after each trip. On my last visit I began to realise that I had established quite a reputation. When I arrived at the Sudan Embassy to renew my visa, they refused to charge me, and instead entered on the forms that I was a 'friend of the Sudan'! I was told that although I had written a number of articles about the worsening Sudanese economy and

The Leper Colony, El Geneina. A tall and once-healthy man sprawls uselessly on the ground.

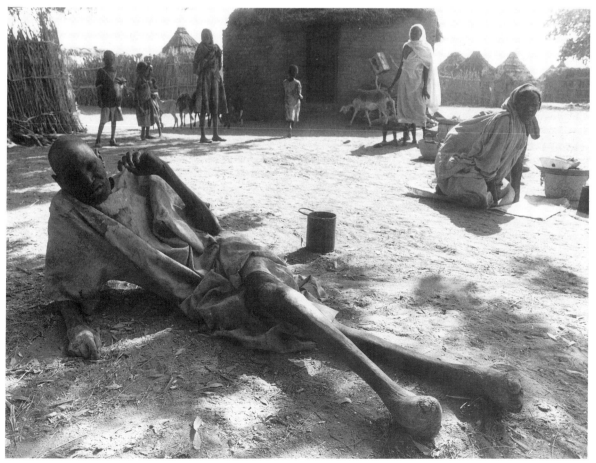

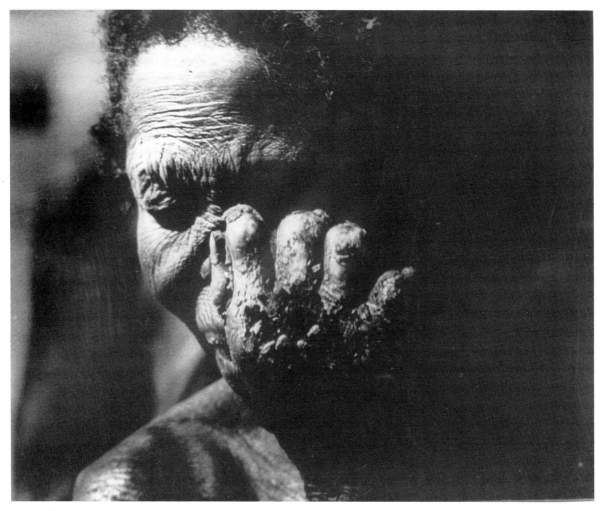

Woman in the leper colony at El Geneina.

had been harsh in my criticism, I always looked objectively at the causes and effects and this had been appreciated by the Sudanese themselves. To achieve that status in a third world country where people are starving, and not to be thought to be exploiting their problems, was reward in itself.

During my last trip I had requested permission to visit the Western provinces, some of the remotest regions in the country. A national Sunday paper expressed interest in my visit, as did a foreign television station. I arrived in Khartoum and immediately arranged meetings with my Sudanese colleagues. One advantage of having been many times to a country is that you begin to know your way around and where the right type of help is to be found.

This time I was stranded in Khartoum for several days before I could begin my journey. The Sudan Airway's timetable shows a plane to Geniena virtually every day, but for over a week every flight was cancelled owing to shortage of fuel.

During the long wait I made use of my time by visiting one of the cotton growing areas, Wadi Medani, travelling with an acquaintance from the Ministry of Information. I spent the Friday (the Muslim Sunday) as a guest of her family, photographing the area, the cotton fields, the cotton picking, and the cotton factories.

On my return to Khartoum I met a British nursing nun, who was in the capital for medical treatment, having broken her arm. She was stationed in Geniena, the town I was planning to visit, and as I was travelling light I agreed to carry urgent medical supplies on behalf of the International Red Cross. I visited the governor of Dafur Province at his office in Khartoum, and it was through him that I eventually managed to get on a plane to El Fasha. El Fasha was still two days journey from the Chadian border area where I wanted to be, but at least it was in the right province.

The International Red Cross also asked me if I could photograph a leper colony when I reached Geniena. Three hundred and fifty men, women and children were suffering from the disease and were not receiving any medical help. The Red Cross had given the medicine the lepers badly needed to the

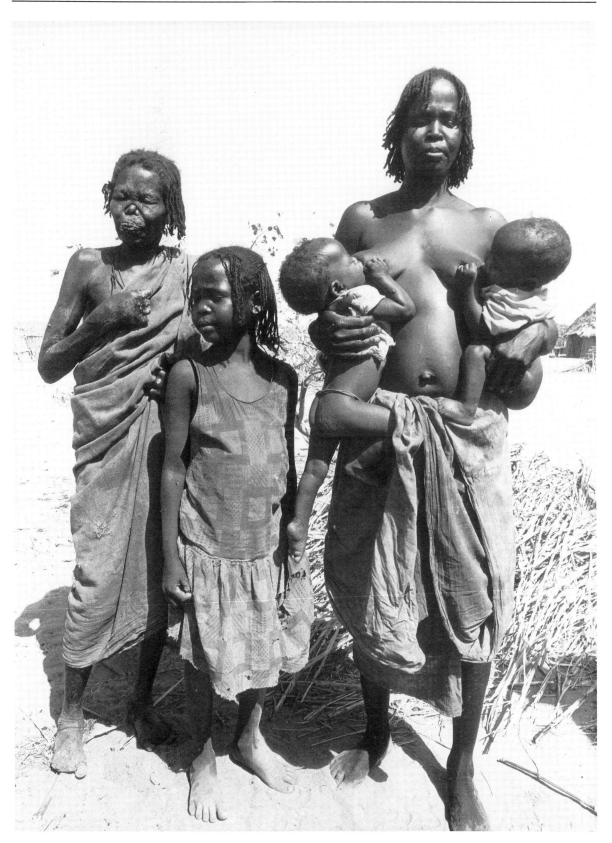

Family group, grandmother with advanced leprosy; mother also suffering; young child shows first signs; the twin babies have not yet developed the disease. Children do not normally show symptoms until five years of age.

local hospital, but although the hospital was within sight of the colony the doctors were so frightened of contracting the disease that they were unwilling to treat anyone suffering from leprosy. Leprosy is a genetic disease and only those people with the right genetic make-up are susceptible. The doctors had the same genetic make-up as those suffering from the disease and therefore were very frightened. Had they taken the medicine themselves they would have become immune, but centuries-old fear of mutation is so deep-rooted that even their medical knowledge was of little comfort.

Travelling West

On arrival at El Fasha airport I was greeted by the assistant governor, who took me to the governor's rest house for the night. I never was able to see much of El Fasha since I arrived in the early evening, and at eight o'clock that night the whole town was plunged into total darkness as the main electricity supply was switched off to conserve fuel. It was incredibly hot and humid; the only sound that could be heard were the mosquitoes buzzing and a couple of dogs barking in the distance.

The Governor had, over the previous few days, been arranging for petrol to be bought so that I could complete my journey over land. The fuel was sold in plastic one litre bottles at black market prices. The plan was to leave late in the evening once the heat of the day had passed, in the back of a lorry.

After a sleepless night I got out of bed early, and when the dawn broke over El Fasha, I made a series of photographs from the balcony of the guest house. The local Sudanese were busily packing up their bedrolls. Many of them had been sleeping under the trees surrounding the guest house.

The assistant governor arrived at seven o'clock with a big smile; he told me that he had just received news that an unscheduled aircraft had flown from Khartoum and was due to land in ten minutes; the plane was full but it was flying on to Geniena. He offered to ask one of the passengers to switch places with me. He warned me that the road to Geniena from El Fasha was a rough track and advised me to accept his offer.

Within a few minutes of my arrival at the airport I was sitting in a seat bound for Geniena. I made two photographs before I boarded the aircraft; the first of the strange airport building, and its carefully laid out flower-beds which seemed so out of place next to the dust-covered runway. The second photograph, which has sold extremely well, was of an airport official with a briefcase carefully checking the fuel levels. There was a strong possibility that there may not have been enough fuel left to refuel the aircraft, but my luck held out and the plane was cleared for take-off.

The aircraft had only been airborne for a few minutes when the Scottish pilot sent for me; he wanted to know if I would care to fly in the co-pilot's seat. In the cockpit we started talking about the Sudan and the difficulties facing not only the Sudanese but the expatriates. During the course of the conversation he asked if I had ever seen Jebel Marra. After looking at my map I discovered that Jebel Marra was a volcano, and not on our flight path. However, the pilot seemed very keen to have an aerial photograph of the volcano, and offered to divert the aircraft provided I made a special photograph for him. I had no idea at this stage that Jebel Marra was the fourth largest volcano in the world, and being extremely remote, there are very few photographs of it in existence.

As soon as we approached the volcano the pilot made a 180 degree turn. I had no alternative but to take the photographs through the aircraft window. The pilot did apologise for not being able to open the window, but as the aircraft was pressurised this was not possible. The Sudanese passengers started to clap and cheer loudly as soon as Jebel Marra came into view. I used a 24mm lens, but even then was only just able to fit in the two enormous craters. Jebel Marra has two crater pools, one thought to be saline while the other contains fresh water. According to the local Sudanese, nomads use the craters as sheep pens. Once the photographs were completed, we headed back towards the border town of Geniena.

The Refugee Camp

In Khartoum the figures I was given for the number of refugees varied according to whom I interviewed, and consequently I had no idea how many were actually living in and around the town. The Chadian war has been in progress for at least a whole generation, and so I did expect there to be quite a number of them. As we approached the town we were able to see for ourselves the extent of the problem. Below us lay a sea of refugee tents that dotted the horizon for as far as we could see, and I realised immediately that this was a major crisis.

As soon as we landed I was greeted by a group of armed security police. I was asked to explain the purpose of my visit and exactly where I planned to make my photographs. I answered that I had planned to photograph the refugee camp, the town and the leper colony. I was immediately informed that there were no lepers in Geniena. The look on the security guard's face told me all I needed to know. I tried to reassure him that if there were no lepers then of course it would be impossible to take photographs of them, but I had unwittingly touched on a hornet's nest.

The International Red Cross personnel who were at the airport to meet me confirmed my worries whilst they escorted me to their camp. Later that day the chief of security requested my appearance at his office. This time the chief himself insisted there were no lepers, and I realised then that by

being honest I had created a very difficult situation and had unwittingly hit upon a massive cover up. Geniena is a very poor area and the local people are so scared of leprosy that they kept the lepers virtual prisoners, denying the colonies existed for fear no-one would come to the area. As it was, they were having difficulty in getting Sudanese doctors to work in their hospitals and clinics. Geniena was regarded by the Sudanese medical profession as the 'hell-hole' of Sudan, and to be stationed there was regarded as being similar to serving a gaol sentence.

That evening I went with the Red Cross nurses on their rounds of the United Nations refugee tents, and managed to make a few photographs of the refugee camp although the light was failing. The doctor had suggested I wait for better light next day, but I always believe it best to get something on film. That way if anything should prevent my return I have at least some results. As it turned out those few shots taken in bad light were the only ones I was ever able to make of the refugee camp.

I spent the evening with the Red Cross and they told me of the tremendous difficulties they were facing in the area. All the water was polluted, and dysentery was rife. The Chadians were being well looked after by the United Nations, who were providing the relief supplies, but the Red Cross fear was more for the Sudanese local people rather than the refugees.

Sudan's Crisis

The market in Geniena used to be one of the most flourishing in the Sudan, but now, with the borders closed, the major supply route had been cut. The fuel crisis had compounded the difficulties, making it impossible for the local people to obtain adequate supplies from Khartoum. The United Nations were unable to provide food for the Sudanese, since under the regulations they were classed as the host nation and United Nations policy is that help can only be given to refugees. Matters were made worse by the Chadians who, seeing an opportunity to make a little money, were selling any excess aid to the Sudanese at vastly inflated prices. There was a great deal of bitter feeling amongst the Sudanese, who were furious that their guests were being looked after whilst their own children were on the brink of starvation. The irony of the situation was that I was supposed to be covering the terrible problems faced by the refugees when, in fact, the story was totally reversed. The more I saw the more I was convinced that those in most danger were the Sudanese, whose problems were aggravated by the inflexibility of the UN.

Early next morning, I visited the refugee clinic and interviewed the young doctor in charge. He was only recently qualified and had been sent for a short

Bedouin child, Port Sudan area, Sudan.

tour of duty to Geniena. Lacking in experience, funds and medicine he still managed to smile at the people who came begging for what little help and comfort he could offer. Working extremely long hours and suffering from nervous exhaustion, he was living in the hope of being recalled to Khartoum and felt totally hopeless in the situation he found himself. Those people he might have helped he couldn't through lack of medicine – the best he could do was to offer a sympathetic ear. He was painfully aware of his lack of experience, but sadly said that any doctor with the necessary experience would not want the job. It was therefore left to medical students and newly qualified doctors who could be ordered to go. He felt the situation would only get worse unless sufficient aid could be found, but it took another two years for the world to realise what this doctor knew, when Bob Geldof visited Geniena and was appalled at the state of the local people.

The Leper Colony

After the clinic we visited the leper colony. We were greeted by scores of children who stayed with us wherever we went. Conditions in the colony were extremely primitive, and there was not even the most basic of facilities. I watched the Red Cross team in action as they showed the people how to bathe their open wounds with soap and water. The doctor assured me that despite appearances the lepers felt no pain. Apparently the nerves in the infected area die before any mutation begins.

Word quickly spread around the colony that I was going to bring help, and soon I was being followed by a massive crowd of people. My original plans were to take two rolls of colour and two rolls of black and white, as I did not want to impose myself on their world for too long. In the event I was forced to photograph every man, woman and child. A rumour spread that the people in my photographs would be helped because they would be seen to be in need, whereas any who might be excluded would be forgotten. I had no time to really appreciate the situation. The sun was nearly directly overhead creating impossible contrast, whilst the people clung to the shadows because the light affected their eyes. The contrasting light was a nightmare, as I knew all too well the limitations of my film.

The reason why there were so many children was simply survival. The adults were unable to go to the town to buy provisions; if they did venture out they were in danger of being stoned by the locals who were petrified by the threat of leprosy. It seemed impossible that this was happening in 1980, photographing living conditions similar to those faced in the Middle Ages when leprosy victims were forced to wear placards around their necks with the words 'unclean'.

Children are not born with leprosy but develop the disease around the age of five or six. The drugs needed to cure the disease are cheap and readily available; there is no need for anyone in the 80's to be mutilated by leprosy. Leprosy does not cause a quick death, just lingering suffering, and if children were provided with a regular supply of tablets they would never develop any symptoms. However, the children in this colony were simply marking time until their horrific fate took a grip. The younger women who were still able were making baskets and mats which could be sold in the town, providing a small inadequate income with which to buy provisions.

When we left the colony the children followed us to the Red Cross headquarters. Everyone knew where we had been, but nobody said a word. Sensing further trouble lay ahead, I left my exposed film in the Red Cross refrigerator before leaving for the market in the town to buy provisions. I managed to take a few pictures of the market and the town; food was clearly in limited supply and very overpriced. When we returned for lunch one of the security guards was waiting outside.

A Sudden Exit

I was escorted, along with one of the Red Cross volunteer workers, to the security headquarters, where I was forced to hand over all my film. I was then confined to the Red Cross headquarters until suitable transport could be found to deport me. It is very hard to explain just how alone I felt without any means of communication with the outside world. I was at the time a single parent, with two children living in England. No one except my Sudanese friends in Khartoum and the Red Cross in Geniena knew my whereabouts.

A couple of days later a seat was found on a plane chartered by the Red Cross. The plane had been taking relief workers into Chad and landed in Geniena, on its way back to Khartoum, in order to collect me. At the airport the chief of security was waiting for me, on the pretext of making sure that I left Geniena. He had with him a plastic bag, inside which were all my unexposed films and the few pictures taken in the Geniena market. He whispered that he had tried to give me time to make my pictures, but had to be seen by the locals to be doing his job. Usually, he explained, he did not like journalists or photographers, but he felt that my interest was genuine and was giving me back what he thought were my pictures of the leper colony so that I could get help for the local people. He also told me that the previous week a team of journalists and photographers had arrived from Paris working for 'Le Monde', but he had refused them permission to get off the plane and turned them back the same

Boys dressed up as girls, Port Sudan area, Sudan.

day. His last words were 'I did help you, didn't I?'

When I realised that I was on my way I had removed my films of the leper colony from the Red Cross refrigerator and concealed them in a compartment in my camera bag. It wasn't until my return to England and all the films were processed that I realised that the security chief had looked after those films he had confiscated, when he could have easily ruined them. The market pictures that had been in his possession turned out to be fine. I flew to Khartoum, and the next day on to London.

The Lost Story

By then I was too ill with dysentery to develop any of my own films, so on my return I handed them to a Sunday newspaper. The paper selected two of my black and white pictures for use the following Sunday, and also accepted the article that I had written, during my return flight, on the crisis facing the Sudanese people.

My work was accepted for publication on Wednesday; two days later the Falklands war broke out. The newspapers were filled with the Falklands story and my story was shelved. However, I was fully paid for the work, and in addition the story and pictures were syndicated by the paper around the world. A second story on the area was subsequently syndicated by a news agency. The pictures have been published world-wide, yet despite all I had been through none of the work was published in this country. No matter how strong the story and pictures are, there is never any guarantee of publication, especially if, as happened to me, an even stronger news story breaks.

Valuable Lessons

Whilst working in the Sudan I learnt more about travel photography than in any other country. It changed my attitude to life and to photography. I learnt how to deal with people in adverse situations but, most importantly, the Sudan taught me how to survive on my own with my camera. Frequently the hospitality and genuine friendliness of the Sudanese people, even when they were near despair, was incredible. Many times I realised that this hospitality – especially the meals they offered – was at the expense of their own children. As a result I now always carry some hard rations with me when working in the poverty-stricken areas of the world.

I continue to work with Sudan from time to time; I have made several broadcasts on behalf of the BBC for Radio Africa, been interviewed by foreign television, and have written many articles on the future of the Sudanese economy. The friends I made during my visits to the Sudan still keep in touch and call me regularly when they visit England, and whenever possible I return to the country to keep my extensive photographic library up to date.

Equipment & Maintenance

The equipment chosen for any assignment will be determined by the preferences of the photographer and the photographic brief. Every photographer works best with equipment he is familiar with and that suits his style of photography, but the subject matter to be photographed will be one of the prime considerations. If the assignment includes a safari and the intention is primarily to make pictures of wild animals in their natural habitat, long lenses are going to be of great importance, far more important than say wide-angled lenses. But if the photographer is hoping to make photographs in a street market, the wide-angle will be more important than the longer focal lens. Therefore it is important for the photographer to work out his objectives before deciding on the actual equipment, although frequently one cannot know exactly what opportunities will present themselves. I prefer to take a collection of lenses that could, if necessary, cover most eventualities.

Travelling Light

For most photographers the limit will come when the camera bag is too heavy to be carried easily. Far too many photographers weigh themselves down with equipment they will never use and that is quite unnecessary. I once watched a professional photographer arrive at an airport – his equipment was so heavy that he was unable to carry it himself, and as there were no taxis at the airport he was

stranded, unable even to get to his hotel! Mobility, for the travel photographer, is a prime consideration. There is also a risk that if the photographer selects too many lenses he will be in danger of constantly having the wrong lens on the camera at the wrong time or, even worse, being unable to find the right lens quickly in an overcrowded camera bag.

When I travel long distances I normally take three camera bodies and a maximum of four lenses. I also carry an automatic camera for quick autofocus pictures in difficult situations. My automatic is a Canon Sureshot, which I find invaluable for situations that require a quick response. During a recent Moroccan trip, I was visiting a traditional market where there were many craftsmen working in tiny, poorly-lit shops in the market place. As I was following a guide there was no time to start using a big flash unit, but in this sort of situation the little automatic camera with its built-in flash and autofocus can just be turned on when needed. The flash automatically balances with the available light, and the infra-red focus takes care of dimly lit subjects that are often too dark to focus without considerable difficulty with a bigger camera.

When travelling on a major commission, such as illustrating a book, I invariably end up taking six lenses, my three main camera bodies (Canon F1's), a small flash unit, a tripod and a bean bag. I usually also include a few filters. I always keep UV filters on my cameras as protection for the lens, but carry

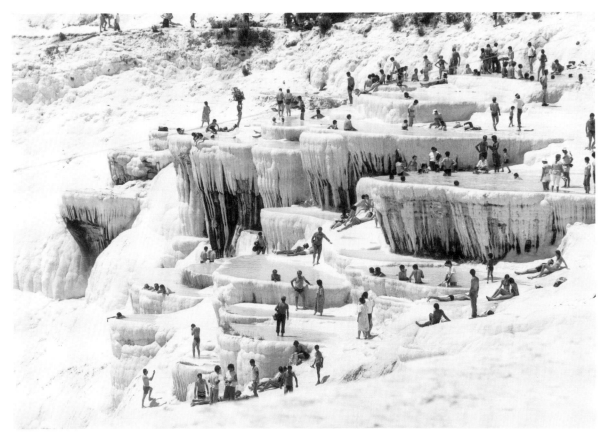

'Cotton Castle' limestone formation, Pamukkale, Turkey.

polarising filters, diffusers and neutral density filters as well. I rarely use special effects filters unless they are specifically requested by clients. I also take spare batteries, a lens cleaning brush and a changing bag which is carried in my suitcase.

There are photographers who prefer to carry two spare bodies at all times. I prefer one, because the only time my camera seems to pack up I rarely find out until my return and I have viewed the pictures. Normally, when working on assignment, I leave most of my equipment behind in a 'safe place'. I only carry three or four lenses and the two bodies around in the street; the rest of the equipment is left at a convenient centrally placed location. It could be in the hotel bedroom – locked in a suitcase – or at a left luggage office. I like to know that I can get to my equipment should I need it, but do not want to be slowed down by too much weight.

The lenses I generally take are:- a very fast 50mm lens F1.2; a fast wide-angle 24mm lens; a 17mm lens; a wide-angle zoom 35 to 70mm. At the other end of the scale I usually take a 70–210mm zoom which has a macro facility and, if necessary, a 300mm F4 telephoto. Dependent on subject matter,

I occasionally carry a 500mm mirror lens. My most used lenses are 17mm, 24mm, 35–70mm and the 70–210mm, whilst a lens I sometimes take if I am largely concerned with making portraits is a 135mm telephoto. My 17mm lens has corrected elements and does not give as much distortion as one would expect, and I find it particularly useful for confined areas and for street work. I often find that I can fill the frame with a person when they think they are safely out of the photograph; this works well for candid photography.

I have two sizes of camera bag; the larger one for travelling to the destination and which contains all my equipment, and the smaller one for the actual location work. As they are made from waterproof canvas they look similar to the old-fashioned fishing bags from which they have evolved, with a flap-over lid and padded compartments that protect the equipment. The tripod is packed in my suitcase, as otherwise it makes my bag too heavy and awkward to manage. Spare batteries are usually kept in both camera bags because I have been known to wander off, forgetting to transfer them, and it is only when I have left a spare battery behind that I find I need

Fishermen on the River Debou, digging fish from the river bed, Morocco.

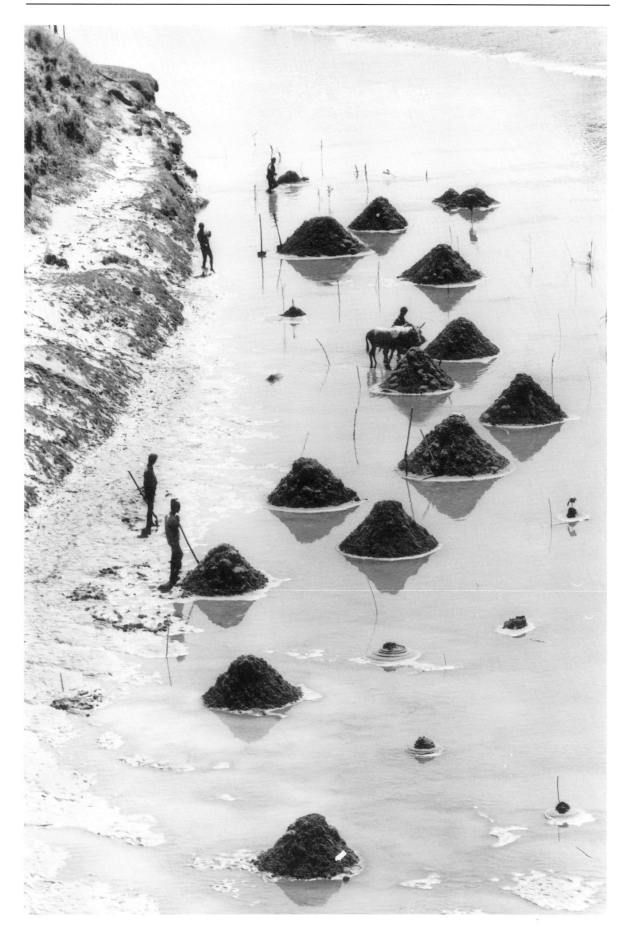

one! The larger bag has pouches at either end; these are removable and used for storing film. They can easily be removed and put in a refrigerator, complete with film, should one become available.

Care and Maintenance

One of the most important tasks a photographer has to deal with on location is the maintenance of his camera equipment. Most photographers carry spare camera bodies as a back-up should a serious fault develop on location, but sadly one is not always aware that a camera is malfunctioning. Luckily most cameras rarely break down if they have been regularly serviced, but there are times when even the most conscientious of photographers will experience an equipment failure.

Regular servicing of all camera equipment is essential, and regular checks go a long way in preventing problems occurring. Cameras are machines and their parts do wear; just because a camera has worked well in the past does not mean that it will work well indefinitely. Precise equipment requires fine tuning from time to time to ensure optimum performance. Many photographers try to save money by waiting as long as possible between camera services. Whilst they do save money, they are also increasing the risk of a calamity happening on location, which could in the end cost far more than they saved in the first place. It is worth a few pounds to avoid having a shutter jam, or have the whole trip ruined by over-exposed film because the camera speeds were wrong.

In the processing chapter hints are given about processing on location. This has many advantages, and is really the only way in which the photographer can be certain that all the equipment is functioning correctly on location. Although processing on the move may not always be practical, it is an easy way to minimise risk. If the photographer is travelling in a country that has good processing facilities, it may well be worth having random rolls of film developed during the assignment to check that the equipment is functioning normally.

Every evening after completing the day's photography, time should be set aside for cleaning the camera in order to remove all loose dirt and other particles. Any dust is best blown off the lenses, both from the front and the rear elements. Fingerprints can be removed with a soft lens tissue. If dust has managed to get onto the mirror and focusing screen, remove the lens and carefully clean both with a soft brush; never touch either with the fingers since there is a risk of leaving a greasy deposit to which dust can easily stick. Cleaning the viewfinder is easiest with the corner of a rolled up lens tissue. Lastly, open the back and carefully, but thoroughly, blow all dust and any film fragments from inside the camera, paying particular attention to dust in the wind-on mechanism. If dust is not removed regularly from inside the camera it may find its way into the shutter and cause it to jam.

A number of photographers prefer to use canned air to clean their cameras, rather than soft brushes. This is purely a personal choice, but as a can of air is larger than a brush and as I have a dislike of aerosols, I tend to use the brush. There is a further very serious reason for not using canned air, and that is because it comes in an aerosol – chemicals used in aerosols are known to cause serious damage to film. It would appear that the chemical actually breaks down the adhesion between the different layers of colour within the film. I have seen this for myself. I had a Cibachrome print in my lounge for a couple of years, and as it became rather dusty I decided to wash it. The moment the print was thoroughly soaked the entire yellow gelatine layer floated off. After making enquiries it would appear that an aerosol furniture spray had been responsible for the damage caused. I have also heard of aerosol hair spray having the same effect. It is therefore best to ban the use of spray cans in your home or risk damage to your films.

Breakdowns

Unfortunately, there are times when even the most careful of photographers is faced with a major problem. It is not unknown for the power to fail in a camera – this is most serious with automatic cameras since they rely heavily on battery power, and especially with those where the shutter becomes inoperable. There are several reasons for power failure, the most simple being dirt on the battery terminals. If this is the case the remedy is simple; carefully clean the terminals with a lens tissue to remove the dirt or grease, and carefully replace in the camera making certain that the terminals are not touched by the fingers. If this fails replace the batteries with new ones. If the power has still not returned then those with battery-dependent cameras may well have to use another until they can return home and have the first camera serviced.

On a long trip, losing the use of a camera can make the photographer's life extremely difficult. I am always very wary of letting unauthorised dealers touch my equipment, and prefer to wait until my return wherever possible. However, a few manufacturers do have world-wide service for the professional. I am a member of the Canon Professional Users' Scheme, which recommends members to authorised repair facilities in many countries.

A few years ago, whilst working in Saudi Arabia, one of my cameras jammed and, having tried all the simple remedies myself, I was recommended to a local repair centre. The mechanic proceeded to take my camera apart, assuring me he knew exactly what was wrong, but when he came to reassemble it, to my horror he couldn't remember where the screws came from! I was left with a camera in a worse state of repair than when I had started. On my return to England some months later, it cost me

Early morning exercises for martial arts, Taipei. A master instructs his pupil.

a considerable sum to have the camera rebuilt!

I always prefer to use a camera that has a total manual facility. With the Canon F1, should the battery fail, it is still possible to take a picture on 90th of a second upwards without any battery. The light meter does not operate, but with experience and knowledge of lighting conditions and film stock, it is still possible to make good pictures. In the past few years I have had both batteries fail in both cameras within a few days of each other, the first time in Amsterdam where both batteries failed within half an hour of each other.

The second time both batteries failed was during a Middle Eastern trip. The first went a day and a half before the second, and during that time I was able to use the meter of one camera to check the readings of the second. I do carry a separate meter, but some types of work, especially candid photography, do not benefit from having too many separate pieces of equipment. I suspect the batteries were weakened by the high humidity – I was carrying two spares with me, but both of these proved to have been affected by the conditions as well. On reflection, the spares had been in my camera bag for some considerable length of time, and I now always check all my batteries before departure. There is a tendency to buy batteries in large quantities, but if they are carried around for too long,

even if they have not been used, they can still be affected. At the time of the second battery failure I was in a remote area of the United Arab Emirates on the Omani border, and there was nowhere I could have bought any replacements. I was, however, able to complete my work successfully using the camera manually.

If a camera jams, always check the most obvious causes first. A jammed camera could mean that the film has finished; also check that the camera has been wound on properly. Sometimes gently moving the film advance lever is all that is needed to free the camera. Occasionally, the film advance fails to engage, and this may cause the camera to jam. Some automatic cameras lock up their mirror automatically if the batteries are too weak, or there may be simply insufficient power left to operate the camera even if the mirror has not locked up. Automatic cameras require considerable battery power to operate all their different parts. The Canon F1 will jam until the weak battery is removed; once removed the camera can be operated manually. If the mirror has locked up, set the camera to its manual mode or to the flash setting which, dependent on the make of camera, should release the mirror. Alternatively, change the batteries, checking the contacts.

On several occasions I have jammed a camera

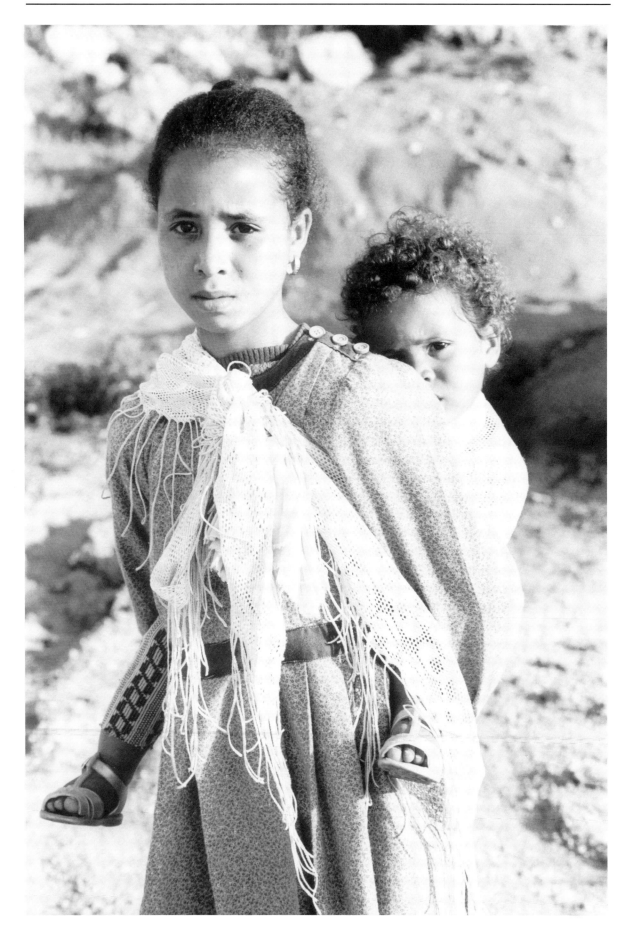

when I have been unsure of the length of my film. When on a long trip I often load film myself, and by doing so save a considerable amount of money. Sometimes a length is left over that is shorter than normal, and unless this is marked the photographer may find that his camera has jammed, simply because a shorter length has been used and the film has run out. I now mark all shorter lengths of film to prevent this happening. On a few occasions I have discovered that the end of the film has come off the spool. In this case it may be necessary to use a changing bag, or wait until a suitable darkroom can be found, in order to unload the camera without spoiling the film.

Once, on location in North Yemen, I was lucky enough to find a darkroom to save the photographs. Fortunately the film came off the spool right outside a photographer's shop in one of the small side streets of Sana'a. The photographer and I did not speak the same language, but I was able to communicate my difficulty by drawing a picture showing the back of a camera with a torn film. He immediately showed me his darkroom, and within five minutes I was able to rewind the film into the cassette. Happily the common language of photography, and photographic problems, are understood by most photographers both at home and overseas.

Adverse Conditions

There will be times when a photographer wants to take photographs in adverse conditions. Some of the most atmospheric and beautiful photographs are made in this way, but one should consider what the effect will be on the camera and try to protect the equipment wherever possible. If the camera is not protected the photographer could jeopardise the whole trip for the sake of just a few frames.

Photographs taken in bad weather often have tremendous sales potential, but many are 'fine weather' photographers, and only take pictures when the sun shines. Therefore the photographer who is willing to suffer the bad weather will find that there is often a considerable demand for this more atmospheric type of work.

In the Sudan during a visit to the Answar (Dervish Dancers), a dust storm suddenly appeared, creating a timeless scene filled with atmosphere; whirling dervishes combined with the swirling dust culminated in the most amazing photographic opportunity. In the past, when working in very dusty places, I have taped over the joints of my camera to protect the mechanism from the dust. The dust particles in a sandstorm are so fine and travel at such a velocity that they penetrate absolutely everything. On this occasion I had no prior warning and as I was already on location, did not

have any tape. I did, however, manage to find in my camera bag an old plastic bag; I punched a hole for the lens and wrapped the camera in the plastic before taking any further photographs. I was standing next to a group of international photographers, all of whom immediately put their cameras away. The storm was so strong that I had to brace myself against another photographer to stop myself from falling over. The photographs that resulted totally justified the risk, but sadly I was only able to take eight frames before I came to the end of the film. Changing film in a dust storm was out of the question, so I had to make every frame count. These photographs have often been used in preference to those taken in perfect conditions because they have far more atmosphere. They have been successfully sold not only to illustrate the Sudan and the dancers, but also to illustrate adverse weather conditions and dust storms.

In Taiwan I was able to photograph the devastation caused by a typhoon. Typhoons are often followed by monsoon type rain, so the main danger to the camera was the heavy rain which, if I was not careful, would not only ruin the film but ruin the camera itself. I therefore improvised a housing for my camera out of a couple of plastic bags, taping them together to form as watertight a casing as possible, with a hole for the lens. The resulting photographs show not only the damage caused by the typhoon but the heavy rain that was bouncing off the pavements!

The adverse weather conditions affected the whole of my first visit to Taiwan. The heavy rain resulted in a tremendous increase in humidity, and every morning before I was able to take a photograph I had to wait for my camera to become acclimatised. I was sleeping in an air-conditioned hotel, but the moment I stepped outside the whole camera would steam up. The condensation on the lens was easy enough to remove, but the condensation on the mirror proved to be extremely difficult; I could not dry the mirror since the water would have left marks. In the end I found the only solution was to get up at least half an hour before I needed to start my photography, in order to let the camera dry out and the condensation disappear. This was certainly preferable to leaving my cameras outside the window, in case they were stolen. On several occasions I found that the condensation actually gave an interesting soft focus effect, but even for this it was still necessary to wait until the camera had at least partially cleared.

Check the Camera

Checking camera settings regularly can also prevent tragedy. One method is to check the sound of the

Girl carrying her sister, road to Casablanca, Morocco.

camera's shutter. When a shutter is released it makes a distinctive sound, and an experienced photographer is often able to differentiate the sounds indicating the different shutter speed settings on his camera. Although it does take a little practice to become proficient at this, it is an extremely useful way of checking that the camera is functioning correctly. If the shutter speeds alter there is a danger that pictures may be lost through incorrect exposure, and if a photographer is aware that there is a suspect shutter in one of his cameras he does have the option of using an alternative camera body.

It is very easy on some cameras for the film speed dial to be knocked, and without realising it a photographer could inadvertently ruin many pictures. Some cameras also have a flash setting that can be knocked accidentally. Occasionally there is a lever by the lens marked X and PF; X is the synchronising setting and PF is the photoflood setting. Should the camera be accidentally knocked from X to PF, even though the speed is right for the flash, the photographs will not be synchronised.

During a photographic session on the island of Samos in Greece, I was photographing a centuries-old tunnel, hand-carved by thousands of men using knives. The camera I was using at the time was an Olympus OM1 with a small Vivitar flash unit. Before entering the tunnel I set the camera to the 60th of a second which was the correct speed. The Olympus has a little lever marked X and PF, but I never bothered to check its position since I never ever used it on the photoflood setting. The flash was firing and everything else appeared to be working well, but, unknown to me, the lever had been accidentally knocked when I took the camera out of the camera bag and as a result, I lost every single frame. The effect of not having the camera synchronised is obvious when the film is processed, as only half of the frame records.

During a recent visit to the Gulf, I was not aware that my colour camera was malfunctioning, and sadly it was only on my return home that I found twelve rolls of film had been terribly over-exposed. When I sent the camera away for servicing, it was found that the speeds were completely out of adjustment. Camera speeds are very delicate and unless regularly adjusted and checked it is quite common for them to read incorrectly. Had I listened to the sounds of my shutter release I would probably have realised there was a problem. Another time, in Monte Carlo, I was luckier; I suddenly realised that the sound my camera was making was too fast for the speed I had set. I immediately checked the suspect camera against the other one at the same speed, and my suspicions were confirmed. I was able to finish the assignment using the spare camera body.

An Ancient World

When I lived in Saudi Arabia I heard wonderful travellers' tales of the marvellous city of Sana'a, the capital of North Yemen, a medieval city whose ancient buildings are built out of mud. I had tried on several occasions to visit the country from Saudi Arabia, but each time this proved impossible. However, I carried on requesting permission to travel to North Yemen and eventually, after five years, my efforts were rewarded. One of my clients at the time had a construction project in Sana'a, and the company offered to help me with some of my expenses.

Sana'a

When I arrived in Sana'a I was surprised, because although I had been told that the city was beautiful I had never imagined just how enchanting it might be. North Yemen is totally unspoiled, having been kept in isolation by its former rulers, the Imams. The rule of the Imams lasted until 1963 when they were finally overthrown, and afterwards there followed a period of civil war. It is only recently that visitors have been allowed into the country, and enforced isolation has done much to preserve the traditional Yemeni way of life that has remained unspoilt for centuries. I decided to make as many visits as possible in order to record a way of life already lost in many other parts of the Middle East.

Although North Yemen is a third world country it is relatively self-sufficient. The people are sometimes poor but never starving, being mainly farmers who produce their own food. They have a tremendous sense of tradition and are very proud of their cultural heritage, and their traditional buildings have evolved over the years to form a unique Yemeni art form.

Sana'a, the capital, is situated high up in the mountains, with a climate that is sunny, dry and mostly cool. The main agricultural export from North Yemen is coffee, and this is one of the few countries in the world where coffee is grown in irrigated fields. Mocha, a name associated with coffee, is the name of a small port in North Yemen where it was first grown. During my travels I came across a beautiful, isolated, white Mosque which locals told me was dedicated to an 11th Century queen who ruled the country, and her name, believe it or not, was Queen Aroma. Whether they were teasing me or not, the story of Queen Aroma, coffee and mocha has sold world-wide!

When I arrived in Sana'a I had very little money left for travel within the country, and most of my transport depended on the generosity and the help of the local people. On one occasion I travelled the whole length of the country at the invitation of a young Yemeni. He was the son of a hotel owner who lived in Yemen's second city, Taiz, on the South Yemen border. I was welcomed at the hotel as an honoured guest and later taken by the family to their country home high in the mountains over-

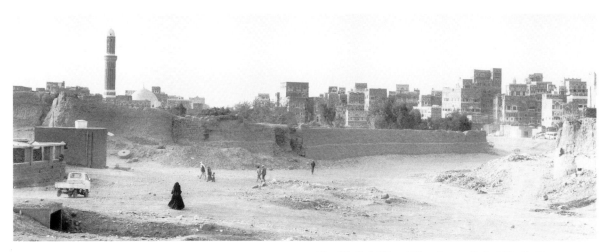

The Walled City of Sana'a, capital of North Yemen.

looking the border. Many of the village people gathered to meet me. The women brought bunches of flowers and herbs from their gardens, a typical gift from small farming communities in North Yemen. On another occasion a Yemeni company provided me with their driver to take me wherever I wanted to go in the country.

A Disappearing Lifestyle

The photographs I made in North Yemen have been published extensively, as they document a rapidly disappearing lifestyle. North Yemen is fast becoming a very popular tourist destination for Americans, and through the people's desire for a better life the country has begun to develop rapidly.

The majority of Yemeni people live in the mountains; however, the country is bordered on one side by the Red Sea where there is a narrow coastal strip called the Tihama. The Tihama is very fertile and many different types of crops are successfully grown, watered by the plentiful underground water which is gathered by the nearby mountains. The Tihama also has a substantial fishing industry, heavily reliant on traditional fishing techniques.

The people of the Tihama are of a different racial descent than those who live in the mountains. Their skin is very much darker and they are taller. The people of the Tihama travel to the mountains to sell their produce, and I photographed a market town halfway up the mountain where the people of the Tihama meet the people of the mountains. Here they trade their different wares. As I photographed the market, it occurred to me that I was watching the original car boot sale! Goods are sold literally from the back of one jeep or camel to another.

In the Desert

The other side of the country borders on the vast 'empty quarter' of Saudi Arabia, the Rub al Khali, the lifeless desert of the Arabian peninsula. During

my visit I was often able to follow the travels of Wilfred Thessinger. Many of the tribes he describes in his book 'Travels in Arabia' still exist and can be seen today, hardly changed.

On one of my visits I was taken to see the ruins of the palace of the Queen of Sheba, the legendary queen who ruled the region some three thousand years ago. Several tall columns still stand, towering above the surrounding desert landscape. Over the centuries sand has buried most of the palace, and how much lies beneath the surface nobody knows, as no archaeologists have exposed the site. On my visit to the ruin, two children rushed to greet me – they pointed to the top of the column and explained that they could shin up to the top. I watched in amazement as these two tiny children expertly conquered the sheer column. Resting their backs against one, they used the next column to walk in a sitting position until they reached the top. My pictures of the ruins have sold well, but without the children's daring feat they would have seemed rather ordinary, nothing more than a series of columns surrounded by sand. The children enjoyed showing off, and brought life and scale to the photographs.

I also visited the ruins of the great dam of Marib, one of the wonders of the ancient world. When the dam burst it caused such devastation that it was recorded in both the Qu'ran and the Bible.

On the return journey from Marib I made a series of photographs of the desert. To many travellers the desert has no beauty, a lifeless wasteland best avoided. I have found that deserts vary, and whilst some are undoubtedly empty, many are fascinating, huge seas of moving sand, with tremendous mood and powerful atmosphere. Some are far from lifeless, and strictly these should be called semi-deserts. The desert surrounding Marib is filled with wizened trees, gnarled with age and the harshness of the climate. The remains of dried plants wait patiently, often for years, for the rain which will bring them back to life. Scorpions and vultures are

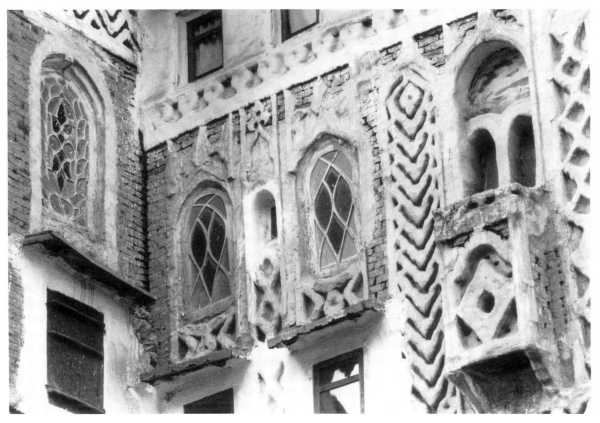

Detail of mud house in Sana'a showing applique work which decorates the houses; each house has its own design. On the right hand side of the box under the window is the toilet. Waste matter is gathered and dried on the roof for fuel in the public baths.

also in evidence, looking and waiting for their prey. The colours, solitude and atmosphere seem to attract me to these barren wastes, which I never tire of photographing.

Turrets and Guns

Whilst living in Saudi Arabia I had noticed changes in the height of traditional buildings in different areas of the country. In the area surrounding the town of Abha most of the old buildings had only two floors, but the height of the houses increased the closer they came to the oasis town of Najaran. In Najaran the mud buildings reached amazing heights, often nine or ten floors.

In North Yemen I discovered the same thing happening in reverse. On this side of the border in North Yemen, the buildings grew smaller the further from Najaran I travelled. In this way I was able to document an architectural curve. The reason that the buildings grow taller would appear to be the need for protection, with the tallest buildings fortified with turrets. The border between the two countries is still uncertain and on the Yemeni side there is an area which is a virtual no-man's land.

There are no police, both Saudi Arabian and Yemeni currencies are legal tender, and most people go armed. There seems to be considerable tribal warfare, and many people are armed to protect themselves against their rivals. Bullets are sold in big wicker baskets in the local markets and cost £1 a time. Many of the weapons are ex- British army, left over from the days when South Yemen was known as Aden, and under British rule.

A Varied Land

There are still quite a few Jewish people living in North Yemen. Jewish Yemenis are the highly respected craftsmen responsible for most of the beautiful silver jewellery worn by Bedouin women throughout the Middle East. Many houses in Sana'a have the Star of David incorporated in the decorative applique work, signifying the home of a Jewish Yemeni. Large numbers of Palestinian refugees also live in North Yemen, mostly housed in camps outside the main city of Sana'a.

The articles I wrote after my North Yemen visits are varied and cover many different topics. I have

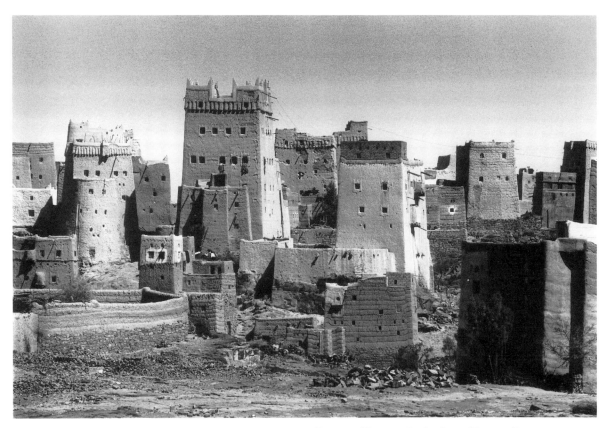

Remote village on the borders of Yemen/Saudi Arabia. The houses are fortified and turretted for protection against local feuding tribes.

written and illustrated guides to the city of Sana'a, plus specialised articles on architecture, traditional ways of life and the Yemeni role in the ancient spice routes. My photographs have been used to illustrate an entire book on North Yemen for schoolchildren in this country, and have won international awards. It is definitely more difficult to sell pictures of remote places without accompanying text, but many of the photographs of North Yemen have been sold in their own right.

Film & Processing

One of the major worries for any travel photographer is what can happen to his film whilst travelling. Being very selective with the film used helps, as does making sure fresh stock is bought; if the film has a long life it is better able to stand up to unforeseen abuses whilst travelling.

The Temperature Factor

Professional films are stored under controlled conditions until the film has matured and the colour balance is at its optimum. This normally occurs a few months before the expiry date; the average time is three to six months. Unless the photographer is certain of the conditions he will meet on his travels and can be sure they will be within his control, it would be best to avoid using professional film which could be adversely affected after any length of time in extreme climates. Amateur colour slide film, although looked down upon by some photographers who claim that the quality of professional film is far greater, is less likely to be affected than its professional counterpart. However, I now use Agfa Professional, mainly because this is the only long-lived professional film on the market. The further ahead the film is expiry-dated, the better it is for extremely hot conditions.

If I am lucky enough to come across a refrigerator in the hotel room, I immediately put all films not immediately needed inside and leave them there for as long as possible. The cold slows down the ageing process which is otherwise speeded up in very hot climates, but film should always be taken out of the refrigerator well before use; ideally four hours to avoid condensation in the film cassette.

Sadly, accidents do happen and despite the best precautions things can go very wrong. Recently whilst working in Taiwan I was being shown the country by an official guide. After several days working flat-out in extreme heat, I was taken ill with a migraine caused by a combination of too much heat and too much continual use of my eyes. I became so ill I was unable to take care of my films, but the guide helped me to the hotel where I was able to rest until I felt better.

Unfortunately, when I was taken ill the driver, who knew nothing about photography, put the exposed films on the rear shelf of the car. I was too ill to return to the car until the following day, by which time the film had been baked by the intense sunlight and heat. When I discovered what had happened I felt that I had lost half of my trip; the metal film cases were so hot they burned my hand when I touched them. Fearing the worst, I laid every film out on a table and fanned them until they cooled down. I marked each film with an X, but realised the chances of re-photographing the work were slim since I was on a very tight schedule. However, when I processed the films on my return, I found that despite the tremendous heat the films had suffered there was no appreciable colour difference between those that had been cooked in

the car and those that had been stored overnight in the refrigerator. I am certain that if I had used professional film stock the photographs would not have survived so well; I had used up most of the remaining life of the film by cooking it! I prefer to sacrifice a tiny amount of quality for the benefits of the longer-lived film.

Processing on the Move

I often carry equipment for processing slides during the longer and more important trips. Very little equipment is actually needed for processing a slide film – I use a small film tank and carry a few small kits of chemicals. I always use up the solutions and never store partially used chemicals whilst travelling. I take three containers in which I mix the chemicals – one for the developer, another for the colour developer and the last one for the bleach fix. I find that I can usually borrow a kettle to heat the water. I use a travelling thermometer protected in a plastic tube, and lastly an old margarine tub which I fill with water and use as a water jacket to keep the tank up to temperature.

The most critical part of E6 slide processing is the temperature of the first developer (black and white), which should ideally be 38 degrees Centigrade – although the film can be processed at cooler temperatures, 38 degrees is the optimum. The chemistry I use is Photocolour's Chromesix, and each kit contains a chart which gives processing times for cooler temperatures. When processing colour slide film it is easy to uprate the film by altering the time of the first developer. In this way 200 ASA film can be uprated one stop to 400 ASA by adding on a few minutes; instructions are always contained in the kit, as the time varies from kit to kit. I use a kettle of hot water to keep the temperature in the water jacket (margarine tub) at 38 degrees.

Once the chemical is mixed I stand the containers in a borrowed bucket or in the sink, and again use a water bath to prevent heat loss. I load the film either using my changing bag or, if one is available, a wardrobe. Once the film is safely inside the processing tank the rest can be done in daylight.

A few years ago, in Khartoum, I climbed into a wardrobe to load a roll of colour film: when I had finished and tried to open the door, it would not move! I was trapped for nearly two hours before I finally got out. I'm sure I would have been discovered the following morning when my room was cleaned, but the thought of spending a night in a wardrobe was not very pleasant. Always check that you can get out before closing the door!

Many photographers are under the impression that colour is difficult to process but it is very easy providing the instructions provided with every kit are followed precisely. Black and white films can also be successfully processed on the move, and most professional photographers regard this as

essential. During the longer assignments I try to befriend a local photographer and have often borrowed equipment to develop my rolls of film, make contacts and frequently prints. However, on some urgent assignments I carry my own black and white developer and fixative. Photographers working for newspapers often produce their own prints on the move so that they can transmit them back to their paper, and travel photographers travelling to remote destinations can sometimes use the facilities of press agencies if the publication they have offered to work for has such connections. Developing film whilst abroad can also avoid problems with x-rays, of course.

With the introduction of XP1 variable contrast black and white film, which is compatible with E6 chemistry, life has become far simpler. A roll can be handed in to a colour laboratory and the black and white negatives will be ready within a short time. Since XP1 is a variable contrast film it is far less critical than colour transparencies, and slight over or under processing by the laboratory will not ruin the negatives. Many photographers working in the more civilised parts of the world now drop off their day's work and collect the negatives the following day, the main advantage being that one can see the results immediately and re-shoot some of the photographs if necessary.

Some photographers carry miniature enlargers – usually built into suitcases – and if the assignment calls for a great deal of black and white much of the processing can be carried out at source. Photographers travelling alone often have long evenings with nothing constructive to do, and this is one way of putting the spare time to good use. It also means that when the photographer arrives home the work is ready to be marketed immediately.

When travelling, powder chemistry is best. Powder developer such as ID11 and powder fixative such as Ilfofix are ideal. Solutions can then be mixed when needed and there is no danger of spillage in the suitcase.

I have successfully processed black and white films in a sink in a Sudanese hotel. The developer was poured into the sink and the film gently rocked in and out of the solution until it was fully developed. I then rinsed the film and poured the fixative into the sink, having previously made it up in a couple of plastic cups. Unfortunately there was insufficient water in the sink to wash the film, but I did manage to wash it thoroughly in the flushing toilet! There is usually a solution to most problems, and a flexible photographer can make the best of situations as they arise.

Whilst the majority of photographers will never have the need to process their pictures on the move, it is a very useful skill to have. In particular, processing on the move allows a news picture with good sales potential to be fully exploited. News pictures have a tendency to date very quickly, and the speed with which a photograph can be delivered

Gateway to Chechaouen, Morocco.

to a paper or magazine can make the difference between a sale and a rejection.

Other Benefits

Processing film whilst on the move does have some other benefits. In many western countries there are clear advantages in using reputable laboratories to process film as soon as it is exposed, to produce maximum quality. However, in many of the countries I visit I rather doubt the quality of the colour processing facilities, and in some there are no facilities at all. Every situation and every country is different. If in doubt it is better to wait rather than risk spoiling the work. Nevertheless I often process a few rolls of film whilst abroad, as this allows me to preview some of the pictures and check how the film is responding to different environmental conditions. Processing on the move can also be a very useful check to see if the equipment is functioning correctly. Sometimes a camera malfunctions and the photographer may not realise until the end of the assignment when it is too late. Processing colour slide film is relatively easy, and if the time can be found to process random rolls it can avert disaster.

In many remote countries there are no colour processing facilities, and the photographer who carries enough chemistry to process a few films can not only gain one or two local clients, but can use

the processing to show off his skills. I have found this works well and frequently have been offered unexpected help as a result; the photographer who can produce work on location gains much respect. In one third world country, where I processed a few rolls one evening in a hotel bedroom, word spread so fast that I was an expert that local photographers started to bring me their problems! I traded advice for local news, which helped my picture making tremendously.

When I am travelling for a long time I carry English postage stamps. I then ask British people I meet en-route to hand carry a few rolls back home which, if they are properly addressed and stamped, can be ready waiting on your return. This is particularly useful for urgent news subjects. I have often telephoned magazines or telexed newspapers, then driven to the airport and handed the roll of film over to a British traveller.

Laboratories

When I was living and working as a photographer in Dubai, I had an agreement with one of the airlines and they carried all my colour film to Germany to be processed. In general, my experience with colour laboratories and their processing has been reasonable. Of course, accidents do happen, and on one or two occasions a fault in the processing equipment has caused me to lose quantities of important pic-

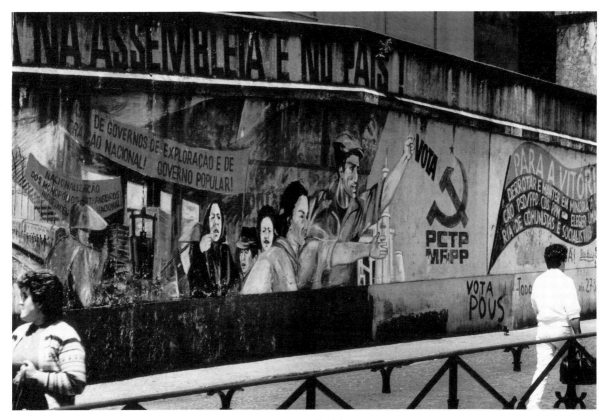

Political posters by the railway station, Lisbon, Portugal.

tures. One particular assignment comes to mind: I was working for a client in Oman, a British engineering company. The work was sent for processing to one of the biggest colour laboratories in the country, who successfully damaged every roll of film through a genuine accident. As a result the client paid a great deal of money for an assignment which, in the end, provided only two or three usable photographs. This situation is a photographer's nightmare; the client is left with no choice but to blame the photographer even if he had nothing to do with the loss.

The obvious answer is insurance, but for many part-time photographers the cost of insurance can be so high as to be impractical. It is only natural that the client in such circumstances, even if they know the photographer really well, will be bound to feel that it is the photographer who is at fault. In a way it is the photographer's duty to protect the client, but random equipment failure is something no-one can predict and it can happen to even the best run laboratories.

There have been cases in the past where both the photographer and the laboratory have shared in the cost of re-shooting the photographs. In one recent case the photographer, the laboratory and the client split the cost three ways. However, most laboratories operate exclusion clauses to protect themselves and are only likely to waive them if they value future business from the photographer or

the photographer has an important reputation; the laboratory may then consider it too damaging to their image not to assist. In the vast majority of cases the photographer is on his own, and therefore it is important to chose a processing laboratory with great care before submitting valuable, irreplaceable film.

Recently a few photographers have successfully sued for negligence, but such action can prove extremely costly and time-consuming. The majority of laboratories are very honest and run by people who have sympathy with the difficulties faced by the photographer, but the chances are that eventually every photographer who is taking large quantities of pictures will experience a serious loss. I now process all my colour slides myself unless the assignment is not that important. I prefer to be the sole person responsible, and not to let pictures that are my livelihood pass into other people's hands unless absolutely essential. It is easier to live with the knowledge that the mistake is your own than having to blame someone else. Processing colour transparencies is relatively simple and, with a little practice, most photographers find it easy to become proficient.

How Much Film?

Estimating the quantity of film needed for any assignment is always difficult. The number of photographs that will be taken depend on many

variables and it is often impossible to be accurate. My method is to work out the number of days I will be on location and how many pictures will be possible should conditions be perfect. I then add one or two days extra film supply and use this figure as the basis for estimating the total quantity of film I will require. It is better to have too much film than to run short on location.

In most countries, even if film is readily available, time is still required to find out where the best price, or reliable stock, can be found. In many African and Middle Eastern countries, the film on sale has been stored extremely badly and as a result may well have been ruined before it is even sold. I have often seen film on sale overseas that is three or four years out of date, and although most manufacturers do allow some leeway after the sell-by date, such film is not worth the risk. In one Middle Eastern country I saw film cooking in the sun on the airport runway; great cartons, hundreds of rolls, and no-one was sure how many days the film had been there!!

There are some times when even the best made plans go wrong and a photographer may have to buy a few extra rolls, even if the films' origin is dubious, or risk losing valuable pictures. I have bought many rolls of film whilst I was living in the Middle East, through necessity. Normally I shipped out my own supplies, but occasionally they would be held up and I had no alternative. I have lost quite a number of films because of unsuitable storage before purchase, so it is a little like Russian roulette – it is never possible to be sure that the end result will be worth having or not.

When travelling overseas I would normally, if conditions are perfect, shoot eight rolls of colour and eight rolls of black and white in any one day. This number of rolls does seem excessive at times, but there are occasions when I can shoot vast quantities of film if the subject matter warrants.

At one time, when I was in the Sudan, appalling weather conditions in England caused all flights home to be cancelled, and as a result I was stranded in Khartoum for three days longer than I had originally anticipated. However, I was able to make good use of my time by visiting and photographing the local museums. The photographs I made included pictures of Middle Eastern and African art, musical instruments, sculptures, paintings – all of these photographs have subsequently sold well. There are always photographs that can make useful additions to a travel library. As a result of the three day delay, I exposed all the film I had brought with me, with the last ten frames exposed in the aircraft during the return flight. These pictures have also been sold!

Closer to Home

Closer to home there are still many adventures to be had with a camera, and ones that can be extremely profitable too.

Amsterdam

A short while ago I was asked to illustrate an article I had written on Amsterdam. I occasionally write an article first, and only once it has been accepted for publication offer to illustrate the words. I already had quite an extensive selection of photographs of the city, but none that showed the blue skies which I felt the magazine would prefer. I therefore offered to return and take photographs 'on spec', without asking for guarantee of usage. Very often taking a gamble in this way pays off, but it is important to be sure of the type of photographs needed since the client is free to accept or reject the results. There are very few magazines who will specifically commission a photographer in Europe, especially a freelance. The picture libraries are filled with good quality European material, and a magazine buying from them can see the pictures immediately and is not dependent on the variables, such as weather conditions, that the photographer has to cope with.

In order to travel as cheaply as possible and limit the financial outlay, I approached British Rail, who were extremely helpful and pointed out a special offer for a day trip to Amsterdam. The total price of the journey from London to Amsterdam Central and back was just £27. As an added bonus British Rail were giving with each ticket a £5 duty free voucher!

I left London on a Sunday afternoon and spent the night on the ferry, thus saving the need for a hotel in Holland. Once on board the ferry passengers can buy a ticket for a berth, the cheapest being an additional £4, but as it was extremely warm, I spent the night on deck in a chair. The ferry arrived at the Hook of Holland early the next morning, and by 9.00 on the Monday morning I arrived at Amsterdam Central station.

I had brought a wide range of equipment, and on arrival that not needed immediately – my tripod and telephoto lens – I left in a left luggage locker. In this way, should I need the extra equipment, it would only be a short distance away, but I did not have to carry it around all day.

Amsterdam is a very small city and it is easy to cover the whole town on foot. The only difficulty I faced was the failure of the batteries in both my Canon F1 cameras simultaneously! My spare battery turned out to have been too long in my camera bag as well. I hadn't known that Monday is early closing day in Amsterdam, and reached the flower market just as it was closing. I had no alternative but to keep on shooting, and was only able to because the Canon F1 can take pictures at 90th of a second upwards without batteries. I know both my film stock and my cameras well enough to be quite accurate, and out of a total of 30 pictures

The Acropolis, taken during the son et lumiere which depicts the sacking of Athens.

taken in the flower market I only lost two through poor exposure. I did some bracketing anyway, as I often bracket for security in case anything should go wrong. When I had finished at the flower market I managed to find a photographic shop that was about to close, and at a vastly inflated price was able to buy a new battery (four times the current price in England).

If I had not made the effort the magazine would have found plenty of good pictures from a stock library, but my offer to go not only ensured the sale but increased my own library coverage. When I presented the work and told the editor that I had taken the photographs especially for him, he was most impressed. The editor told me that few photographers would have taken such trouble and taken the work so seriously.

One other problem I had in Amsterdam was the weather. Usually photographers complain of dull rainy weather, but in this instance my concern was too much sun! The good weather resulted in most people wearing very little clothing, but as the magazine is sold in the Middle East any photograph showing even a bare arm is frowned upon. The problem was compounded by the Dutch love of beer. Every second wall in Amsterdam carried a beer advertisement, but any photograph showing alcohol would never have passed the censors. Perhaps photographs showing people well covered,

and no beer, is presenting an unrealistic picture of Amsterdam, but these have been subsequently published in other countries where there are no restrictions on photographic content. I am therefore confident that the photographs did not really distort the atmosphere of the city by what they left out! Restrictions can spoil photography, but not always.

Athens

I was planning to visit the city of Athens and some of the Greek Islands for a holiday. Before I finalised my plans I let my contacts know that I was available to take photographs on commission, and was approached by a company in need of a picture of the Acropolis for the cover of a brochure. Had I thought carefully about the chances of taking a really good picture of the Acropolis in midsummer and at the height of the tourist season, I would have probably declined the offer!

Needless to say, when I arrived at the Acropolis the place was filled with tourists. My instructions were very specific; the inclusion of one or two people would be acceptable but the preference was for none at all. I had a major problem. Normal opening hours at the Acropolis had to be ruled out, and there was no hope of getting official permission to empty the place even for ten minutes, as it would probably have caused a riot! I was on the point of

giving up when I remembered that every evening a son et lumiere is held at the Acropolis. The arena where this is held is opposite the Acropolis on a nearby hill, which offered a good view whilst at the same time ensuring that the audience would be seated suitably far away from the subject.

I arrived shortly before dusk and joined a large number of English and American tourists already seated. There are three showings each night, one in German, one in French and the other in English, so deciding that I may as well understand the play whilst taking my photographs, I chose the English version. The Acropolis was quite a distance away, but I was able to fill the frame by using a 300mm lens, supporting it with a sturdy tripod. The moment the performance started I began to take pictures, and by using one of the aisles I was able to avoid heads obstructing the view and managed to achieve the photograph I had envisaged.

What was totally unexpected however, was the audience's behaviour, for as soon as the show started the entire crowd of around two hundred and fifty tourists began to blitz the Acropolis with their 110 cameras and small flash-guns, hoping to cover the half mile distance! One gentleman even offered to loan me his flash-gun as he thought I would not stand a chance with my tripod! The resulting photographs, of both the Acropolis and the audi-

ence with their cameras, have been very successful. One particular frame was exposed during the short time that the Acropolis was lit up with red lights signifying the sacking of Athens, and has been published in a photographic magazine in an article on the creative use of lighting!

Paris

France, being so close to England, is often regarded as having poor freelance opportunities, yet over the past few years I have had a series of photographic commissions covering most of the country.

Often when I have been in France the weather has been appalling. On one particular commission in Paris, I was asked to photograph the Pompidou Centre. The client did not have much of a budget, so we scanned the long range weather forecast before deciding when I should travel. The weather was important, as most of the photographs requested were not only colour but had to be shot outside. We chose a week when the weathermen promised sunshine and, as so often happens, the weathermen could not have been more wrong. I ended up in Paris during a week of torrential rain, so heavy that it proved impossible to get any depth into the photographs. The place was nearly flooded! I contacted my client, and although he understood the situation he also understood the limitations of

In the Louvre, Paris. Taken with the aid of a bean bag to avoid vibration on a long exposure.

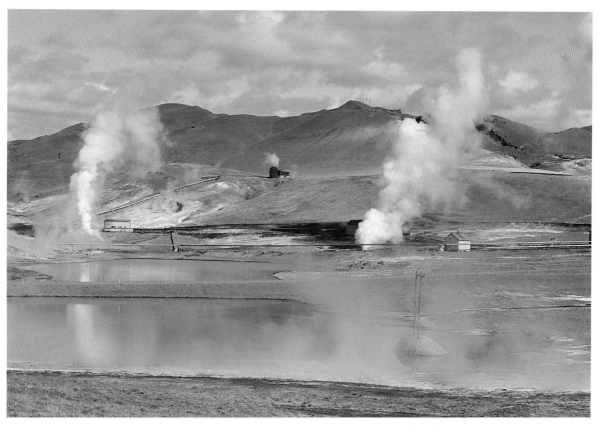

Geothermal plant, Myvatin, Iceland.

his budget and so gave me a maximum time limit of two days. The next day the weather was even worse, and in order to make any photographs at all I had to resort to fast film and accept the increase in contrast would inevitably mean blank skies. I spent a lot of time both inside and around the Pompidou Centre trying to work out a solution to the problems. The series of photographs of the outside did have the hopeless skies; more successful though was a series made in the transparent escalator that snakes up the facade of the building. These were complemented by some interior shots. Although the photographs definitely show problems, I was able to save the job and the client was reasonably happy in the end.

The following year I undertook another assignment in Paris that was equally affected by adverse weather. This time I was able to take advantage of a sudden break in a storm, as a shaft of light momentarily illuminated the Eiffel Tower. It was late November, the trees were bare, but the stunning storm made the Eiffel Tower look particularly special, almost as if it had been made from lace. I had only enough time to shoot three frames before the light disappeared, but given the chance I would have shot an entire roll. This picture is now one of my best-selling stock photographs.

Frequently when travelling I resort to sleeping on peoples' office floors in an effort to save money. When I was asked to photograph some of the wine

regions in France and Italy I hired a tent to save accommodation costs. One advantage of camping is, that with a little careful thought, you can pitch the tent in an interesting place so that when dawn breaks it is possible to roll out in your sleeping bag and take pictures without even getting out of bed!!

This particular assignment included visiting local Chateaux to try locally produced wine. Unfortunately the wine tasting proved a problem; as I progressed through masses of different vintages I found it increasingly difficult to focus the camera. I learnt a great deal about the wine, but had to double the length of time needed for the picture taking!

Sienna

Recently I received an assignment in Tuscany to illustrate a travel article on the region. Tuscany is a very picturesque place with very beautiful buildings; a place where the traditional life-style of the people has remained unchanged for centuries in spite of the area being a popular tourist destination. In Tuscany I found Italian people working and living in timeless settings.

In particular I felt great empathy with Sienna. The narrow twisting streets of the old city are very appealing and hard to resist, but the imagery of Sienna often proved too difficult to convey in a flat, one-dimensional photograph. The heart of Sienna

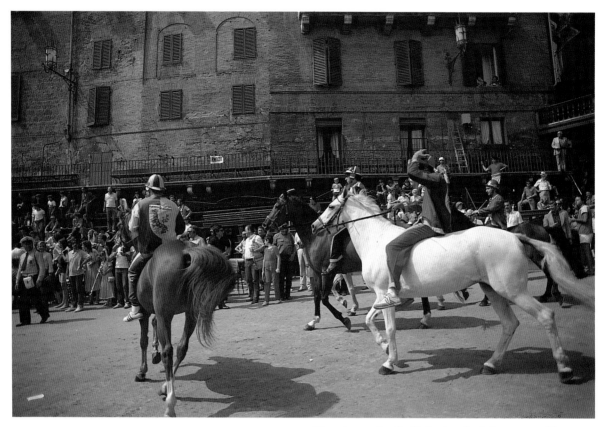

Warming up for the Paleo bareback horse race, Sienna, Italy.

is made up of little alleyways that are a photographer's nightmare; with blazing sunlight up above deep shadows form on the streets below, creating a tremendous contrast that films simply cannot handle. Even the most experienced photographer would have difficulty in coping with such extreme lighting conditions, which are critical for colour work. My assignment was exclusively colour, and many of the pictures I saw would have been totally impossible to photograph. Although I attempted quite a few only a handful were really successful. Those that worked have proved quite profitable, because if a photograph is difficult then all photographers will be facing the same problems.

The highlight of my Sienna visit was the Paleo, a spectacular bareback horse race run in the central piazza. Tickets to the Paleo are like gold dust; most are snapped up by local Italians and are hard for outsiders to buy. The Paleo is held twice a year and for several weeks beforehand the normally sleepy town of Sienna becomes a hive of activity. The town is divided into sectors, each having its own costume and flag dating back to medieval days. The race is taken very seriously and there is much bravado as each side tries to gain supporters and coerce opposing teams. Horses are taken into churches to be blessed, whilst people in medieval costumes dance and perform in the streets, trying to enlist support from passers-by. Large amounts of money are wagered on this race, and people have been

known to lose everything they own, betting on a fancied horse.

The Paleo is a race without any rules; anything and everything goes, all that matters is to win. On the day of the race crowds throng the square and the atmosphere is incredible as excited Italians jump up and down waving multi-coloured flags. Photography is difficult, and photographers have to fight their way through the packed square, some holding their cameras high above the crowd in the hope of at least getting a picture as the horses flash by. The most successful photograph I managed was extremely risky; as the riders were approaching a bend I jumped out and grabbed a single shot as they thundered by, leaping clear at the last moment.

Pisa during the summer is as hopeless as the Acropolis. I was unable to isolate the famous tower from the crowd of tourists, but did find that there was plenty of opportunity for candid photography. My best photograph of Pisa is of a photographer taking a picture of someone trying to 'hold up' the leaning tower; a favourite occupation amongst visitors, but one that always brings a smile.

Rome

I was recently able to take advantage of a cheap winter break in Rome, including flight, accommodation and breakfast for two days. In January even Rome can be cold and there is no guarantee

of good weather, but with a little luck the sun can shine and when it does Rome is at its best, with far fewer tourists than at any other time of the year. A previous assignment in Rome had been ruined when a group of Scotsmen wearing kilts invaded the Coliseum whilst I was working! However, a photograph of the Scotsmen was later sold to illustrate some of the problems faced by a travel photographer.

When I arrived in Rome on Friday the skies were grey, it was raining and many of the streets were flooded. However, on Saturday morning when I opened the curtains the sun was shining and the whole weekend turned out to be glorious. The only mistake I made was to visit Naples. Naples is a very depressing place, and many of the buildings are now derelict. The weather was also dull and depressing which made the town look even worse. I felt extremely uneasy walking around the streets with my camera bag. There were many unsavoury characters hanging around on street corners and the whole visit was most unpleasant. I have since been told that Naples has the worst crime rate in Italy. On one street, as I crossed the road, an Italian lady came screaming out of a side street, her hair covered in ice-cream, having been attacked by a group of youngsters. Before visiting a new city it is always worth asking someone who knows the area if there are any problems.

Nice and Monte Carlo

One March an editor rang me and asked if I could write and photograph a travel article on Nice. Unusually he guaranteed to give me three pages in his May issue, but the number of photographs would depend on the quality of those I took. After calculating costs, I worked out that if the magazine used eight photographs at their current rates I would break even. I agreed to go ahead, but I had to buy my own ticket and pay hotel costs as I would not be paid until the publication of the article.

March is a month of uncertain weather in Nice. I travelled with another photographer, arriving early on Saturday morning. As the weather was glorious we decided to start work as soon as we had left our luggage in the hotel. We walked around the entire town and even climbed high up into the surrounding hills to take photographs showing the town and the coast. By the time evening fell I was exhausted; I had shot a total of fourteen rolls of colour film and five rolls of black and white. That evening I felt confident I had safely 'in the can' most of the photography I would need for the illustrations. This was extremely fortunate as, when I woke up on the Sunday morning, it was pouring with rain. The article was successfully published with a total of ten photographs shot during that Saturday afternoon.

There was little point in staying in the rain in Nice so we took a local train to Monte Carlo, a journey of only half an hour. The weather con-ditions there were rather poor, with a few short bursts of sunshine in-between heavy rain. It was with extreme difficulty that I managed a series of photographs of both Monte Carlo and Monaco. When the Monaco article was published two and a half thousand words were used over four pages with twelve photographs, all taken during the short intervals of sunshine. I had needed two thousand words and eight photographs published to break even, and in the end achieved a total of twenty two published photographs and just over five thousand words.

Behind the Curtain

For a long time I had wanted to work behind the Iron Curtain to see for myself what conditions are like. I tried to find assignments that would justify a visit, but work for photographers in the Eastern bloc is not that easy to find. After much searching I managed to secure the photography for a travel brochure which would give me a reason to travel to both Romania and Bulgaria. The budget was very tight, but I wanted the experience and hit upon the idea that the trip could save me the cost of a summer holiday for my children, and in this way make the journey more profitable.

I was warned before leaving that I would find the Romanians distant and difficult to communicate with, but the Bulgarians, I was assured, were very friendly. It is strange how wrong people can be, because I found the Romanians to be openly friendly and much easier to understand than the Bulgarians.

Bulgaria

The visit began in Bulgaria, where I was based at a holiday complex especially designed for British and German tourists. It became quite clear after only a few days that what I had read in the press at home of two standards of living in the Eastern bloc was sadly true. The holiday village resembled a holiday camp and could have been anywhere in the world; it certainly had very few Bulgarian influences and was designed to cater for the visitor as if he were at home. There was virtually no contact possible between the tourists and the local Bulgarians. Those that worked within the complex served specific functions and as soon as their work was completed they left for home. My job was to take photographs that would entice visitors to this village and to the country.

It proved very hard to find anybody to hold a conversation with, and so learn more about Bulgaria itself. Most Bulgarians avoided contact with foreigners, and it was clear that most of those I did eventually meet did not know what to make of the tourists. Those that did make contact did so for specific reasons, such as offering to change foreign money on the black market. On arrival all visitors

**Policemen at the funeral of the mayor of Esposende,
North Portugal.**

are warned not to be tempted to illegally change money in this way, but current black market deals mean that visitors get up to twice the official exchange rate. Deals usually take place at night, and it is fairly common for dealers to substitute wads of cut newspaper wrapped up in a few notes for the actual currency.

The black market is not only restricted to currency but covers all luxury goods that are in short supply, such as stockings, cosmetics and clothing. The Government operates duty free shops in an attempt to recover the foreign currency it loses to local people, and in these shops items for sale include refrigerators, which certainly could not have been on many visitors' shopping lists! It would appear that items in short supply, such as refrigerators, are sold only for foreign currency, and although this is intended to recover the lost money from the Bulgarians it actually creates an incentive for the black market.

Most of the photography required for the brochure was relatively simple. The Bulgarians and Romanians in the holiday areas are clearly used to having their photographs taken by tourists and made no objections to being photographed, and were only too happy to help arrange difficult pictures. The main difficulty with the Bulgarians was their attitude. If a meal was served cold, which

it frequently was, the Bulgarians could not understand why the visitors were complaining; to them food was food, and a luxury at that.

I was warned by one of the Bulgarians working in the hotel that my room had been bugged. I was also told that I was being followed. I never noticed anyone tailing me, and although I searched hard I never found anything that looked remotely like a microphone. When I next saw the man I teased him, but he said it was normal procedure for all foreign photographers and journalists to be put under surveillance.

I was given plenty of fact sheets that contained Bulgarian propaganda. Mostly the claims concerned their achievements and were highly amusing – one leaflet claimed that the Bulgarians had invented the jet engine! Still, they are genuinely accredited in the West for inventing yoghurt.

The most interesting place to visit from the holiday village was Nessebar, an old Bulgarian town that shows the influence of the Thracians, Romans, Byzantines and Proto-Bulgarians. A hydrofoil service operates along the coast to the old town. The hydrofoil itself was very interesting; there were many notices on the side of the hydrofoil stating that it was made in the USSR, yet in the cockpit all the navigation equipment was made in either the United Kingdom or West Germany.

Street scene, Lisbon, showing the Elavador, the lift designed by Gustav Eiffel.

Romania

In Romania I was not as restricted as in Bulgaria, and was given the use of a car as I had to take photographs of several resorts along the coast. I used the car to explore several towns but found them rather uninteresting, mostly filled with utilitarian concrete tower blocks that did not lend themselves to photography. I photographed Romanian school children wearing bright orange school caps and walking in crocodile fashion down the road. The most successful photographs I made in Romania were undoubtedly of the people.

One interesting feature of my hired car was the lack of windscreen wipers; these turned out to be locked in the boot! Rubber is in short supply in many Iron Curtain countries and windscreen wipers are often stolen. Needless to say when it did pour with rain I was soaked whilst attaching the wipers, and not being a Romanian I forgot to take them off when I parked the car and so they were pinched anyway! Every little experience can lead to an interesting photograph. I have several pictures showing rows of parked cars with no windscreen wipers!

The market for material from the Eastern bloc is not very big, and most of the demand is for photographs taken in Russia. One or two pictures have sold because of their photographic content, but I have never made any significant sales from my Bulgarian and Romanian photographs apart from the original brochure.

When travelling in Eastern bloc countries be wary of x-ray equipment. Although most of the equipment is reasonably modern, in smaller airports the older equipment that ruins film is often still in use. At airports it is frequently difficult to find anyone to help, as there are few people able to speak English, and most Eastern bloc countries do insist on x-raying film.

The Modern World

A considerable part of my photographic income is derived from the sale of American pictures. Even the most well known of subjects, such as the Statue of Liberty, sell well. America – and New York in particular – is a great place to photograph. The skyscrapers make interesting geometric patterns and although other American pictures do well, I have found that the ones that sell best are those that show the American life-style combined with strongly geometric building patterns. These photographs seem to epitomise the American image.

New York

Even the most obvious pictures, if taken with superb lighting, always sell well. For example, those pictures taken from the top of the Empire State Building which always tend to be used as introductory photographs in articles on New York. Personally I find New York rather claustrophobic and prefer open spaces, but feelings such as these can be useful if the photographer is able to translate them into pictures. The majority of my pictures show people as small as ants scurrying about between the massive, towering buildings. The inclusion of people is useful in cityscapes in order to create scale.

New York can be very difficult to photograph though, as the effect of so many tall buildings is to block out sunshine from the streets. The contrast is as bad at times as the narrow winding streets of Sienna in Italy. Getting the exposure right for the top of the buildings often forces the photographer to sacrifice detail in the streets themselves.

During one visit to New York I received a commission requiring a series of photographs of Wall Street. New York's most important financial street is totally overshadowed by skyscrapers, and to complete the series I had to visit Wall Street four times during different parts of the day to try and get the lighting right. If the sun is at any angle other than overhead, the buildings cast impossibly deep shadows on the streets below. Midday was the best time for daylight photography, but the best of the photographs were taken towards dusk, when the buildings themselves were lit up inside and the receding daylight and the lights of the buildings were of about equal strength. The midday pictures, although they did do justice to the buildings, were still rather flat and dull. The bright sky made it difficult to retain colour in the brightly lit tops of buildings. At dusk everything was bathed in a gentle light and contrast was kept to a minimum, but the light was only at its best for about twenty minutes.

I also had a request to shoot a magazine cover illustrating the New York police. The photographs could have been arranged, but would have required considerable time to organise and gain the necessary permission. I decided to take a chance and see if I could find suitable material whilst walking the streets looking for other photographs. I made several photographs, but the one that became the

Double exposure of New York skyscrapers.

cover picture was the result of a chance meeting with a group of housing police. They were working on a recruitment drive and four officers were being filmed for a video. I started a conversation with them, but was not taken very seriously because my two children were with me! I gave the name of the magazine, and when they burst out laughing I realised that here was my picture. Crouching down low, I used a wide-angle lens and filled the frame. As I was about to push the shutter release I noticed that the building directly behind them had the words 'New York' carved into the stonework. I moved slightly sideways to get the sign above their heads, and this captioned my photograph. Self-captioned pictures always do well, as there is no need for words. This photograph successfully made the cover of *Police* magazine, whilst inside they used five other photographs I had taken during that visit. The pictures were subsequently published again in another country.

However, my favourite area for photography in New York must be Chinatown, where I love to photograph the people in the street; I find the variety of different faces fascinating. Chinatown has an atmosphere all its own, with hundreds of small shops with interesting names, such as The Coffee and Pastry Shop situated next to the Cheung Fat Company; these photographs always raise a smile

and have been used to add a little humour to otherwise serious travelogues.

Florida

In Florida I covered the opening of the Epcot Centre and wrote and illustrated a story about alligators, a story that started by accident. I overheard two businessmen talking about golf; one of them complained that the last time he played golf in Florida an alligator snapped at him from a water hole on the golf course. Golf has always seemed rather a dull game to me, and the thought of alligators in water holes rather appealed; this could add an interesting extra dimension to the game! Quite by chance I picked up a copy of a local magazine which described a new drive by the Florida government that extolled the virtues of eating alligator meat. It appears that alligator meat is low in cholesterol, cheap and extremely healthy.

During my stay in Florida I pieced together a story on the alligator. I visited the Gator Taster restaurant where I tried a 'gator steak'. The meat was, on the whole, bland and rather tough. Alligators are found in only two countries of the world. China and America, and are extremely well protected by law. The result is that their numbers have increased to such an extent that there are far too

Between the twin towers of the World Trade Centre, New York.

Street scene, Chinatown, New York – this picture has been used frequently because of the juxtaposition of shop names.

many of them, but they cannot legally be killed unless they are used to provide food.

Alligators were reported to be turning up in swimming pools, on golf courses and in general upsetting the local people. To illustrate the story I photographed people eating gator meat in restaurants, and alligators sun-bathing and swimming. One photograph has a sign in the middle of a lake saying that swimming is not permitted; around the sign are a large number of alligators. The final illustrated article was published under two different headlines, 'Other Peoples' Sunday Dinners', and 'Meals that Bite'.

Having read a great deal about Epcot, Walt Disney's 'third world', a technological world of the future, I decided to see it for myself. Epcot is an inspirational place for photographers, filled with strange-shaped, mirrored buildings and geospheres.

However, photography inside the buildings is difficult, and most of the displays are inaccessible. Visitors are transported through the buildings in small trains, and the lighting, combined with the motion, makes photography extremely difficult unless flash is used. Although the flash pictures were undoubtedly easier to make, they look very hard

and unreal; the best photographs were made using fast film and by bracketing the exposure whenever possible. There was no time for preplanning and most of the photography was largely a case of trial and error as I made my way through the confusion of images. The results show a reasonable cross-section of displays, but there were many which were lost through lack of time and through poor lighting.

One of the most requested subjects and one of the most difficult to illustrate is the future – future technology and future worlds. My Epcot photographs sell over and over again as illustrations of these concepts.

Epcot is divided into two halves; first is the exciting technological world which is housed in the futuristic buildings, whilst the second part is Epcot's world showcase, which I found very disappointing. The showcase is divided into small sectors in each of which there is a display of a country's culture, such as a mini Eiffel Tower built out of plastic for France; for Britain there is a plastic pub and telephone box. I went into the public house, where an American barman was selling ice-cold beer. Americans hate warm beer, but the barman did offer to warm the beer up for English visitors! I

Housing police on a recruitment drive, New York.

Waiting for passengers, ferry station, Macau.

made a few photographs but the whole thing looked very artificial and the photographs have a tendency to exaggerate the worst aspects.

The saddest part of it is that many of the American visitors actually believe that they have visited the country represented. One article I later wrote was largely about the American attempt to package culture in the same way as they do convenience foods.

Hong Kong and Macau

Sometimes the images that are used to represent a country are totally out of date, and so impossible to find when you want them. One editor specifically requested pictures of a Chinese sailing junk in Hong Kong harbour. When I arrived I discovered that this foreign idea of Hong Kong was totally outdated. None of the junks in Hong Kong harbour have sails; the sail has given way to fast outboard motors. Although I spent considerable time trying to find one with a sail they simply do not exist any longer. Hong Kong is one of the fastest developing countries in the world and pictures taken only two years ago are significantly out of date. Space is at

such a premium that even the newest skyscraper has a very limited life span before it is pulled down and replaced.

Without the Chinese signs Hong Kong could be anywhere in the world; it is a vast conglomeration of concrete and steel, resembling an American city more than a Chinese one. Hong Kong is one of 235 islands leased to Britain in 1898 for a period of 99 years, and because the lease expires on 1 July 1997 there is now a great deal of foreign interest in Hong Kong and the likely changes that could occur.

In order to get photographs that look Chinese the photographer has to leave Hong Kong island itself. Macau is only 40 miles from Hong Kong and a fast jetfoil service operates regularly. The journey takes only one hour, and in Macau the traveller can hire a mini-moke on arrival at the port. These are ideal for photographers as they have no sides, and make it easy to take a whole series of pictures whilst travelling around the islands and the mainland. There are two islands that can be reached by car, the first via a causeway and the second over a bridge. Although there are many places that photographers can visit, my best pictures of Macau were taken in a small village set back from the main road, which I discovered by sheer accident. The

Street scene, Taipei, Taiwan. Taipei is so congested that during the rush hour it is impossible to drive anywhere.

Fishing boats on the Suao Peninsula, Taiwan.

village consisted of a few houses, a couple of shops and a little ferry station serving some of the remoter islands. The people waiting for the ferry boat and those I photographed in the village appeared untouched by the modern world. The photographs could have been taken a hundred years ago, and form a remarkable contrast with those taken in Hong Kong. They illustrate two completely different Chinese worlds, close together yet miles apart.

Hong Kong. View from the peak over central district and Victoria Harbour – in the background, Kowloon Peninsula.

Be Prepared!

Once the photographer has chosen a destination, he should spend some time researching the culture and environment of the area, and also plan an itinerary which, ideally, should be kept reasonably flexible. It is vital that research is carried out into the country's customs and regulations – many countries operate restrictions which could affect the photographer. A few simple enquiries beforehand can save a lot of difficulties later.

Customs

Probably one of the greatest worries for any travel photographer is what will happen when passing through customs check-points. It is always worth checking just how much film and how many cameras are allowed to be imported into different countries, and under what circumstances. For example, Ethiopia at present has severe restrictions unless prior permission is sought. I have seen photographers have their cameras impounded by customs until they leave, often defeating the purpose of the visit. In some countries one camera and two or three rolls of film is seen as the normal requirement for the visitor.

It is advisable to prepare a list of all cameras and lenses and take a few copies. One copy can be deposited with British customs on leaving, and other copies can be used when necessary throughout the trip. A list can be useful when leaving a country or at any other time when there is a need to prove that the equipment was imported with you – this can avoid long discussions over the cameras' origin.

On a recent visit to Jordan, the customs officials wrote the serial numbers of my cameras and lenses in Arabic in my passport; this was done to ensure that I re-exported the equipment and did not attempt to sell it during my stay, as cameras fetch high prices in Jordan. Since then I have been to several other Middle Eastern countries, and they have noted with appreciation the Arabic numbers in my passport. However, it is also fortunate that none of the immigration people have checked the numbers against the bodies because the Jordanians got a little confused and wrote the lens numbers down instead of the body numbers!

In other countries, notably the African ones, customs officials are prone to be suspicious about a photographer's intent. It is always a good idea to carry any paperwork that proves the camera equipment was bought at home, whilst letters from any interested magazines can help to prove the purpose of the visit. Customs officials can make life quite difficult if they become suspicious. I always try to obtain one or two letters from sponsors, especially those that are non-political, and from any

Cafe, Barcelos, North Portugal.

publications who are in need of pictures, before I go.

It is also best to avoid, if possible, having 'journalist' or 'photographer' written into a passport as your occupation. Immigration officials in many countries often react strongly to the word 'journalist'. In my own passport my occupation is described as 'designer'.

X-Rays

X-ray machines are a continual source of anguish for anybody who takes photography seriously. Despite the common myth that modern x-ray machines do not harm film, they can and do. At the very best the effect of the new breed of 'safe' machines is cumulative and takes several passes to cause damage. At worst, the operator can turn up the power should it be suspected that something is concealed inside a bag; anyone who has ever watched a camera bag being x-rayed will realise that the bracket of a flash-gun can resemble a weapon.

In Europe the majority of countries offer to carry out a hand-search for professional photographers. It is generally accepted that the highest ASA film is the most susceptible to damage, and many countries now display notices saying that if you have 1000 ASA film it should not be put through the x-ray equipment. However, it is frequently necessary to

be insistent. Usually the photographer who insists long enough will eventually be hand-searched, and most officials are amenable when they realise they are dealing with a professional. The only exception in Europe I have found is Brussels, where only 1000 ASA film will be excluded from being x-rayed. No doubt there are many who would probably not notice the difference caused by slight x-ray damage, even if the film has been screened several times, but the best answer is to avoid as many screenings as possible and if the film is screened, to use it up quickly and not allow it to be screened any further.

The majority of photographers do not help customs officers; they expect it to be their right to be given a hand-search on demand. If a photographer is patient and waits until the customs officer has time, there is usually no objection and officials are far more co-operative. Where possible carry sealed film – i.e. packets of ten sealed by cellophane – because it greatly reduces the amount of time needed for the hand search, although at Gatwick recently all my cellophane was undone and random film boxes checked. Keep all film in a carrier bag on top of the camera equipment, to allow the equipment to go through the x-ray, whilst the film can be hand-checked separately.

In Paris recently I had a long argument with an officer, after which he reluctantly agreed to hand-search my camera bag. The one worry he had was

Reflected people and buildings in the fast developing financial district of Hong Kong.

Grandmother and child on the Ali-Shan narrow gauge railway, Taiwan.

my bean bag. Not many photographers carry bean bags, and of course he asked me what it contained. Trying to tell a non-photographer that the bag contains a pound of chick peas and that it was used to support the camera during long exposures, did not help matters. He became furious, as he thought I was making fun of him, and in total disbelief he x-rayed the bean bag!

I had a near-catastrophe at Gatwick at the beginning of one of my visits to the Sudan. I was very short of time and had foolishly decided to carry my black and white film in a 30 metre roll. The customs officer had never seen a 30 metre roll of film before and decided to open it. As he was about to expose my entire black and white film stock I created quite a fuss, and pointed out that the tin had on it a warning 'to be opened only in total darkness'! Disgruntled, he took the roll of film off to check with his supervisor, and I had no way of knowing what happened to it and if they had fogged the entire 30 metre length. Had they opened the container I would have lost all my black and white pictures, and there was no black and white film available in Khartoum at the time. In the end it turned out to be perfectly alright, but I had to work for ten days not knowing if I was going to lose my work or not. It is not worth the risk of carrying film in bulk!

Outside Western Europe, the problems with customs officials become far more acute, and many third world countries still operate antiquated x-ray machines which are capable of wiping out film altogether. Recently I heard of a professional photographic team who were on assignment in the Soviet Union, and on their way through one of the smaller internal airports all their film was exposed to x-ray. The only pictures that survived were those still in their cameras. They lost 500 rolls of exposed film and six months work! Photographic experts who examined the film estimate that a 2″ thick lead sack was the only way these films could have withstood the strength of the x-ray used.

Will They Search or Not?

Unfortunately, with so many extremists hijacking planes, it is essential that luggage be thoroughly checked. In the past, people posing as photographers have carried dangerous weapons onto aircraft. The safety of air travel depends on the efficiency of the customs officials, and understanding this makes it easier to appreciate their point of view. I personally wish that all customs officers made no exceptions and thoroughly hand-searched all photographers' equipment every time – after all, my life may depend on their efficiency.

On one trip, I arrived in a country just days after a major terrorist attack on an aircraft. I requested a hand-search and was told to stand to one side. I was absolutely shattered when the customs official waved me through; he could not even be bothered

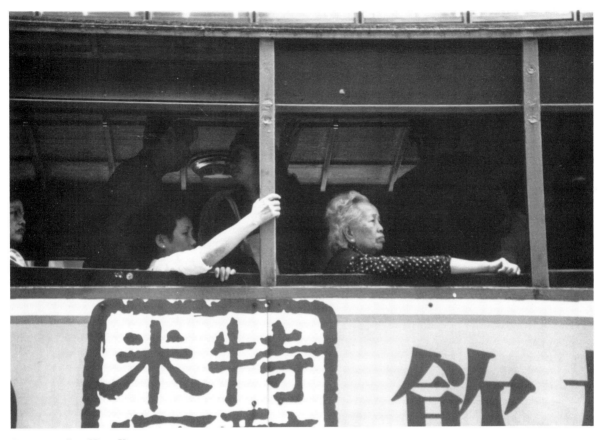

Passengers in a Hong Kong tram.

to look inside my camera bag. Even though my film had escaped the x-ray, such instances are of no comfort to the regular traveller. This was not an isolated incident. Two years ago, following an attack in a Middle East country which had cost many lives I was relieved to find that security had been doubled, or even trebled, yet the same apathy prevailed and my unsearched bag was handed over all the x-ray points. When leaving another country recently, passengers were escorted under armed guard to the check-in and only allowed to enter the terminal once the plane had been called. Three x-ray points had been set up to examine passengers' hand baggage. The first was positioned in the entry hall, another was positioned by the main entrance before entering the customs hall and the last before boarding the aircraft. In all three cases my camera bag was lifted over the x-ray machine and nobody even bothered to look inside!

Under IATA regulations all countries should x-ray suitcases before they are loaded onto aircraft. One airline that I was working with told me to put my film inside my suitcase because the particular airport I was passing through did not carry out such checks, despite this being contrary to all the international airline agreements. They also told me that another airport was operating the same procedure, so on my return through the second airport

I loaded 60 rolls of exposed film into my suitcase. However, when I arrived at the check-in desk suitcases were being x-rayed in front of the passengers, and I was forced to open my case in the middle of the check-in area. It was well packed, so when I undid the catches rolls of film shot all over the airport floor and there was a scramble as passengers tried to help me retrieve them! I was extremely lucky that the suitcases were being checked in front of passengers; had the check been carried out, as it often is, as they they are being loaded onto the aircraft, I may well have lost all my films. I never pack films in my suitcase anymore, as it is not worth the risk.

In Africa many of the machines really are very old, and at many small internal airports these can present serious problems for travelling photographers. On one particular trip, I spent nearly half an hour trying to save my film from a really lethal looking x-ray machine. There was no way I was going to be allowed to by-pass the equipment, when suddenly a passenger in front of me tripped over the cable and accidentally unplugged the machine. Immediately armed police surrounded the remaining passengers, and we were all forced to undergo the hand search I had requested in the first place!

On one recent trip I calculated that I had to deal

with eight separate x-ray checkpoints, and this is when the cumulative effect really becomes serious. Leaving the United Kingdom I was hand-searched at Heathrow, again as I left Schipol in Holland and again on leaving Taipei when I flew to Green Island, a small island in the China Seas belonging to Taiwan.

On the outward journey, the passengers had been allowed to remain on board at Bangkok while the plane was refuelled and cleaned. On the return journey however, it was decided to facilitate the cleaning of the cabin by asking all passengers to leave the plane and wait in Bangkok's transit lounge. It was requested that we take all our hand baggage with us. I found myself struggling with a heavy camera bag in the early hours of the morning, and as we arrived at the entrance to the lounge, all the bags were being x-rayed. The customs officers were very sympathetic, but insisted that it was their duty to x-ray all my hand baggage, and that included all my films. I asked if I could be allowed to return to the plane; this they said was impossible. I explained that the photographs were for an educational children's book, and that whilst their machine might not affect my film on its own, I had other checkpoints to pass through before I returned home. Eventually, after sitting down and refusing to move for half an hour, I was allowed a hand search. I only just made it in time to reboard the aircraft.

The next airport was Schipol, and again they were insistent on x-raying the films. By now, however, I was suffering from lack of sleep and jet-lag, and kept dropping my hand baggage, and I think in the end the customs officers felt sorry for me. In any case they could see from the hundreds of rolls of film I was carrying that I was a professional. Some photographers use protective film shields, and although these are a good idea the number I would require would make my bag much heavier, and as I often have to carry my cameras and films long distances I try to keep weight to the minimum. Film shields are designed primarily for small quantities of film and do not prevent a curious inspector turning the power of the machine up to see what is inside, thus rendering the shield ineffective.

Medical Requirements

Some countries require certificates of immunisation against specific diseases, such as typhoid and cholera. A telephone call to the relevant Embassy, or to either the London School of Tropical Medicine or your general practitioner, usually produces the necessary information. Even if a particular vaccination is not strictly required, it may well be desirable.

During my travels I have come across British people hospitalised for both cholera and typhoid, and in nearly every case the person was so unwell

Contra diction, Soho, New York.

Taiwanese girls at the hot springs at Shippen, Taiwan.

that they were unable to return home, particularly unfortunate when medical facilities are very often considerably less advanced than in Britain. Many photographers who travel frequently find it easier to have their vaccinations 'topped up' regularly during the year rather than face a battery of injections immediately before a trip. Occasionally a person reacts badly to vaccinations and finds that they feel unwell for some days afterwards. One colleague of mine had such a bad reaction that he had to cancel his proposed trip, as he could not even carry his camera bag.

On one occasion, through lack of time, I failed to 'top up' my vaccination, and during my stay in Greece there was an outbreak of cholera. In order to be allowed to return home I had to have the vaccination at the airport. The outbreak created a shortage not only of vaccine, but more importantly syringes, and although these days most infected areas normally use vaccine guns, there are a few that still use old fashioned syringes. It is much better, whenever possible, to have vaccinations at home.

If you do fall ill and require medical treatment get in touch with your Embassy for their guidance; they will know the best local places for medical advice. Many countries do not have the facilities to test blood, and many other facilities which we take for granted at home are non-existent or totally inadequate in many other parts of the world.

Basic Research

Looking at published photographs from a country can be a useful indication of photographic possibilities. Travel sections in many libraries are decidedly poor, but they often have a facility which lists other libraries' selections in the area and, for a few pence, a book can be ordered. Make careful note of any special events that occur during your stay, and the areas that appear to be most interesting. Also buy a detailed map of the country and area you are visiting. Many major book shops stock a wide selection of maps, and can order on request other maps which are not in stock. Visit airline offices, travel centres and embassies in search of information about local events and places worth visiting. Look at brochures from holiday companies and tour agents, partly because they show photographs, but also because after the trip there may even be a possible sale there if you can improve on the illustrations shown. In the local reference library check newspapers for any recent news stories from the country; there may be a possibility of a follow-up piece or photograph. Once all the information has been collected, a list of possibilities can be drawn up and a feasibility plan can be made. On every trip there will be places of interest that will have to be missed through lack of time, or perhaps accessibility – either too far to travel, or if permits are required. Too much valuable time will be wasted if the photographer travels vast distances in search of a single photograph.

Shooting on the Move

Travel photographers are often rather solitary individuals who see life in terms of photographic potential, and whose greatest pleasure is the excitement of capturing their own personal vision on film. This can make them singularly unsociable! Non-photographers often complain that they cannot understand the need to return to a place already visited, simply to achieve different or better lighting.

Photographers will forgo many pleasures offered to them on their travels, preferring to continue with their solitary work. However, some people like to travel 'en masse' on photographic holidays or safaris, but to travel this way requires infinite patience and a need to always respect other people's pictures. There is nothing more annoying than to have another photographer walk into frame just as you release your shutter! I prefer to travel on my own or with one friend, because I am far from patient. Photographic holidays however, do have some good points – as they are mostly organised for photographers by photographers, special facilities are often 'laid on' for the party.

An experienced travel photographer knows that from the moment he steps out of his front door there will be photographic opportunities, and one does not need to wait until actually reaching the destination; the journey itself can produce interesting photographic opportunities. I always like to arrive early for my flight, not only for immigration checks but because very often there is a choice of seat. Whenever possible I ask for a window seat, because in-flight pictures are useful as introductory photographs for travel articles as well as having a market of their own. The best pictures are usually taken immediately after take off and just before landing, because of the aircraft's height. Once the aircraft has reached its cruising altitude, the land below or the sea is not usually visible, obscured by haze and clouds. The best seat to have is one on the side away from the sun, as the windows on most aircraft are scratched and prone to show reflections. Keeping the camera as close to the window as possible but without touching it, choose a camera speed of at least 1/250th to avoid vibration from the aircraft. If you can, find somebody to hold a jacket or coat behind you to avoid reflection from inside the plane; this can help. Polarising and UV filters can be used to increase clarity, but on some types of window the polarising filter has given me problems, reflecting a rainbow of colours.

Some countries do not permit photography from aircraft during descent or take-off. These countries include Saudi Arabia and North Yemen, but normally the airline crews announce restrictions over the aircraft's public address system. When such warnings are given it can also be taken for granted that no photography will be allowed at the airport until you have passed through customs. It is better

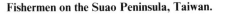

Fishermen on the Suao Peninsula, Taiwan.

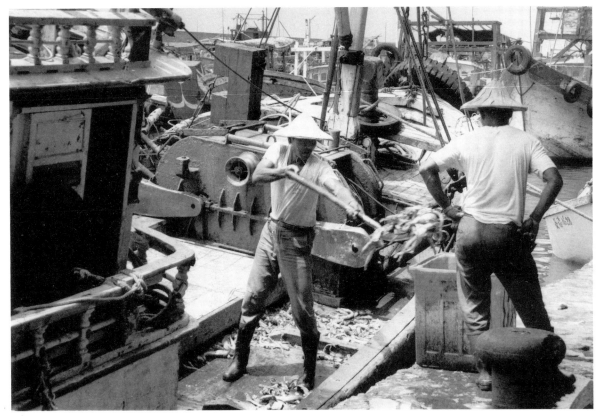

to ask before taking a picture – many photographers have been arrested before they even enter the country!

Local transport within a country by train or bus can produce some extremely interesting images which tell much about the people, their life-styles and the landscape. Of course photography whilst on the move requires fast reactions, but is not impossible. Film is relatively cheap; the biggest expense of any trip is always travel and accommodation. One frame of a film costs comparatively little, so wasting film is better than missing opportunities. Again, wherever possible, try to secure window seats. Before deciding where to sit on coaches or buses check if there is an opening window – it is often possible even in air-conditioned coaches to find a small window that can be opened. Keep the camera on an average setting. The best shutter speed is dependent on how fast the bus or train is moving – sometimes 1/500th is sufficient; at other times 1/1000th will be necessary. I always carry a few rolls of fast film especially for this purpose.

Focusing a camera from a moving vehicle takes practice. A 50mm lens focused on infinity is easier to handle than a telephoto, but the telephoto does have an advantage – the ability to cut out the fast moving foreground. A fast telephoto zoom will also allow for composition if there is enough time. My first attempt at photography from a bus was dreadful; out of two rolls of film there were only two usable frames! Since then, with a great deal of practice, my reactions have improved and I tend to use a combination of lenses.

On a recent trip across Jordan, I found that when the coach slowed down in the narrow streets of small towns it was also useful to have a wide-angle lens, and this was one of the few occasions when I found the automatic facility on my camera useful. The automatic setting gives greater control in fast changing light conditions. Automatic exposure leaves the photographer far more time for composition and allows faster shooting. In open countryside I prefer to use a medium range zoom to allow more manoeuvrability with the image.

On one occasion a coach journey across Sinai gave an opportunity for pictures of the oil rigs just offshore. As our schedule was very tight the bus was unable to stop, but I managed to persuade the driver to open the doors, and wedging myself in the doorway I was able to take twelve photographs with the 70–210mm zoom. Six were hopelessly unsharp, and of the remaining six, two were badly framed, but two were perfect and both have been published. I always work on the premise that it is better to have a go and fail than not to bother at all.

In North Yemen I made a journey by car across the entire country, and in one small town I saw two ladies with striking red head-dresses having a tete-a-tete on a street corner. At the time, my companion told me, we were driving at 50km an hour. I saw

them in the distance and was able to pre-focus, and as we passed by I shot two frames in quick succession. The first totally missed, but the second was very successful. Sometimes none of my pictures taken at speed are worthwhile, and this sort of photography does require a certain amount of luck, but on the whole I would estimate that one in four photographs shot on the move are usable, which is not a bad average.

Look out for News

When travelling in remote areas always be prepared for the unexpected event. In most Western countries the news networks are very efficient, and there will be very little opportunity for most visiting photographers to take news pictures. Large picture agencies and local newspaper photographers will have syndication facilities world-wide, but there are occasions when the photographer finds himself the only person available to take the picture; this happens most often in remote areas. Many experienced freelance travel photographers pick up useful sales in this way.

Over the years I have covered many news stories for national newspapers in the remoter parts of the world where there are no established news services. Before departure I telephone my contacts in this country to let them know my travel plans and, where possible, give them contact telephone numbers so they can leave messages for me. If a good story develops I telephone the paper, a copy writer takes down my story and if I have been lucky and found someone travelling home who can take the film or pictures, let them know the flight number. If the story is important enough they will send a courier to meet the person on arrival at the airport. Getting the photograph back in time is very important, and I will send undeveloped rolls of film if I have no way of processing them; the newspaper can always handle the rest. Occasionally, it can take days to get a telephone call through, and the only consolation is that it will be taking days for any other news person as well! Still, very often stories will die before they are used, simply because the story is too old when it finally arrives.

When a photographer/journalist becomes well-known at a newspaper, and has had successes in sending material back, the paper will frequently pay for a story even if it cannot be used.

Occasionally, if the paper deems a story to be important, they may even offer to help meet some of the costs involved in securing the picture. One word of warning though – always be certain of the facts. If a paper is persuaded that something is true when it is not, they will never believe that photographer again. Likewise if the photographs are substandard it will be remembered, and there are plenty of good photographers around who will be happy to take on the work – there are few second chances in travel photography!

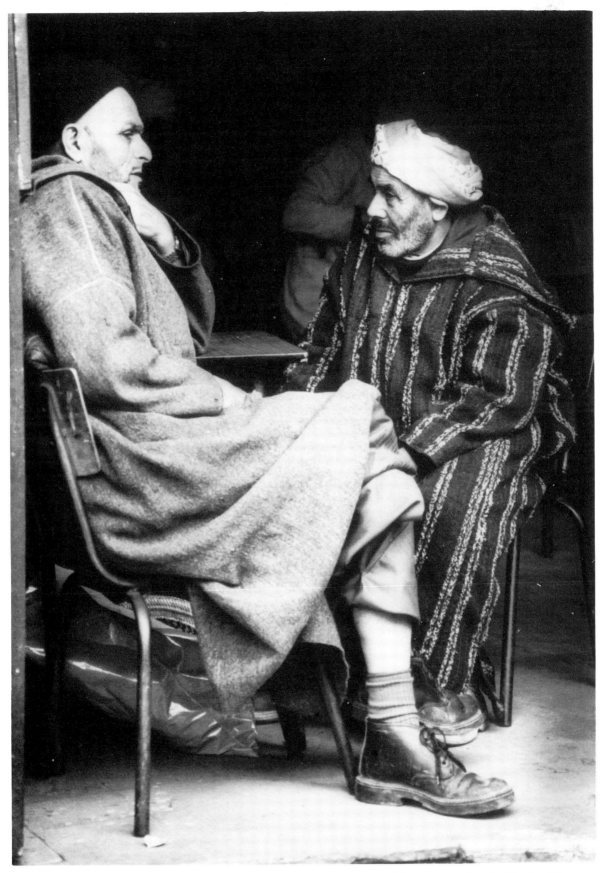

Moroccan men in cafe, Tangier, Morocco.

Danger and Disaster

Photographers who travel regularly realise the importance of safeguarding their equipment, are aware of possible dangers and know that a little forethought can avert a major calamity. No photographer is immune from having a crisis on their travels, and how they deal with that crisis can have a great deal to do with the amount of experience that person has. Experience is a great teacher, and once the crisis is over most people will have learnt something, even if it is only how to stop the same thing happening again. There are, however, those trips which cause even the most experienced photographer's hair to turn white.

The very worst thing you can do in a difficult or dangerous situation is panic. Usually, even with a serious disaster, with a little thought you can still save at least some part of the assignment. Keeping calm is important, since stress will only harm you and not sort out the problem.

There are so many different things that can go wrong in so many strange situations that it would be impossible to document every one, but most disasters tend to fall into one of several main groups.

Theft

Theft is perhaps one of the cruelest blows; to lose all the equipment at the outset of an expensive expedition can be heartbreaking. A keen photographer does not stop seeing photographs simply because he no longer has a camera, and each image seen will only heighten the feeling of distress. The simplest solution is to take out a good insurance policy, one that comes under the 'all-risks' category and replaces old equipment with new.

If the photographer loses all his equipment he may be able to buy more during his travels. Whether this is worthwhile will depend on how important the assignment is, how much money he has had to pay to enable him to travel, and lastly, how much duty he will pay when reimporting the new equipment back home.

If the photographer is in an EEC country he will be allowed to bring into England up to £250 worth of goods without paying any duty. However, he will probably find that he will have to pay Value Added Tax or its equivalent when he is buying the goods, and further VAT may be charged when declaring the new equipment on arrival back home. It is possible in some EEC countries to obtain a form from the retailer that exempts the photographer from paying VAT in the country of sale. This form is then stamped at the airport on re-entry into the United Kingdom. Unfortunately it is not always possible to obtain the form at the time of buying

Tribesman, Northern Sudan.

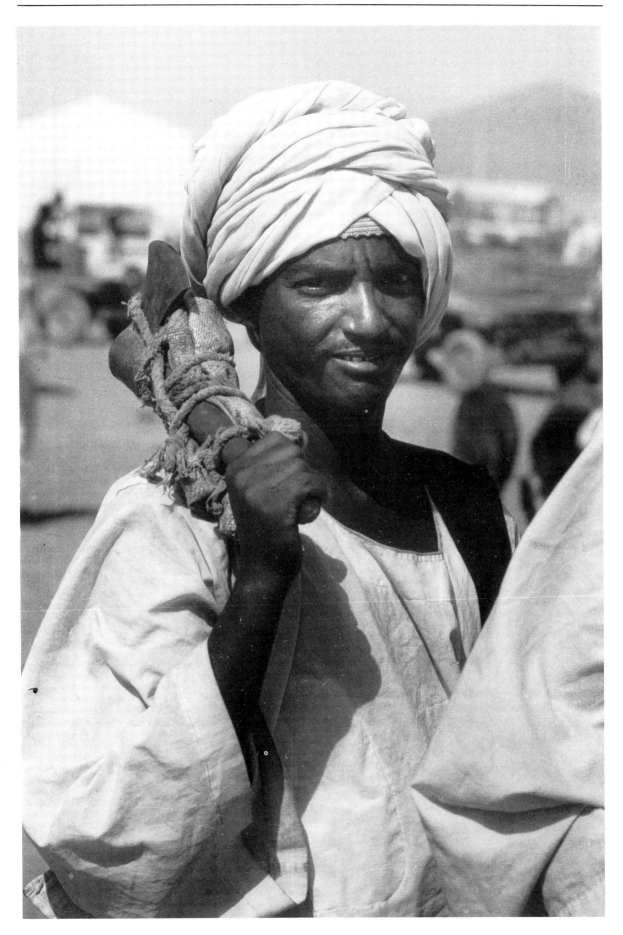

Practising Tai Chi, Taipei, Taiwan.

equipment, but if this happens the photographer can still claim back the VAT from another EEC country, from the United Kingdom. It should not be necessary to pay VAT twice.

The problem is worse for those travelling in non-EEC countries; those returning home from a non-EEC country are only allowed to bring home £32 worth of goods duty free. Any other goods bought above this amount must be declared and import duty and VAT paid on entry. Although this sounds pretty disastrous for the unfortunate photographer who has had his camera stolen, where the photographer is at the time of theft can make all the difference. Many countries, such as in the Far East, sell camera equipment far more cheaply than at home, and as import duty and VAT is based on the price paid, the photographer may well be able to buy his replacement equipment, pay the duty and VAT, and still end up saving money on English prices! In other countries, the price may well end up the same as in England.

The photographers that will lose out are those working in countries where equipment is far more expensive than in the United Kingdom. In this case it may well pay to return home to buy the replacement equipment, before returning. If the photographer is insured he could buy his replacements overseas, pay duty and VAT on entry, and then claim on his policy. The final decision on whether to buy or not could also be dictated by the value of

the photographs that will be lost if the photographer does not replace the equipment and abandons the assignment – although this will be harder to quantify, it is an important consideration. If the photographer is on commission when his equipment is stolen, it may be preferable to pay higher prices rather than risk losing the commission. Of course the photographer may decide to replace only the equipment essential to the completion of the job in hand and replace the rest on his return.

Taking Precautions

I tend to be very cautious with my equipment until the journey is completed. I often ask for my cameras to be put in the hotel safe if I do not need them. I have often been made fun of by co-travellers when I insist on never being parted from my camera bag. Even when I am a guest in a restaurant, my equipment is under the table and never away from my side.

On a recent visit to Jordan, I was travelling in a coach with fourteen tour operators who were evaluating the possibilities in Jordan for British holidaymakers. On our schedule was a visit to the famous Nabatean city of Petra. After a long journey the coach pulled in at a guest house where we were given an opportunity to use the rest-room. I instinctively picked up my camera bag before leaving the coach. Our guide immediately told me

to put the bag down as the cameras would be safe on the coach. My non-photographic companions started to laugh when I still insisted on taking it with me. The last laugh was mine because, when we returned to the coach, it had gone and so had everyone else's cameras! In fact the driver had decided to refuel the coach and the cameras were safe, but as time was short we could not wait for the coach to return. As a result I was the only person in the group that was able to photograph Petra. As an added bonus several of their companies bought my photographs to replace the ones their representatives were unable to make!

Designer bags that advertise their contents are best avoided, as they increase the risk of theft. My own bag is 'tatty' and well worn. I also try never to carry equipment around that I will not need; any extra equipment that is not essential for the day's work is left where I am staying locked in a suitcase.

Most insurance companies require that the photographer informs the local police when equipment is stolen. This does not present too much difficulty when the photographer is in a large town or city in the Western world, but there are occasions, when travelling the remoter parts of the world, when the nearest police station could be many miles away. If the piece of equipment is not that expensive, the valuable time lost must be taken into account.

Losing Money

Once, travelling miles from anywhere in the Sudan, I lost some money. The thief was very considerate, though, leaving me just enough to return to the airport. I told a Sudanese friend that most of my money had been stolen, but that the thief had left a little; my friend explained that in the Sudan this was normal. The area where the theft took place is poverty stricken and it is hunger that usually drives people to steal, but they often worry about their victim and so leave a little behind. My friend wanted me to report to the nearest police station, but this would have meant my travelling to the nearest large town which would have taken a few days. I decided that since the amount was relatively small and I still had sufficient funds to return to Khartoum, I would not waste the last few days of my trip.

On my return home I telephoned my insurance company and asked if I was covered. I explained the circumstances, they accepted the difficulty in

Shark fisherman and boat, Ras al Khaimah, United Arab Emirates. Ras al Khaimah has the largest shark fishery in the world; the fins and tails are dried and exported to the far east to be used in medicine.

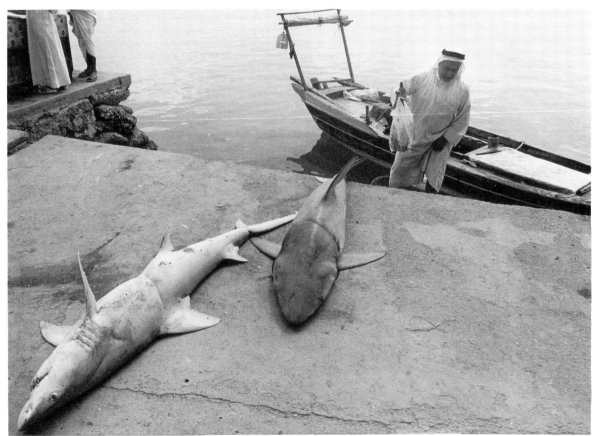

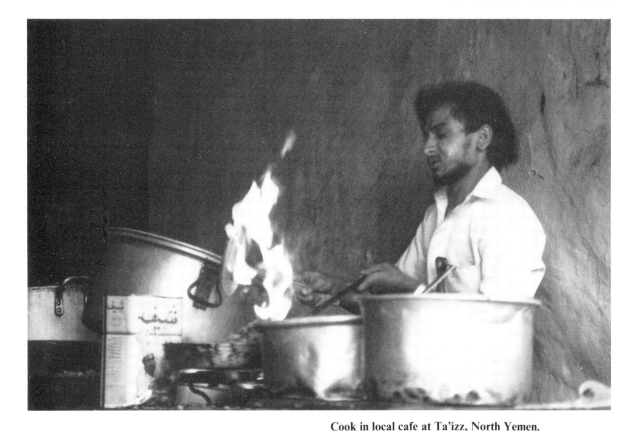

Cook in local cafe at Ta'izz, North Yemen.

reporting the theft and I was repaid in full. On the whole, insurance companies are really quite reasonable, but do check that your policy covers all risks and if there are any exclusion clauses.

Care of Film

Camera equipment is relatively easy to insure, but rolls of film are normally only insurable for the cost of replacement and not for the pictures they contain. Towards the end of an assignment the rolls of exposed films are often more valuable to the photographer than his camera equipment. There are special insurance schemes that cover this, but these do tend to be very expensive. There could be circumstances where the photographer is on commission and the company commissioning the project may agree to take out a policy, but they will only do so if the loss of photographs will cost them more than the insurance. It is my experience that most companies do not bother. I always, as a matter of course, point out the insurance problem so that the company is made aware of the cost of insurance and that, as most often happens, the money being offered for the work is not enough to meet that cost. In this way, should anything happen to the films, the company has been forewarned. On my return

journey I take great care of my film; I can always replace camera equipment, but with all the work completed the film becomes extremely valuable. I carry the film with me and never let it out of my sight until I am safely back home.

Passports

Losing a passport can create many problems. How it is lost is of no real importance, but without a passport the photographer may find that he is stranded overseas unable to return home, possibly unable to cash his travellers cheques and with mounting accommodation costs. The best advice is always to contact your embassy or consulate. In a few places, owing to unfortunate political situations or diplomatic difficulties, there may not be an embassy or consulate, but when this occurs it is normal for the British government to make arrangements with another neutral or friendly embassy to take care of its citizens' interests. In these exceptional circumstances the best solution is to contact any embassy, since all should know who is representing the interests of British citizens.

Avoiding Arrest

Occasionally, photographers can upset local

Unusual rock formation, Yehliu National Park, Taiwan.

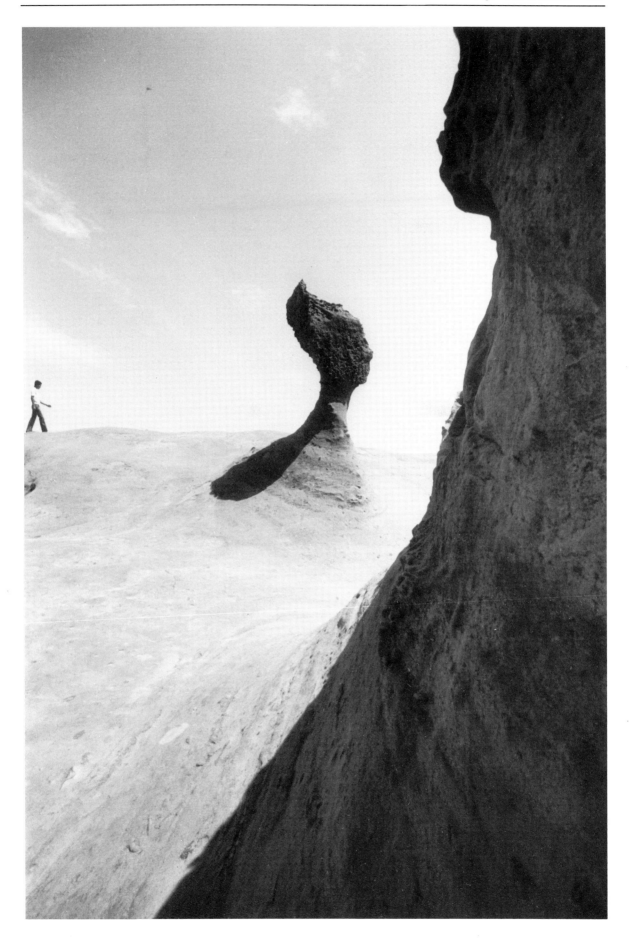

The Trump Tower, New York.

officials. The most common cause is when a pho-
tographer either knowingly or unknowingly takes
photographs in a sensitive area. In most countries
the authorities issue visiting photographers with a
list of 'sensitive' subjects, and erect warning notices
near any installation or area they deem to be sensi-
tive. In some countries the sign used shows a camera
with a red cross. There are usually two signs – one
at the beginning of the sensitive area and another
at the end – and between the signs photography is
not permitted. Unless official permission has been
granted it is only an extremely brave or foolish
photographer who will try to sneak a photograph,
since one frame could cost him at best his roll of
film, and at worst, his freedom.

The restrictions vary tremendously from one
country to another. In Zambia, for instance, *all*
public buildings are restricted. Although most
countries do make an effort to notify visitors of any
restrictions, sadly this is not always the case and
innocent photographers have run into trouble
taking photographs of seemingly innocent looking
subjects. In general, the countries to be most wary
of are those that place a great deal of importance
on national security. In such countries it is wise
to be extremely cautious when photographing any
form of military installation, police building,
customs building, or near ports and airports.

When a photographer finds himself in the unfor-
tunate situation of being arrested he should always
insist on speaking to someone who can understand
English. All too often innocent people are arrested
through a misunderstanding and because of the
language barrier are not able to sort out the diffi-
culties. Never try to communicate if you only know
a few words of a foreign language – the chances are
that your few words will be inappropriate, or worse
still, they could convince the authorities that you
understand more than you are letting on. Insist on
a translator by not replying or indicating with your
hands that you do not understand.

Sometimes the impasse can be resolved by simply
offering the film in the camera. The worst thing to
do is to become angry, as this could make the
officials far less co-operative – they are, after all,
only doing their job as they see it. If all else fails
insist on contacting your embassy, or get another
person to go to the embassy and explain your pre-
dicament.

Difficult Situations

Several times in the past few years I have found
myself in extremely difficult situations. The first
time was in Saudi Arabia when I was photo-
graphing some ruins in the town of Najaran on the
North Yemen border. The ruins are described in a
small guide book, but nowhere in the book did it

mention that these ruins had Semitic connotations and that photographing them is only allowed after official permission from the Ministry of the Interior. I managed to take a few frames before two Arab gentlemen approached carrying large sticks and demanded the roll of film from the camera. Winding the film on the roll very tightly it was possible to tear the film in half, and they were given the unexposed portion of the film. Luckily they seemed reasonably satisfied but I did not wait for them to change their minds; at the first opportunity I jumped into the car with my travelling companions and we put several miles between them and us before we stopped! The pictures did survive – one of them shows the strange hieroglyphics engraved on some of the stones in the ruins and has been published a few times.

In Jeddah, whilst taking photographs of an interesting fish market, I was stopped by officials. Unknown to me the customs building lay directly behind the fish market. Sadly, this time it proved impossible to save any of the pictures as the camera was checked. Along with the pictures of the fish market – none of which actually showed the plain concrete customs building – were a series taken in a small deserted town on the outskirts of Riyadh. These photographs were taken with official permission, but there was no way this could be explained to the officials in Jeddah; it was far safer

to hand over the roll of film without comment. By being as co-operative as possible at least the rest of the exposed film in my camera bag was safeguarded.

On the Greek island of Samos, I was accompanying another photographer when he innocently took some pictures of children playing in the sea. Unknown to either of us, on the hill overlooking the bay where the children were playing was a small military post used for monitoring the Micale Straits that separate Greece from Turkey. Two policemen approached us and demanded the film. I was able to speak enough Greek to tell them that the photographs were innocent and simply pictures of children, but a local Greek had made an official complaint, saying that he saw us photographing the installation. The policemen were very understanding and probably well used to this situation with tourists, and they promised to develop the film and if it was as we had claimed, return the photographs to us in England. They kept their word and we did receive the film soon after our return. The only problem was that they had failed to appreciate that the film was colour slide since most tourists use colour negative film. They had developed the transparency film as negative, so the photographs were totally useless! There are many military installations on the island of Samos, but this was the only one that was not marked.

Indiscreet photography can sometimes even lead

Greeting the sunrise, Alishan, Taiwan.

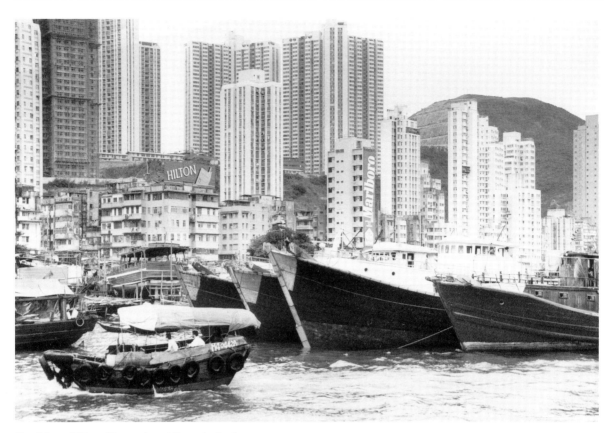

Outskirts of Hong Kong, viewed from the harbour.

to physical attacks. Whilst taking photographs of a new mosque being built on the banks of the Nile just outside Khartoum, I was attacked by an angry Sudanese with a huge stick. Luckily I was not alone, as I had taken the precaution of asking my Sudanese taxi driver to stay with me until I had completed the work. The mosque I was photographing was in the process of being built, having been designed by a British company who had commissioned a series of pictures to show the unusual structure. I had already explained to the taxi driver that I was a little worried, as I was a woman and a non-muslim and strictly should not enter a mosque. I managed to convince the driver that as the mosque was only half completed it was only half Allah's house, and therefore I was only half wrong! When the irate Sudanese charged me with his stick my driver chased him away, but not before I received a severe blow on the side of my head. Then the driver screamed in Arabic that the mosque was being built by 'this lady's friends' and my attacker immediately dropped his stick and came over to apologise. To add insult to injury, when I submitted my photographs to the company on my return they were most delighted with one slide that had 'a real Sudanese flavour'. When I looked at the shot they had chosen

it was of my attacker, taken seconds before he hit me! I had taken the picture as a precaution – if I had not survived the attack they may have found the culprit through it. In the end my attacker appeared not only in the company brochure but on a poster as well!

Health Risks

Although camera loss or damage must rate as the number one potential disaster area for the travelling photographer, close behind must come ill-health. The experienced traveller learns very quickly to be wary of situations that may put his own health at risk. Prevention is always far preferable to the cure, and many serious illnesses can easily be avoided by taking a few simple precautions. To begin with a photographer should always have all of the recommended inoculations before travelling abroad. It only takes a little time to seek expert medical advice before embarking on a journey and it is important to keep up-to-date; medical advice has a habit of varying due to the changing nature of many diseases as well as the continuous advance of medical knowledge. For example, smallpox inoculations used to be essential when visiting many

Scene at a village church, Asturias, Spain.

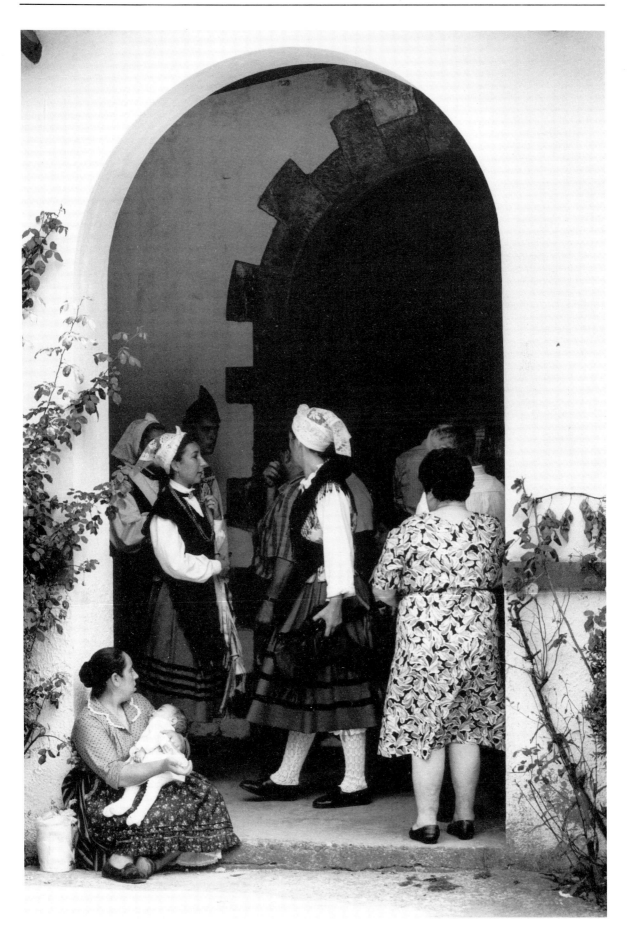

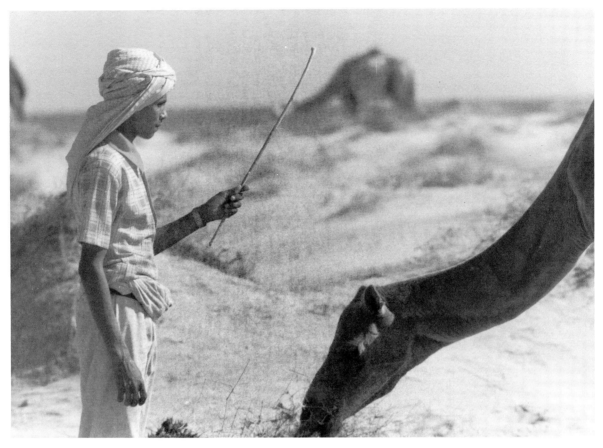

Arab boy with his camel, on the beach at Gizan, Saudi Arabia.

countries, but recently smallpox has been successfully eradicated from the world and there is no longer any need to be protected. Malaria, on the other hand, is on the increase. The mosquito and the disease itself appear to have become immune to many of the drugs used to protect the traveller from malaria. In certain areas doctors are now recommending that the dosage of certain antimalarial drugs should be doubled.

The dangers of contracting AIDS should be of great concern to travelling photographers, especially those visiting Africa. If at all possible, avoid local hospitals and clinics where there is any uncertainty about the standard of hygiene. Many of the very poor countries simply cannot afford the luxury of proper hygiene and syringes and needles are frequently shared, putting those that use them at great risk. Many AIDS victims in Europe and America have become infected whilst travelling abroad.

Natural Hazards

The photographer travelling alone in remote places would do well to learn some basic rules of survival. When I was living in the desert regions of Saudi Arabia, I learned how to deal with victims of snake bites and how to avoid scorpions and desert spiders.

It is interesting to note that most people die of the shock that follows a snake bite rather than from the venom itself; a little medical knowledge can save lives. I always made sure that I knew the nearest place that held the antidotes for snake, scorpion and desert spider bites. At one time, in a particularly infested area, I even carried some of the snake antidotes with me. I never had occasion to use them, but the area where I was working was so remote that the nearest hospital of any consequence was a two-hour flight away, and flights were only scheduled on Tuesday and Saturday.

It is advisable when venturing off the beaten track to always wear thick-soled boots or shoes. After all, England is one of only a very few countries in the world that does not have poisonous snakes; the adder exists but is rarely seen.

In Saudi Arabia it was particularly difficult to make sure that my two accompanying toddlers kept their boots on. Every morning before the children went out to play, a local Bedouin would carefully examine the sand. Desert snakes leave trails during the night as they move about in search of their prey, and the Bedouin were able to follow their trails and find them. During the day the snakes bury themselves in the warm sand with only their eyes protruding. These desert snakes, although small in size, are quite lethal.

The Bedouin lived in great fear of snakes, and when they found one they would hit it repeatedly with their sticks, often decapitating it in the process. Even after they had mutilated the snake and it was obvious that it was dead they would never touch them, but carried them away on the ends of long sticks. Often on my journeys in Arabia I would ask the local Bedouin for their help and advice, and without their knowledge I am sure I would never have fared as well.

During a second tour of Saudi Arabia I lived for a while in the town of Gizan on the Red Sea coast. The Red Sea is one of the most exciting seas in the world, filled with beautiful coral reefs and multi-coloured fish, and is extremely attractive to visitors. However, the coral reef harbours many hidden dangers. There are sharks and electric eels, but the worst danger of all is the stone fish. These fish are so called because they resemble the stones on which they are found. Many travellers have been killed by treading on them with bare feet, or touching them with unprotected hands. When the stone fish is disturbed it ejects a poison for which there is no known antidote. The only safe way to explore a coral reef is to wear shoes and never touch anything with a bare hand. The only person I have heard of that survived the sting of a stone fish was a Dutchman living in Jeddah, who saved his life by amputating his own finger before the venom could travel through his body and kill him.

Another danger is shell collecting. Often at low tide boldly patterned cone shells are found buried in the sand close to rocks or amongst the coral debris lying on the beach. When disturbed these cone shells fire a dart that contains a lethal poison. The dart is so powerful that it has been known to penetrate through plastic bags into the carrier's legs. I have collected many different types of cone shells, and have found them frequently on the Red Sea Coast as well as the Arabian Gulf.

Unloading relief supplies, Port Sudan.

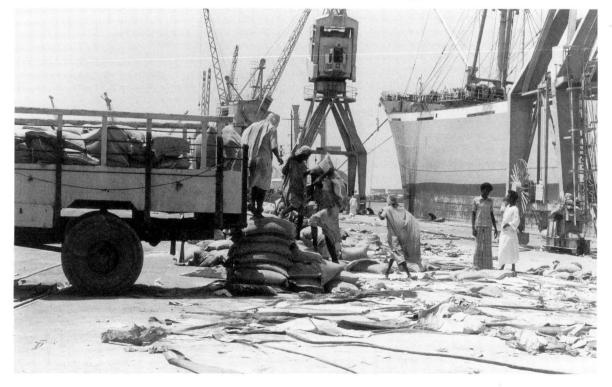

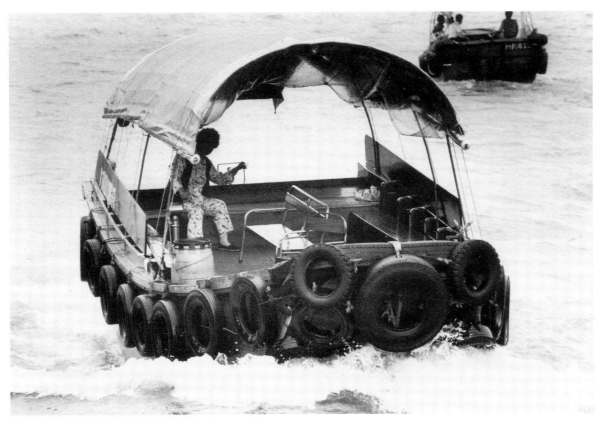

Motorised transport in Hong Kong harbour.

Zabeed, North Yemen, where it is said that algebra was invented.

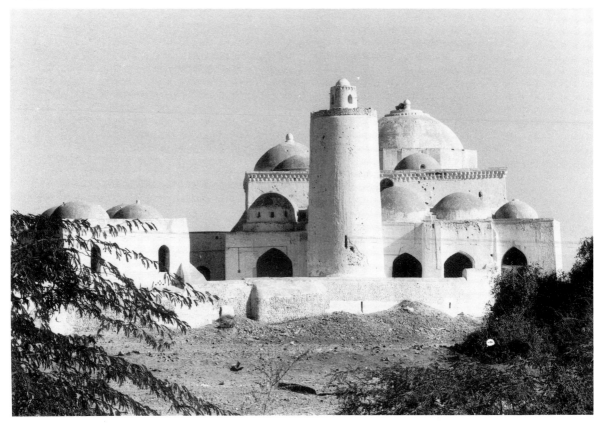

Selling the Photograph

Selling your own photographs is never easy; however, many photographers succeed and earn a good living by marketing their own work.

Photography is, by its very nature, a solitary pursuit, and the photographer uses his camera to produce his own personal vision. The moment the photographer starts to market his work however, he is taken out of his own insular world and forced to deal with a completely different situation. The needs of other people, be they picture researchers, editors or advertising agencies, now have to be taken into account. Dealing with clients and their widely differing needs requires considerable research into their specific requirements and the likely end use of the photograph.

Some people have a natural ability to communicate with others, and respond to marketing their own work as a challenge, learning as they go along. Other photographers, who find marketing difficult, have the option of using an agent or photographic library to represent them. There are also currently many interesting courses available which offer to teach basic marketing skills, and these are excellent for building confidence and learning communication skills. To succeed it is essential that the photographer is confident about his own work; it is pointless trying to market material that you do not believe in. It is also important to target the work to the sector of the market most likely to use it.

It is almost impossible to say with any certainty which subjects are likely to be saleable. Over the years I have made notes of picture requests I was unable to supply. On many of my earlier trips I did not fully realise the wide variety of photographs that sell, and as a result I missed out on many picture making opportunities. The true selling potential of each assignment can only be worked out through balancing potentially saleable material against a list of markets, the photographer's capabilities and the market demand. Very often it is the unusual picture that makes the most money, because the obvious pictures are already available in many picture libraries, and because they add variety to travelogues.

First Experiences

The very first photographs I marketed were a selection I personally felt were interesting, taken during the year I lived in Saudi Arabia and largely illustrating the changing life-style of the Bedouin and the changing face of Arabia. I approached the picture editor of a leading national newspaper in London and made an appointment. I was feeling extremely nervous when I walked in, and it was a disaster. His abrupt, curt manner left me tongue-tied. I distinctly remember planning my escape when he shouted at me: 'show me what you've got'. I laid my pictures out and he turned round and

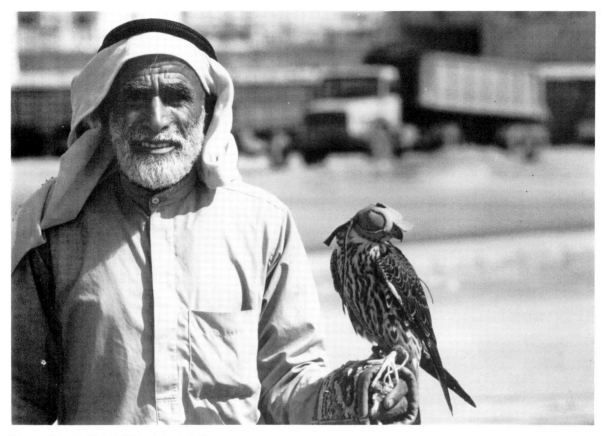

Man and hawk, Dubai, United Arab Emirates.

snapped 'Who is your favourite photographer?' My mind went totally blank; the last thing I had expected was an inquisition into my likes and dislikes, and after some very noisy, silent seconds during which the room seemed to echo my heart-beat, I stuttered the words 'Don McCullin!' The picture editor turned glaring towards me and in a most aggressive tone said: 'They all say that. Your photographs are lousy, you are not a photographer and what's more, you will never become one!' With that he showed me the door. The feeling of freedom as I escaped through the door was fleeting; I was soon filled with a sense of total rejection. As a result I gave up photography for three months, but despite this first catastrophic rejection I could not really believe that my photographs were all bad.

Next I mailed a few prints to the features editor of *Amateur Photographer* magazine. I prepared myself for another rejection, but instead received a telephone call asking me to bring my portfolio to his office. When I telephoned for an appointment, it turned out that he passed my home every day on his way home from work. A few days later, after a cup of coffee in my house, the editor selected a group of my pictures for a portfolio on the work of a woman photographer in Saudi Arabia. The photographs published were the very same pictures I showed the first picture editor in London! I learnt

a great deal from this experience and the kind words of encouragement this editor gave me.

The twist in the tail came exactly two years after my portfolio in *Amateur Photographer*, when I was telephoned by the picture editor of that same national paper. He had seen my published work and wanted to use some of my unusual pictures of Saudi Arabia to illustrate an article in the colour supplement. He had forgotten what he had once said to me; in fact, he had forgotten me altogether. He was very specific in requesting one of the published photographs of some Bedouin children that he had previously rejected, and I enjoyed telling him that unfortunately the pictures were not for sale to him at any price!

Have Faith in Yourself

There are so many photographers who would like to earn a living or at least pay for the costs of their film and travel through their work that the competition is quite formidable. The photographers who do well are those who can survive rejection and maintain faith in their own work and ability. Sadly, many good photographers with wonderful pictures get by-passed because they are not positive enough and give up as soon as they are criticised. A picture editor sees hundreds of would-be pho-

tographers in the course of his work, and of course many are simply not good enough. Poor quality work may sell occasionally, but when there is competition – the same type of work but of far better quality – the inferior work will quite rightly not stand a chance. The photographer who is truly confident about his work stands a far greater chance of conveying that confidence to the picture editor. Confidence also improves your photography; those who are confused in their approach to life tend to be uncertain about their photography and end up with confused pictures that have very little to say.

However, it is not unusual for pictures to be totally rejected by one magazine and then be used by the next. People and magazines are very different and the old adage of 'one man's meat is another man's poison' is very true. Then again, a photographer who has consistent work of good quality will find he can submit his pictures to different types of magazine, and the same photograph may be published several times in different contexts.

Sales Breed Sales

There are a few pictures which become famous and well known in their own right. These pictures will sell over and over again and often sell themselves. Sales breed sales; once a picture is published, and if it is outstanding, other users will contact the photographer or whoever is holding the picture and ask to include it in their magazine or newspaper.

The *Observer Colour Magazine* once published a photograph of mine from an exhibition, illustrating life in the Emirates, that was being shown simultaneously in Dubai and London. The picture was spotted by the editor of an international magazine, who contacted me and selected several pictures from the exhibition to use across a double-page colour spread. In Holland, the director of a third world TV magazine programme then saw these pictures and telephoned me. He flew immediately to London and made a selection for the Dutch equivalent of *TV Times*. During our meeting I mentioned a recent trip to the Sudan and as a result was invited to appear live on Dutch television to talk about the economic crisis there. As well as a fee for my appearance, a second selection of pictures was chosen to illustrate my talk, plus expenses for the air fare and hotel. A Dutch engineering company saw the programme, and contacted me after seeing a photograph of a project they were working on. They subsequently bought photographs for their company magazine. The sales of photographs to two magazines, a television programme and a company brochure overseas, all came as a direct result of one small photograph in the *Observer Magazine*.

Bedouin children, Gizan area, Saudi Arabia.

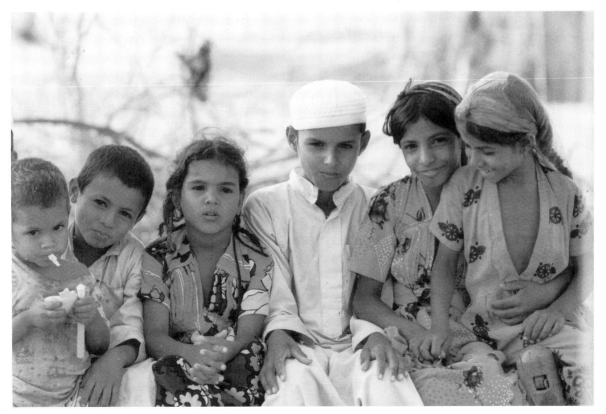

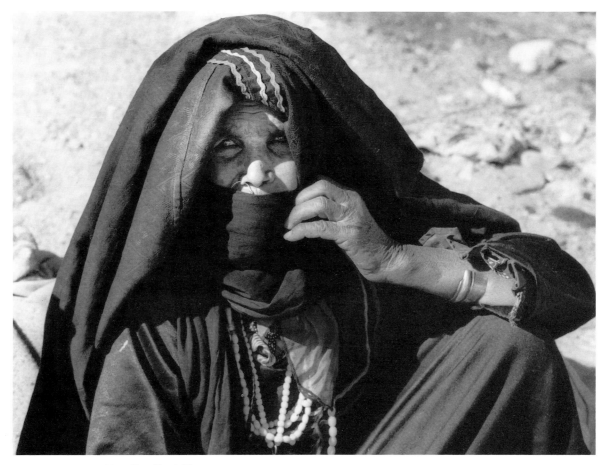

Bedouin woman at Nuweiba, Sinai, Egypt.

Accurate Targeting

When I first started selling I frequently had work rejected. These days the rejections are far fewer as I have learnt to be much more accurate when selecting the markets for my photography. I spend a good deal of time studying magazines and the pictures that are used by different types of publication, then if the opportunity presents itself, I make photographs specifically for the editor of the magazine I am targeting.

Photography is a visual art, and as with all artists, photographers are affected by many outside influences. Occasionally a photographer may be so impressed by an image that his mind subconsciously retains the impression. Then when the opportunity presents itself, he may unwittingly take a similar image. In reality most subjects have been so well photographed that there are many similarities between different photographer's work on the same subject.

Originality of vision often makes a photograph more saleable; it certainly enables the markets for the photograph to be more varied. However, the vast majority of photographs that sell are standard, well-composed pictures recording the images that

people identify with a country or town. To illustrate an article on London, for instance, a red double-decker bus, a black taxi-cab, Big Ben or Tower Bridge are traditional London scene-setting subjects. Thus many very successful travel photographs tell the viewer where the photograph was taken without the need for a caption.

There is an enormous market for photography in this country, with thousands of publications in constant need of good pictures. The bigger the size and circulation of the magazine, the more likely it is that they have their own staff photographer or regular picture sources, but the majority depend heavily on freelance work.

A leading picture research agency recently told me that they estimate that as much as 75 per cent of all published pictures in this country come from sources other than the magazines' staff or files.

The most common reason for freelance photographs being rejected is sending the wrong picture to the wrong magazine. I replied once to a request for photographs in the Bureau of Freelance Photographers' *Market Newsletter*. The magazine was looking for interior pictures showing the use of

plants in decoration. The editor said that four photographers had replied, but three subsequently sent photographs of interiors where the plants appeared so small that they needed to be searched for! Only one photographer actually read the item and really understood what the magazine was looking for – a photograph showing plants on display with a small amount of background environment to explain where the plants are.

When I submit photographs to a magazine I always include as much variety as possible on the theme. As I work exclusively in 35mm I include, wherever possible, both horizontal and vertical pictures. Rarely is a square photograph used, and by including both I find it goes a long way to making up for the smaller size of my pictures. I have tried using a medium format camera but unfortunately the weight was too much for me to carry over the long distances necessary for my work. I try to include both close-ups and scene-setting shots, and straightforward record work together with more imaginative photographs. In this way the picture editor has a comprehensive selection and can decide which pictures will suit the article best.

However, it is true that for many photographers, especially those working closer to home, the use of medium format can prove a distinct advantage when it comes to selling colour transparencies. Many editors will always go for the larger format if they have the choice between good medium format and good 35mm.

The Personal Touch

Attending meetings is extremely time consuming, so frequently I will set aside a whole day to visit a series of different picture editors and publications. The personal touch works best where possible, and I have often been to see publications with one selection of work and picked up further sales at the same time. Keeping in touch also keeps the photographer in the forefront of the picture editor's mind. There are many good photographers, but very often it is the first one to telephone or walk through the door that gets 'first refusal'. Providing the pictures are good, the photographer should be able to form a rapport with a picture editor and a good working relationship will often develop. It is therefore important to be highly self-critical and not throw in poor pictures just to increase the selection; these 'fillers' can often degrade the whole visual standard of the work. A good reputation for delivering on time and coming up with the right photographs will usually bring in further work.

I recently wrote a travel article on New York and as soon as the words were approved made an appointment to show the picture editor my New York portfolio. As I was both writer and photographer we made the selection together. Later over a cup of coffee I found out the publishing schedule of the magazine and sold four more selections of photographs to illustrate the work of other writers. I sold a total of twenty six photographs,

Taoist temple, Taiwan.

from Jordan, the United Arab Emirates, Florida and Saudi Arabia. Had I not taken the trouble to personally deliver my New York selection, the editor would have accepted it through the post and I would not have had advance warning of the other articles. In conversation afterwards, the editor said that he only associated me with New York and Saudi Arabia, and had been going to invite other photographers to submit the photographs of United Arab Emirates and Jordan. Equally, when a photographer visits an editor with bad work or work that is not relevant, it will be remembered, making future requests unlikely even if the photographer's work improves.

Brainstorming sessions can pay dividends; I look at each series of pictures and try to imagine the different articles each photograph could illustrate. I then try to identify any company that may be interested. Ideas often come in the most unusual places; in the bath, during the night. I always carry a pocket notebook where my ideas can be written down before I forget them. Ideas are very important; they frequently lead to sales, new clients and new saleable photographs.

For colour reproduction transparencies are best, but where there are no slides in existence, colour prints may be acceptable. With today's modern laser techniques, the quality of colour separations made from prints has greatly improved, but the preference is still undoubtedly for slides.

Of necessity, all of my photographs of Saudi Arabia were shot on colour negative. The area where I was living was, by Saudi standards, under-developed, and the local people were afraid that photographs of the area would show the country in a bad light. I therefore lived under constant threat that my photographs would be confiscated. Using colour negative material allowed me to mail my film back to England; the negatives could then be safely stored in this country whilst the prints were sent out to me. As there is a shortage of good work on the traditional Bedouin life-style the resulting prints have been used extensively. The photographs also sell well in Saudi Arabia, and the Saudi Arabians are now amongst my best customers. Having seen my work published they immediately understood that they were not being shown in a bad light at all!

Humour

There are many different types of photographs that sell well. Many of the sales a photographer makes are dependent on his own ingenuity; the photographer who has the ability to see how the same pictures can be used in different contexts can sell his work to a wide variety of different markets.

The policeman and the bus minus roof, Epsom, Surrey.

Musicians playing traditional instruments, Morocco.

The humorous travel photograph is always in demand, as it can be used as a filler in magazines and newspapers both in this country and abroad, especially America where there is an insatiable demand for humorous pictures. These pictures often appear very simple but are actually quite difficult to produce. The successful humorous shot often has to be thought out in advance, and the situation created can involve the photographer in a great deal of preparation.

On the other hand quite a number of these photographs depend on the photographer's ability to react quickly to a fleeting image, often involving animals or people in funny situations. Situations such as 'the bus', which I photographed when the poor driver took a wrong turning and ploughed under a low bridge, slicing off the top of the bus rather like a tin can! The first photograph was not the best: shortly afterwards a policeman produced his pocket book to take down the details of the incident and by standing at the front of the bus he looked, to all intents and purposes, as if he was about to book it. The resulting photograph sold twice in black and white. The incident took place at about 7.00 pm. on a rainy evening as I was heading down to my local town, so you can see that 'travel' photographs can even be taken at home for

use in international or foreign markets. I always carry a camera wherever I go and keep a couple of rolls of film in the car.

When I had finished the black and white pictures the officer moved, but realising that there might be opportunities for colour sales with the red bus, I asked him if he could return to his former position and re-shot the series in colour. The police officer found this quite amusing and was most obliging and helpful. The resulting colour picture became a cover the following month on a police magazine, and his wife even bought him a print! To create contrast in the rain I pushed the film one stop and in this way strengthened the colour.

Another humorous picture which has sold well was one I took at my children's school during dinner-time. I used fast black and white film to eliminate the need for flash since I wanted the children to be unaware of my camera. Using a medium range telephoto lens I managed to get quite close to the children without disturbing them. After about ten minutes of nothing very interesting, I noticed a small boy with a wonderful expression on his face; his nose was screwed up, his finger and fork were parallel to his nose and as I focused, his tongue popped out. The picture, once printed, revealed a further amusing aspect; his tie was one

of those with elastic round the neck and was back to front! This photograph has achieved sales in a children's magazine, in a photographic magazine and has been hung at several international exhibitions of photography around the world.

Photographers who specialise in humorous pictures never know when they might occur, and so have to be ready at all times to take advantage of situations as they present themselves. There are a number of events, such as carnivals, which regularly produce amusing pictures, but the vast majority are observed or thought out by photographers who have a strong sense of humour themselves. Many magazines and papers are continually on the lookout for funny pictures, and if you are lucky enough to take a good one you are assured of plenty of sales without too much hard work.

In Lisbon I managed to shoot two humorous photographs in a row. Both were situation photographs and required my reacting very quickly, and in both cases had the camera not been in my hands at the time I doubt whether I would have had the chance to secure the shot. The first was a couple cuddling in a corner – he suddenly turned to her, pulled a face and pointed a finger to his head as if to shoot himself. I often wonder what she said to him to get such a reaction! The second, which has been very successful, was observed across a busy Lisbon street. A lady was standing at a bus shelter, leaning against a poster advertising beer and with the bottle on the poster seeming to disappear down the back of her neck. The advertisement for a well-known make of beer flashed through my mind – 'reaching the parts'! I used a telephoto lens to fill the frame and waited for a gap in the traffic. As I pushed the shutter release I could not have been luckier; the lady sneezed, completing the picture in a completely unforeseen way!

Studio Travel

On many trips, when I am in a hurry, I collect useful material that I can bring home with me and photograph when I have more time. In Egypt I visited a small gallery and was allowed to take a series of an artist preparing papyrus. I was on a very tight schedule and did not have time to make pictures of the papyrus paintings themselves, but I managed to buy some good prints and at home was able to use studio lights to make successful slides. The series of photographs, when combined, were sufficient to illustrate an article on the revival of papyrus painting.

On another occasion, when I was in the Middle East, I brought back a collection of silver Bedouin jewellery and some brass coffee pots. In my home I was able to create several 'set-ups' using a hand-woven Bedouin rug brought back on a previous trip. I placed the coffee pots on a glass table and shone a projector lamp underneath, and with the use of a star-burst filter I was able to achieve a whole series of attractive compositions.

The jewellery I arranged on a colourful bath towel, which gave a simple but richly textured background. Many of this series have been published, one being used in an international company's brochure. The editor, when choosing the photograph, said that he loved the richly textured background! The most common set-up that I use involves photographing the subject on a copying stand, and for this I use the base of my enlarger with two 200 watt lights placed on either side of the stand. I find that it is usually necessary to bracket the exposure a little. In this way I am able to achieve studio quality without a studio. I find that photographs made in this way sell extremely well, and are in many cases preferable to a grab shot on location.

Photographic Themes

One of the easiest ways to sell photographs is on a photographic theme – selling several pictures at one time can be far more profitable than selling a single photograph. Single pictures, when used as covers, may initially make more money, but after a photograph has appeared on a magazine cover its future sales can be limited as a result of the greater exposure.

Many travel photographers always choose to work on themes, as they find that by doing so they increase their sales potential. In principle the theme is a great idea, but it can take someone who has never worked in this way before a little time to begin to see their travel photography as a series of themes.

It can be equally difficult to be able to identify which theme has the best selling potential; seeing in. this way does take some practise. On occasions it is possible to identify a theme before travelling to a new destination, but nearly all the themes that have been successful for me have evolved whilst I was working.

Ideas From the Subconscious

The way that themes can evolve is often surprising – sometimes the theme is not obvious until the work is completed. I have tried to analyse how themes occur and I am convinced many of them develop in the subconscious mind. The photographer who works consistently in this way begins to develop the ability to successfully relate often seemingly unrelated photographic images. Whilst the majority of themes are relatively obvious, such as those based on architectural style, or recurring shapes and patterns in nature, there are plenty of themes which can be equally successful whilst being relatively obscure in origin. These can often be the result of a chance conversation that triggers off a photographer's insight into an unusual aspect of the life-style of the country that may not otherwise be obvious to an outsider.

Ideas occasionally register within the photographer's subconscious mind, and he may then gradually begin to relate these thoughts and translate them visually into the pictures he sees before even realising that this is happening. It is often only when the photographer has an idea that he begins to see pictures that are related.

Sometimes the theme may not even become apparent until the photographer processes the photographs and examines them on the light box. It is often then that a possible theme can be spotted. Themes can be used to form the basis of a successful portfolio, as well as producing series of photographs that compliment each other. A selection that has a theme running through the photographs, and where the photographs compliment one another, tends to look good when arranged on a printed page.

Study Published Work

The best way to see how photographic themes work is to study magazines and books where collections of photographs are published in groups. Picture editors frequently use a photographic theme when selecting work for publication. Sometimes the themes are subtle, a colour that is common to all the photographs, or a photographic style. At other times the theme can be very strong; powerful recurrent shapes or even a strong group of portraits.

The picture spread produced by an expert picture editor always takes into account the inter-relationship of images and the way pictures affect each other when published together. Successful photographers also nearly always take into account the page layout possibilities when submitting their work, and the ways in which the pictures can be used. This knowledge is also very helpful during the actual taking of the photograph and when the photographer is considering the composition. An experienced photographer takes many different compositions of any important subjects, so that the work has greater flexibility when it is used. A knowledge of layout and design is most useful when selecting photographs for submission, and can dictate the presentation of the work as well as the selection. The photographer with a carefully thought out presentation can better convey his ideas to the picture editor than one who does not bother and presents a random selection of images. This knowledge can make the difference between a sale and a rejection.

Worldwide Themes

Over the years many of my photographic themes have been published. Most of these have arisen from photographs taken during a single photographic trip, but occasionally a new theme comes to mind that pulls together photographs from many different countries, and may well consist of photographs from several years of work.

During a recent trip to Iceland I became fascinated with the solfataras and hot springs, and after a few days I decided to find out where were the most likely places to continue this theme. As a result, I changed my entire itinerary. On my return I grouped together all the photographs of steam, hot springs, volcanic activity and others that complimented the theme. I then selected ten very strong images, mounted the slides in a presentation folder, and made an appointment to see a picture editor. He immediately commissioned one article on the Icelandic landscape, and a second piece for business travellers, on Reykjavik.

As another example, during my Icelandic travels I began to notice the extraordinary quality of the Icelandic wool. At every opportunity I added photographs to my wool theme – woollen jumpers in shop windows, portraits of Icelandic people wearing woollen clothing, and the inevitable sheep. Icelandic sheep are quite different to those found in warmer countries; the harsh climate makes it impossible for them to be sheared, and instead the shepherd allows the sheep to shed their wool naturally. The result being the tattiest sheep I have ever seen, with their straggly coats trailing round behind them in the mud, only partially attached to their bodies! Underneath, the new fleece can be seen quite clearly, since the new coat is far cleaner than the bedraggled old one. However, the theme was limited, as I was unable to find suitable material to show the different stages of the processing of wool, such as spinning.

The previous year, during an assignment in Morocco, I had watched women washing wool fleece in the rivers. Then, in Fez, I had watched women and young children spinning wool with huge spinning wheels. I also had a comprehensive collection of weaving and carpet making photographs taken all over Morocco, and also in Fez I photographed a square totally filled with vats of dye. When I combined the photographs from the two trips I found I had a selection that showed a sequence illustrating wool from its origin to its end uses. The selection now had an international flavour which I felt could be expanded. After much careful consideration, I included some more pictures; bedouin tents in Saudi Arabia made from woven carpets, and Jordanian scarlet rugs from Kerack. The Jordanian pictures added a splash of colour that livened up the colour content. I then felt I needed more human interest, and added a portrait of two Aborigine women knitting in Taiwan, this adding the unexpected as well as bringing the Far East into the story. Now the story that began in Iceland had crossed the globe. The words tying all the photographs together took a little longer. A trip to my local library produced three books on the history of wool and its importance to different societies throughout the ages. I immersed myself in these books, learning everything I could, and even visited an exhibition run by a company marketing wool. The article began with Babylon, 'Land of Wool', showing early Egyptian wool spinners, and these I illustrated with a photograph of a Papyrus painting. The final article ran to three thousand words and has recently been published, with a total of twelve photographs published across five pages.

Developing Ideas

Usually the photography comes first, then the words follow, but occasionally the words dictate

Narrow street, Chechaouen, Rif Mountains, Morocco.

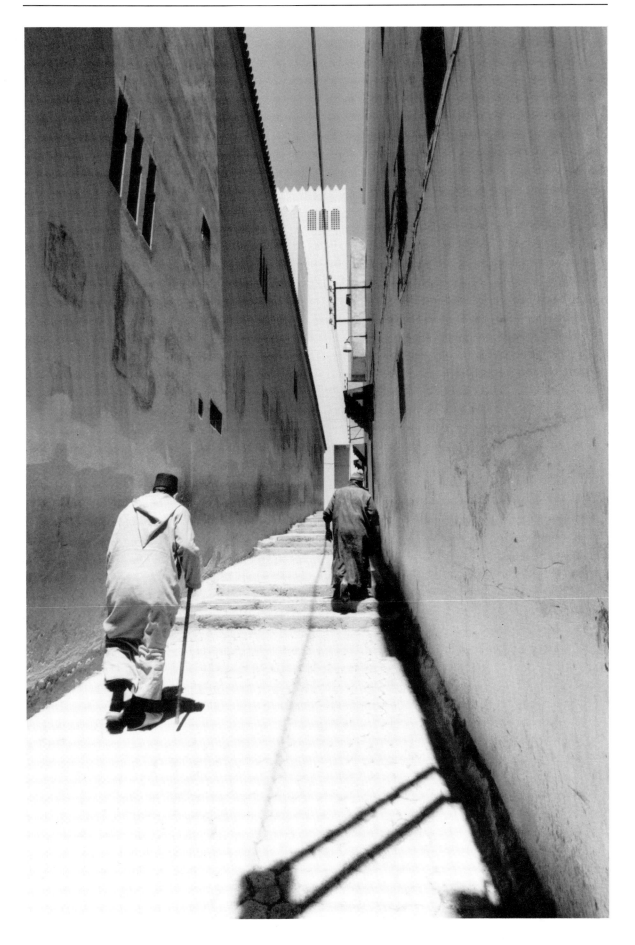

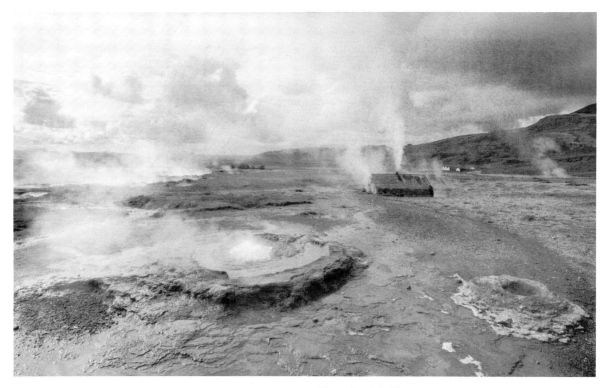

Namaskard Solfatares, Iceland.

the photography. Sometimes it is a little like being back at school and having to write two thousand words on 'Spring' or on 'fountains'!

Usually I am given sufficient warning to be able to make additional photography once the theme has been commissioned, but I do find that once an idea has been discussed, it begins to grow. Frequently, when an editor suggests an idea, I think that it is hopeless, but as soon as I spend a little time considering different approaches to the subject I find that there are possibilities after all. I never turn down a suggestion, no matter how strange, until I have had time to consider, as I find that it is invariably better to say yes straightaway and work out the whys and wherefores later.

When an editor actually rang me and suggested 'Spring' for an article I was convinced that he couldn't be serious. It was certainly an idea I had never considered before. I wrote the words in the autumn, before I began to look for possible illustrations. The real problem that neither the editor or I had considered was that this article had been specially commissioned for a magazine sold in a country that does not even have a spring. Spring is peculiar to temperate climates; in parts of the world such as Africa and the Middle East, their 'spring' is not a season as we know it, but a period of time following the rains that 'triggers off' the rebirth and re-growth that we associate with our spring months. This gave rise to all kinds of difficulties since his readers would not be able to associate spring with

the season he had in mind. In the end I think it was fortunate that the writing came first, because at least I knew the content of the article around which the photographic theme could be built.

The article was due to be published in March, but the magazine needed the photographs in late January, mid-winter, so I had to rely entirely on my picture library. The photographs eventually published were wide-ranging – springtime with flowers emerging and green fields were chosen from my Moroccan collection, the result of a visit to the Rif mountains the year before; a sleepy English village with masses of green leaves, children dancing around a maypole, swan and cygnets from a London park, and a photograph of my children playing amongst budding trees – all from my English collection; Washington, showing sky-scrapers surrounded by a park filled with daffodils; a table top photograph of a vase filled with spring flowers taken in my home; two from Saudi Arabia taken after the rains and illustrating re-growth in a non-temperate climate. A photograph showing snow was used to compare spring with winter and to help the readers understand why people in distant countries looked forward to the arrival of spring. The last photograph used was taken in Normandy nearly twenty years ago on a Kodak Box Brownie, of a sheep and her twin lambs. This was the first photo-graph I ever took, and since it was published in the 'Spring' article, it has been used again! I had kept it for nostalgic reasons and never expected it to sell.

Buildings of Mud

During the past few years I had been gathering, wherever possible, information about the architecture in North Yemen. There is very little authoritative material published, but gradually over a period of three years I amassed a suitable collection of Yemeni architectural photographs and information on the construction and history of these mud buildings.

When I was satisfied that I had enough material I prepared a small portfolio with both colour and black and white photographs. I then prepared a brief synopsis as to the proposed structure and information the article could contain. I decided that because of the architectural content of the photographs, the article should be aimed towards British architects, and so sent my selection of pictures and synopsis to the editor of a well-known architectural publication. Three months passed, and as I had not even had an acknowledgement from the editor I assumed that the idea was not acceptable. I telephoned to ask for the return of my pictures, and it was only then that I was told that they wished to use them. The editor then asked if I could send in the article within the next few weeks.

Luckily it only took me a couple of days to write since I had already gathered all the information I needed. Two months later, my illustrated article on the architecture of North Yemen was published. One of the photographs was used on the cover of the magazine and six appeared inside. I was very pleased with the finished article, although it was sad that the editor had forgotten that I had both black and white and colour pictures. I had even sent some of the black and white prints to the magazine when I first presented them with the idea. As a result the magazine made the black and white pictures from my colour slides with resultant loss of quality. However, I was also very pleased to receive a large bundle of correspondence that the magazine forwarded from architects wanting to know how to get to North Yemen!

Ramadan

A quite different example occurred when travelling around Morocco searching for suitable photographic material to illustrate a children's educational book. I suddenly realised that the Moroccans were busy preparing for their holy month of Ramadan, the ninth month of the Muslim year during which every devout Muslim is required to fast. Throughout the entire month, from the first glimpse of the moon's crescent until its reappearance one month later, all Muslims fast from sunrise to sunset and are only permitted to eat and drink once the sun has set. Each evening, the break of the Ramadan fast is announced by the firing of a cannon, and then the celebrations begin. Special food is prepared to celebrate the breaking of the fast and all over Morocco there is a carnival atmosphere.

On my arrival I did not realise that Ramadan was imminent, but as I travelled around the country I began to notice the preparations and the excitement.

Every evening children would stare up at the sky, each hoping to have the honour of being the first to spot the new moon that would signify the beginning of Ramadan. Little cafes were being decorated in preparation for selling the special cakes that are eaten at the end of each day when the fast is broken. Workmen were erecting scaffolding around the minarets of the mosques in order that the moment Ramadan was declared a white flag could be flown to let everybody know that it had officially started. As soon as the new moon is sighted the King appears on television and officially announces the beginning of the month of Ramadan.

It occurred to me that if I photographed all the different preparations I could have the makings of an unusual theme.

Over the next few days I made a large number of photographs that together illustrated the preparation for Ramadan in Morocco. During the day most of the people who are fasting try to stay indoors out of the heat, but as soon as evening arrives and the fast is broken, life returns with a 'bang' to the streets and my photographs taken late in the evening show the lively carnival atmosphere.

When I returned home I visited the local library where I found several books on the Islamic faith that described in detail the wide variety of traditions associated with Ramadan. The article I wrote was successfully sold back to the Middle East; it was bought by an Egyptian editor who was fascinated to read an article on the Islamic faith – especially one written by a non-Muslim English woman!

A Belgian Weekend

Frequently a photographer travels with one particular idea in mind, and then a second idea evolves out of the photographs associated with the first. One February I felt a need to travel and make pictures, but decided that I would not be able to go very far since I was rather low on funds. I found a cheap weekend break in Belgium and having never been there before it seemed a possible choice. I was very concerned about the Belgian weather which, during February, can be worse than the weather in England. Had I more money I think I would have tried to travel further afield!

I find it hard to stay at home for longer than a few months. Many photographers who travel regularly find that the almost nomadic life-style can be extremely addictive. The desire to see new places and meet new people can make one very restless.

I left England in pouring rain on a Friday after-

noon and arrived in Brussels wondering why I had bothered; the streets were awash with a week's rain and the whole place looked dull and unpromising. The next morning though was completely different. I awoke to see Brussels bathed in irresistible February sunshine. The low winter sunlight is far better photographically than sunlight at any other time of year; the sun, being lower on the horizon, can create an almost three-dimensional effect. Later in the year, when the sun is higher in the sky, it is far less effective, and the shadows created by low sunlight are lost except for a few precious hours at each end of the day. It is also far easier to get good colour saturation during the early part of the year.

I wandered about the Brussels streets for a few hours, and then on the spur of the moment decided to buy a train ticket to Bruges. Bruges turned out to be a photographer's dream. There were virtually no other visitors on this quiet February weekend, unlike other times of the year when floods of visitors fill the small town's streets. I immediately realised that I had a unique opportunity to photograph the town and its people, and that an article was feasible if I was able to find enough interesting photographic material. I began to explore the possibilities, and it was whilst I was looking for photographs for the Bruges theme that I began to notice how many shops were filled with the delicate Belgian lace. It was not long before I decided that it could also be

profitable to take a series of photographs depicting the art of the Belgian lace makers. As I had only one day to take the photographs for two themes it was hard work; when I was too exhausted to take any more pictures I discovered I had exposed a total of ten rolls of colour and an additional six in black and white.

I returned to Brussels at 6.00 in the evening when the light had all but disappeared. On my last day in Belgium I returned to my original photographic theme on Brussels, which I had envisaged would develop into a destination piece for businessmen. The lighting in Brussels was good, but somehow the city did not have quite the same magic as Bruges.

On my return I processed the films and separated them into the various themes. The lace pictures were particularly successful; the one which pleased me most was a Belgian lady window shopping in front of a whole window filled with lace blouses. There were several photographs showing close-ups of lace curtains in the quaint little Bruges houses, and these were supplemented by a few pictures taken in Brussels of lace table-cloths.

The pictures of Bruges, I felt, were comprehensive enough to support an article on the town, but the pictures of Brussels, although good, were lacking in variety. There was one picture of Brussels, however, that was particularly strong; a vertical colour slide

Boys spinning wool, Fez, Morocco.

Scribes in the main square, Marrakech, Morocco.

of an armed Belgian policewoman. Whilst I was taking the picture a rather large burly man had walked into the field of vision. At the time I remember thinking that he had ruined the picture. Back at home I realised the possibilities; it looked as if the policewoman was chasing this shady figure. The figure was slightly out of focus because of the speed at which he was walking, and this had a visually disturbing effect. This picture was successfully sold as a cover for a police magazine.

My two Belgian themes, lace and Bruges, were both successfully placed as illustrated articles. The article on lace required a great deal of research at the local library, but eventually came together and when completed ran to about two thousand words with ten photographs. The Bruges article was used under the title of 'Bruges-Venice of the North'. This time a total of eight photographs and two and a half thousand words were used.

The Belgian weekend break was totally reliant on the weather and could have gone horribly wrong if the conditions had made photography impossible, but that weekend was the only one for two months that Belgium had reasonable weather, and as it turhned out, the trip proved to be very profitable. Luck plays an all-important role in travel photography, but unless the photographer makes the effort no amount of luck will ever help him.

Keep Looking

In my little 'tatty' notebook are many ideas that I will never find the time to use, but whenever I have five minutes I glance through the pages and sometimes realise how a theme could be developed. Then I usually scribble down more notes, but it may take many months before the theme is properly worked out. At any one time I may have as many as a dozen themes in different stages of development. I frequently have to put aside this work when more urgent requests are made, but I can always return to it whenever I have the time.

It is only when a theme starts to come together that I begin to look for a possible buyer, and in this way I avoid too much pressure on myself to complete the work. I find that when I am very pressured I begin to lose some of the excitement that I usually derive from my work. Occasionally, on a free afternoon, I visit my local library to read the latest magazines and newspapers and look through directories of publications. I mark down the names and addresses of those publications that may possibly be interested in my work, and try to work out subjects that they may use.

As time allows, I periodically examine my photographs on the light-box. This helps not only to sort out in my mind any new ideas, but very often helps

me to see new themes in existing photographs. I also look at photographs from different assignments and see if I can find any relationships between the different pictures. Many times I have just been browsing through my collection and a photograph that I have previously ignored will seem suitable for a particular market. Some photographs are so strong that they dominate others, and when a photographer is pleased with certain photographs he will see them to the exclusion of all others. This can prevent him noticing others that may also stand a good chance of making sales and that could prove even more successful.

Recently, for example, I noticed a photograph I had taken in a Jordanian restaurant in Amman, and began to wonder how many pictures of Middle Eastern food I had on file. I collected nearly twenty, and when I had sorted them out I contacted the best onto a 10″ × 8″ Cibachrome which I sent to an editor for comment. The editor did not seem to care for the photographs, but he did say that he had no idea that I was interested in cookery! The same editor telephoned me two weeks later having further considered the inclusion of an article on food; he had decided that this was not such a bad idea after all. I ended up being commissioned to write two articles, the first on Moroccan food and the second, believe it or not, on Chinese food. The only reason for the latter was that the editor was partial to Chinese cuisine! The first article was illustrated with a mixture of photographs from my library plus specific photographs set up in my own kitchen showing the preparation of some of the Moroccan dishes. I tested all the recipes included in the article and, in addition to payment for the words and pictures, the editor covered the cost of the food I had to buy. I had a free supply of food for a week as a bonus!

For the Chinese article I had no stock pictures, and so asked for more time. I had already secured another commission in Hong Kong, and so whilst there I was able to take the Chinese food photographs in my spare time and at no additional cost to either the client or myself.

Presentation

Presentation can make the difference between a sale and a rejection. I have watched editors open dog-eared envelopes and pull out dog-eared prints covered in drying marks and with unretouched hairs and scratches all over them. I have heard these editors say that if a certain photograph had been spotted and not creased down the middle, it would have been used. Frequently there just is not enough time to contact the photographer and ask for a better print. Retouching prints is not that difficult, and stiffeners for envelopes can easily be made from pieces of cardboard; better to pay the small increase in postage than lose a sale.

Each print or slide should include the name, address and telephone number of the photographer, plus the copyright mark © and any relevant reference number. Sticky labels can be used for this purpose. I prefer to write on the margin of the actual print with a permanent fine felt-tip that is designed to write on plastic, since the information cannot then be accidentally detached. Whilst most clients are extremely honest there are a few unscrupulous ones, and I have knowledge of a few cases where names have been removed and the copyright subsequently infringed. A large number of picture editors also have files of prints and slides where the name has become accidentally detached and cannot be retrieved.

Prints and Captions

Black and white photographs are best printed on 10″ × 8″ paper with a glossy surface, since this reproduces best. Colour slides may be any size from 35mm upwards, depending on the end uses of the picture. For example large posters are nearly always best when taken from large format work, and this applies to both black and white and colour. The captions should include as much information as possible – names of the people in the picture, the place, time and even why the picture was taken. It is always better to include too much information; the editor can then select the relevant details he wishes to use. An editor is frequently too busy to take time to telephone or write to a photographer for further details, so if there is not enough included the photograph may well be discarded and a sale lost.

Keep in Touch With Editors

I am now aware of the frequent lack of communication between people working on the same newspaper but in different fields. In the past I have written words to accompany my pictures only to find the words published with another photographer's work because it was assumed that I was only the writer! It is useful to end an article with a

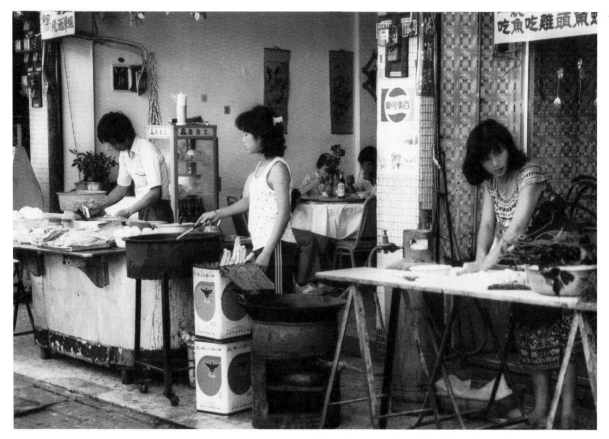

Preparing breakfast, Sun Moon Lake, Taiwan.

list of photographs that could be supplied to illustrate the contents. However, this should not be totally relied upon, since when the words are typeset the original text is filed away and forgotten. If work is going to be used, try to find out the exact date if possible, and make an appointment then and there to see the picture editor well before that date so that he will not be tempted to go elsewhere. Most important, keep in touch with all concerned until the work has been published.

One cannot always get a personal appointment, so if it is not practical to submit work in person one must write a covering letter to the editor with the submission. Proposals or suggestions for new work can also be sent in by letter, and one great advantage of this is that a copy can be kept on file. Then if a reply has not been received within a reasonable amount of time a follow-up letter can be sent. Another alternative is to telephone and discuss the possibilities with the editor or his assistant. This works best once the photographer is known, and can be a quick way of getting a direct response. Editors are extremely busy and appointments are often made so far in advance that the material for consideration may well be out of date by the time it is seen.

Slides and Packaging

I always submit photographs with a stamped addressed envelope and adequate packaging for return; many of the photographs I submit are sent 'on spec' and many have sold as a result. I frequently send photographs to overseas markets in this way and have had such pictures published in Japan, Germany, Holland and in the United States. When submitting overseas I either send 10″ × 8″ black and white prints or duplicate slides. I never send the originals unless they are being hand-carried by a courier.

Duplicate slides can easily be made, either by a custom lab or by using a slide copier. I have a contrast-controlled copying system which fires two flashes; one upwards illuminating the slide, and the other across the first flash to reduce the contrast. One needs to experiment to find the best setting. My unit has paid for itself over and over again. I use filters to control the colour of differing slide films and prefer to copy using the film in my camera. In this way I can finish rolls of film quicker and, since I use E6 film exclusively, am able to process my duplicates soon after I make them.

Many picture editors say that they can tell if a

slide is a duplicate. However, there are slides that can actually benefit from copying, and a duplicate can be more successful than the original. I have noticed that this is particularly true with low contrast slides, which benefit from the increase of contrast that results from copying. I have also been able to get rid of colour casts in some slides by using filters under the lens. I do not use special copying film, since each batch varies in film speed and it is necessary to run tests first to establish the speed before any copying can be carried out. Although I have sold many duplicates I make a point of never pointing out which slide is a duplicate, as there is a good deal of prejudice. In this way I have had one picture published simultaneously in three different countries. Whenever I am fortunate enough to have a slide that sells well, I make several copies and rarely let the original be used unless it is a special publication.

A few years ago some of my photographs were being returned from a printer who had been making a calendar for one of my clients. The slides were sitting in a postal sorting office when a bomb, addressed to Mrs Thatcher, went off. The remains of my work – a melted mass of film and plastic – were later returned, and luckily none of the slides were originals. I was able to photograph the remnants returned by the Post Office, and that subsequent photograph has sold many times!

Whenever posting work I always use either recorded delivery or registered post. If material is lost the Post Office only offer very limited cover. If the work is valuable and irreplaceable, it may be worthwhile considering taking out special insurance. The Post Office do offer this facility, but it is necessary to request this service at the time of posting. If possible try to deliver pictures to the editor personally; often this provides a useful opportunity to glean more information about current requirements and publishing schedules.

Film Choice

Many magazines have a preference for a certain

Yemeni cafe on the outskirts of Ta'izz. Taken on a Canon Sureshot autofocus compact.

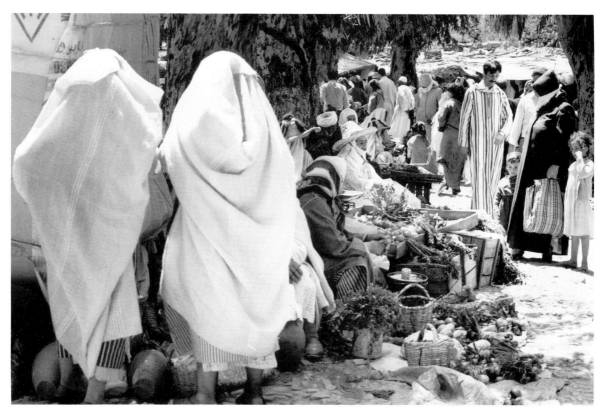

Berber market, Asilah, Morocco.

manufacturer's film. There are some that request Kodachrome and others which insist on Fujichrome or Ektachrome. The reason is primarily that different printers are more geared to using certain types of film. However, with the laser scanning techniques in use today, this is no longer strictly true. The problem is that prejudice and old habits die hard. I use Agfa Professional exclusively for my photography and used to remount slides for selection in my own personalised mounts. In this way I managed to overcome most of these difficulties. Since the new film launched recently has received excellent reviews, I no longer find it necessary to do this. In any case, it is simply not feasible to shoot every picture on three or four different film stocks.

The Importance of Quality

When showing work to prospective buyers, always show the very best photographs so that a reputation for quality becomes established. With black and white prints it is worthwhile remembering that there is a tendency to 'ink up' when reproduced. Unless they are showing a specific technique, prints should have a good tonal range and should be lighter than those printed for exhibition purposes. When a black and white picture is reproduced in a newspaper there can be a tremendous loss of quality, and confused pictures that are very busy in content look far

worse in this context. Uncluttered, strong compositions sell best to newspapers. I usually arrange the final selection of prints in a portfolio, carrying the contacts of the films in a separate envelope so that the editor can choose from those as well if a bigger selection is required.

On some of the larger papers the editors like to take the negatives and produce the prints in their own darkrooms. I have always freely given my negatives to one national Sunday paper whom I know from experience will look after them, but would refuse to part with my negatives when working with most other newspapers. The newspaper technicians are often under tremendous pressure to produce vast numbers of prints and have a tendency not to take as much care of the negative as the photographer would. However, frequently the technician's print is superior, because apart from being a professional, he has the added advantage of knowing the printing process used by the paper and understands the tastes of his picture editor. Then again, I have seen darkroom technicians drop negatives on the floor, and often once they have produced a print the next negative is in the enlarger carrier and several different prints are made before the negatives are re-filed in their protective sleeves. It is a risk I prefer not to take unless I know the paper extremely well.

When starting out a photographer may well find that until he has the experience to produce a top

quality print himself he may make more sales by using another photographer to print his work. Many of the most successful photographers never print their own work because they are too busy taking photographs, so they make an arrangement with a local laboratory or employ their own technician. Editors do notice when care is taken in the presentation of work. Well presented work does not only please the editor, it also maximises the sales potential.

Craftsman re-tinning coffee pots, Najaran, Saudi Arabia.

Adding Words

I have always included as much information with my photographs as possible. After I had been selling pictures for a while, I began to get requests from editors asking me to write a paragraph that could accompany the photographs. As I became better at writing, the sales of photographs began to increase. Then a couple of editors asked if I could write a few paragraphs, and offered to pay for my words. One of the main advantages of writing text to go with photographs is that both text and photographs belong together; too often pictures have little connection with the text. Many of the places I have photographed are extremely remote, and it is rare that enough information is readily available in this country to write detailed articles, unless the information is gathered at source by the photographer. Although I do illustrate articles written by other writers, about 75 per cent of my photographs are sold for editorial use with my own words.

I Hate Writing!

I am a photographer who dislikes writing intensely. Someone once told me that writing is easy; all a writer does is sit at a typewriter and bleed. I agree totally with those sentiments; to write an article I have to really discipline myself and make myself write. It does not hold the attraction that photography has, but I now see it as an essential part of my work and enjoy creating a need for my photography.

Slowly my paragraphs grew into short articles and short articles grew into longer ones, until now I am under contract to write several books. The majority of freelance photographers do not write at all, but a large number of successful travel photographers do. When the photographer and writer are the same person, it does make the editor's life much easier. These days many of my clients ring up and ask for ideas, and frequently I am given two or three pages to fill as I like!

The role of the photojournalist is much better established in America than in this country. In the States, there are a great number of photographers who sell the complete illustrated article; in this country there are surprisingly few. I have been offered several full-time jobs with publications, but it is always either as a photographer or a journalist. Yet there are definite advantages for the photographer who can write, and many editors will use that person rather than have to engage both a photographer and a journalist.

Recently I had a request to illustrate two articles, one on flower arranging, the other on Tuscany. I submitted material I had on file, as the request was urgent there was no time to take specific photographs for the text. When the article on flower arranging was published, the text and photographs bore no relation to each other; the article described completely different flowers from the ones shown! As for Tuscany, the pictures became totally dependent on their captions, since half the places illus-

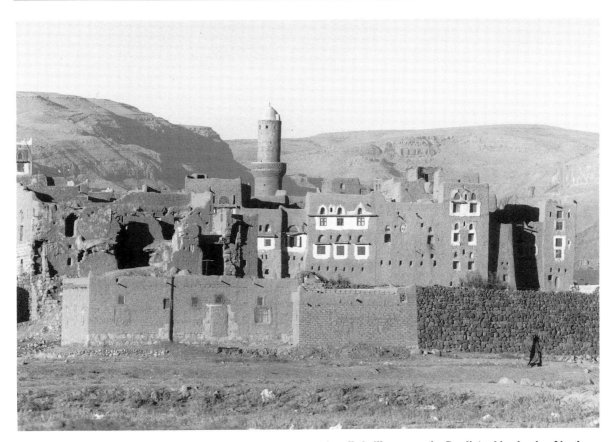

A walled village near the Saudi Arabian border, North Yemen.

trated were not covered by the text. I have also sent photographs for use in illustrated books and exactly the same thing has happened – the picture editor liked and used photographs that had no relation to the text.

It is not necessary to have any training to become either a writer or a photographer. I have a diploma in art and design but no formal training in either photography or writing. I do both largely by instinct, and now spend a great deal of my time helping others learn in the way I would have liked to have been taught myself. I was unable to afford lessons, and all my skills have evolved through trial and error – of which there has been plenty.

There are advantages and disadvantages in learning whilst working. Having had to learn photography the hard way has meant basic errors costing me both time and clients. The advantage is that having made most mistakes, if something should go wrong now I know how to cope and seem to be able to avoid most pitfalls instinctively. However, these days there are a very wide choice of courses and workshops that photographers can attend to learn all sorts of skills.

Perhaps the easiest way to learn to write is to talk to a typewriter and pretend it is a friend! This may seem very basic but it does seem to work. It amused me when an editor recently said he liked my direct, no-nonsense approach! I always carry my notebook around and when useful words spring to mind I make a note of them. Before I begin every article I write down a structure and organise my thoughts on paper before writing. This helps to make the article 'hang together'.

Frequently I write an introductory paragraph which is scrapped when the article is complete. This seems to be a necessary process and has a lot to do with the way some people's minds work when they are writing; only in the second paragraph does the mind get down to the essence of the piece.

Learning As You Go

The very first articles I wrote were written longhand. Most editors will refuse to accept anything other than typed copy, but I found four editors who each bought an article from me, and the resulting money paid for my very first typewriter. Every writer has his own special difficulties; mine is an inability to spell! Having no desire to learn to spell, I have always employed a proof reader who checks my work before I submit the finished article. However, I find it helpful, if time permits, to write a rough first and then rewrite before submitting.

Armed tribesmen at Marib, near Saudi Arabian border, North Yemen.

Computers can Help

These days life is far simpler, using a word processor which checks spelling at the touch of a button. Complete paragraphs can be moved, deleted or rearranged with its editing package. It is very easy these days to use computers, as most of them have help pages than can be called up whilst working. Don't be put off by the jargon used by the so-called computer experts that sell the machines; many of them forget that ordinary people are not used to their language. Choose a specialist computer shop that offers service. Whilst computers may be cheaper in some of the larger stores, it is extremely useful to be able to call up for help if something does go wrong.

I am currently in the process of entering my travel library onto a database. This will give me, at the touch of a button, not only details of the photographs in any of the categories but also where each photograph is, if it is out on loan and how long it has been out. In this way I will have all the information at my fingertips should a client call, and know when I need to chase up a publisher that has been holding on to my work for too long. Reminders can also be sent at the touch of a button.

The computer runs the office, with packages for accounts, filing and storage of information for future work, leaving me more time for actual photography.

Most writers find that it is easier to work when they are given a deadline. Quite a number don't even start to write until the deadline is nearly upon them. Writers need to have discipline; it is too easy to become distracted, and only when the deadline approaches and the need to work is real does the writing get completed. I frequently find that my best work is written to tight deadlines. This means there is less time to rearrange words and rewrite, which can ruin the spontaneity of the article. Writing needs to flow, and at the same time to be organised, but if it is too well organised it can tend to become boring.

Never Fear a Subject

A good writer is never limited to his existing knowledge but uses every source available to expand that

Hot springs at Myvatn, Iceland.

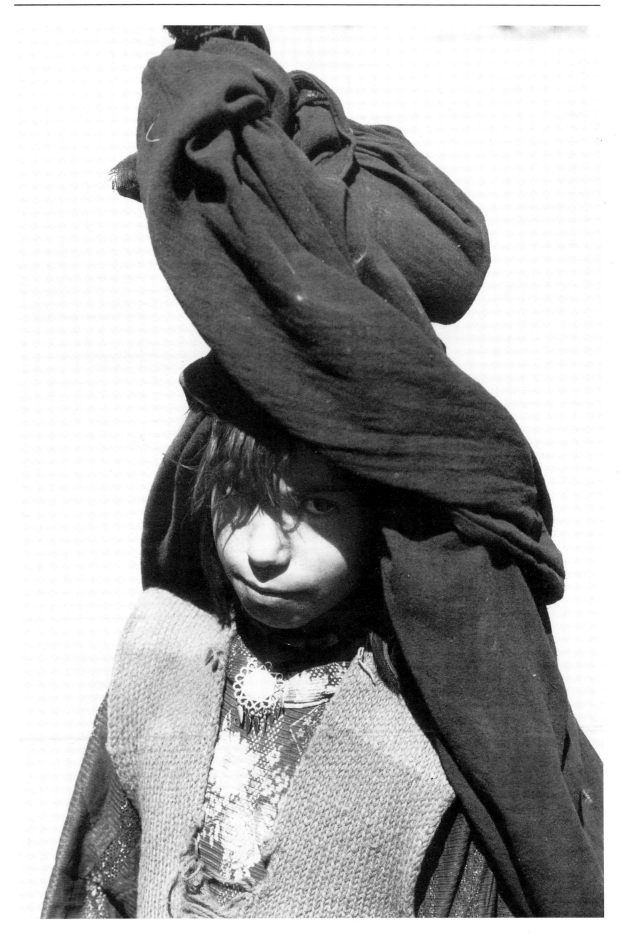

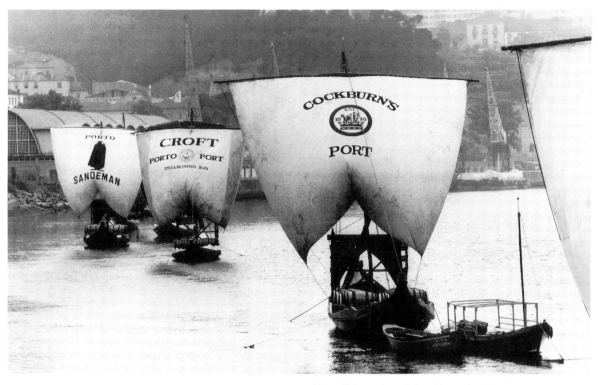

Port Shippers' traditional boats in the harbour at Oporto, Portugal.

knowledge, through libraries, archives and other people. A lay person should never be frightened of tackling a technical subject, for as long as he has the ability to assimilate information and is prepared to carefully check the information he uses, he can provide a stimulating, lively alternative for the many technical publications that are filled with deadly boring, but highly factual, technical information.

I have written and illustrated articles for the Institution of Civil Engineers and RIBA (The Royal Institute of British Architects). I am not an architect, and I am certainly not an engineer! I have no in-depth knowledge of either subject, but I do derive great pleasure from photographing structures and architecture. Through very careful research, interviewing experts and reading as much information as possible, I am able to write authoritative pieces on specialist subjects, such as the history of the architecture of North Yemen.

For several years I was an overseas correspondent, writing a weekly column dealing with property markets world-wide. Before I started writing I knew nothing about property. Initially the research took ages, but as I became more proficient, I became faster and faster. I have also written about international financial matters for leading financial papers.

Photographer or Writer

It is very easy to become careless, and I always check very carefully the contents of every article before my work is submitted. I regard each article as a challenge, and illustrating it as an equal challenge. It is strange, but when I write I am thought of as a writer who occasionally takes pictures; when I sell pictures I am a photographer who occasionally writes. Editors seem to have a need to categorise people, and it is therefore useful to mention from time to time that although you write you are first and foremost a travel photographer, and that you write primarily to sell photographs. The editor and picture editor on bigger publications are usually two separate people and very often the photographer will have to deal with both. Each person will only be concerned with one aspect of your work; the picture editor will not realise you can supply the words and the editor will not realise that you are a photographer.

I recently submitted an idea for an article to a Sunday newspaper. The objective was to sell some photographs taken on a recent trip to Jordan. The features editor commissioned the words, I wrote the feature, and it was only when I asked to see the picture editor that my photography was considered. The usual procedure would be for the proposed

Young girl carrying tins wrapped in a bundle on her head, Zabeed, North Yemen.

Boatwoman in Hong Kong harbour.

contents of the paper to be given to the picture editor so that he could then begin his research. He would first ask any staff photographers if they have any photographs on file or about the feasibility of them being able to take the pictures required. If the photograph cannot be supplied from in-house sources the request will be passed on to one of the large picture agencies. It is very easy for the picture editor to forget to contact the journalist concerned if he is not working close at hand. Of course there are far more photographers who write than journalists who take pictures.

Two aborigine women knitting, in the Taroko Gorge, Taiwan.

Index

(Page numbers in italics refer to illustrations)